FAMILY CHRISTMAS TREASURES

To : The Entress Family

Merry Christmas 2018

Love, Daniel, Jen, Hayden & Abby

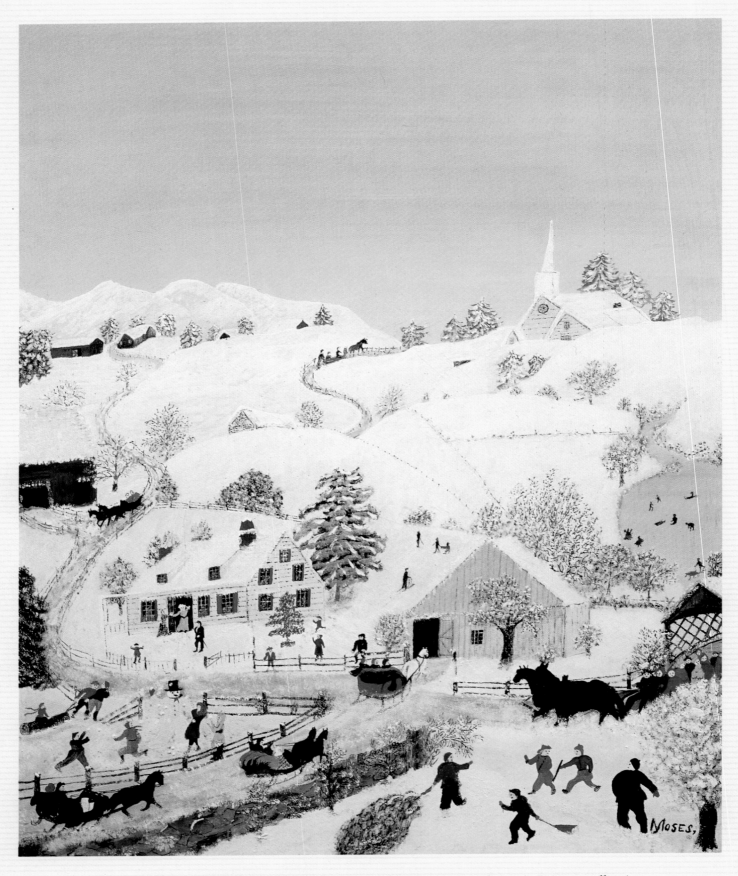

GRANDMA MOSES. *White Christmas.* Copyright © 1955 (renewed 1983). Private collection.
Grandma Moses Properties Co., New York.

FAMILY CHRISTMAS TREASURES

EDITED BY

Kacey Barron

UNIVERSE

Published by
Universe Publishing
A Division of Rizzoli International Publications, Inc.
300 Park Avenue South
New York, NY 10010
www.rizzoliusa.com

Design: Charles J. Ziga

2015 2016 2017 2018 / 10 9 8 7 6

Printed in China

ISBN-13: 978-0-7893-9971-7

Library of Congress Catalog Control Number: 2008922556

CONTENTS

THE SPIRIT OF CHRISTMAS

INTRODUCTION

"Time was, with most of us, when Christmas Day, encircling all our limited world like a magic ring, left nothing out for us to miss or seek; bound together all our home enjoyments, affections and hopes; grouped everything and every one around the Christmas fire; and made the little picture shining in our bright young eyes, complete."

—*from "What Christmas Is as We Grow Older" by Charles Dickens*

harles Dickens established in his fiction the ideal family Christmas, where family and friends gather around the hearth to enjoy one another's company, to feast, and to make merry. It is the bright scene that many of us picture when we think about Christmas today. But Christmas is a theme that has long inspired a host of artists and writers, both notable and obscure, whose imaginative creations have shaped our conception of Christmas in many ways. This compendium of fine art and literature, both classic and contemporary, explores from various perspectives the celebration of Christmas as it is enjoyed throughout the world. As we browse through these pages, we experience the glorious sensations of Christmas—the thrill of anticipation, the bustle of preparation, the comfort of familiar customs, the pleasure of stories, the poignancy of memories, and the peace of the season's spirit.

The anticipation of Christmas can be as magnificent as its culmination. It is a time of promise, a time when anything seems possible. In the weeks preceding Christmas, there is a buzz of excitement in the air: shop windows are bedecked for display, homes and trees are festively lit, and Christmas cards and mysterious packages arrive by mail. Hints of the approaching event abound, from the heavenly aroma of Christmas cookies baking, to the fragrant scent of evergreens and spiced candles. We smile as we hear the familiar cadences of Christmas verse and the jubilant discord of carols sung out of tune. Christmas, an explosion of warmth, color, and life, is a gala for the senses.

INTRODUCTION

Is there a better way to capture the beauty that surrounds us at Christmastime than with art? From charming Victorian Christmas cards; to classic book illustrations; to gorgeous paintings by Claude Monet, Camille Pissarro, Paul Gaugin, Childe Hassam, Pablo Picasso, Thomas Nast, Norman Rockwell, Grandma Moses, and many others; to bold and vivid designs by modern artists such as Andy Warhol, here are the stunning portrayals— each with its own unique vision—of the Christmas season in all its splendor.

With "Christmas Eve," from E.T.A. Hoffman's classic story of the *Nutcracker*, the doors open to the rapturous realm of imagination that epitomizes Christmas Eve. The children, who—in keeping with the German custom—are allowed to have their first view of the decorated Christmas tree and open gifts on Christmas Eve, whisper excitedly about what they hope the evening will hold for them. This anticipation of extraordinary things to come continues in selections from Washington Irving's *The Stagecoach*, a jolly journey to the English countryside for the holidays; Willa Cather's *My Ántonia*, in which the characters prepare surprises for each other; and Truman Capote's *A Christmas Memory*, in which a young boy and his caretaker triumphantly find the perfect Christmas tree.

Christmas customs, stories, and lore are essential to the celebration of Christmas. They are a way for us to connect to our larger cultural identity, and they remind us of the true meaning of Christmas. Filling the house with evergreens and putting up a tree is more than just decorating for the holidays; it is a way to express the importance of home in our lives. Preparing special foods to share with family and friends brings us together. The carols we sing and the stories we share reaffirm our heritage and beliefs.

Of all the Christmas traditions, the reading and retelling of stories through verse and song is a constant. Even if the stories are not familiar to us, we can recognize in them universal themes—the Christmas tree; the Christmas feast; some form of the popular mythical figure known as St. Nicholas, or Santa Claus—that span our differences and bridge understanding. But it is not just the content of the stories that is so magical, it is the act of reading them aloud with loved ones that fosters a sense of community and brings the family circle closer.

Christmas stories take many forms. Some offer creative explanations for why we have certain traditions. *The Legend of the Poinsettia*, by Pat Mora and Charles Ramírez Berg, describes how a little boy's humble but sincere offering to the infant Jesus of a simple weed transforms into a beautiful red poinsettia. In Clement C. Moore's *The Legend of the Christmas Tree*, the Christ Child rewards children for their good deeds by miraculously producing a fruit-bearing Christmas tree. Other narratives impart morals, such as William Dean Howell's *Christmas Every Day*, a didactic tale that warns children of the dangers of

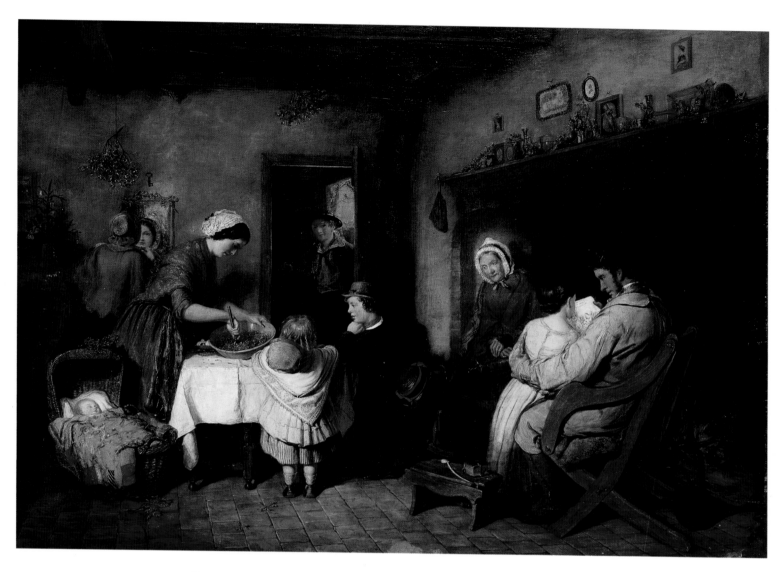

FREDERICK DANIEL HARDY. *Christmas Visitors Stirring the Pudding.*
Christie's Images, London, UK/Bridgeman Art Library.

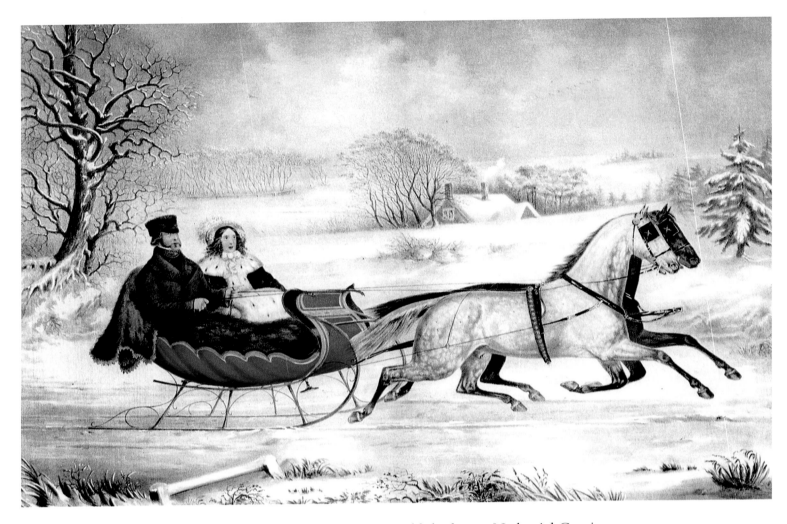

OTTO KNIRSCH. *The Road, Winter.* Published 1853 Nathaniel Currier.
Hand colored lithograph on paper. Image provided by the Currier & Ives Foundation.

greed. And though all stories entertain, some do it to delightful excess. Look at L. Frank Baum's hilarious *Kidnapped Santa Claus* and Leo Rosten's *Mr. Kaplan and the Magi*.

By allowing ourselves to revel in the spirit of Christmas, we glimpse a better world, one that observes the message of the first Christmas—peace on earth, goodwill to men—and we feel a surge of well-being. The passages from Charles Dickens's *A Christmas Carol*, Louisa May Alcott's *Little Women*, and Harriet Beecher Stowe's *The Good Fairy* let us remember how good it feels to help those in need. We contemplate the way we interact with others—strangers, acquaintances, and loved ones—and we resolve to do better by them. In stories such as Pearl S. Buck's *Christmas Day in the Morning* and Marjory Talcott's *The Christmas We Will Never Forget*, we realize that even our smallest thoughtful gestures mean a great deal to our families. Christmas is also a time for reconciliation, for replacing bitterness with tolerance and understanding, as we see in Maeve Binchy's *A Typical Irish Christmas* and Maureen Hull's *The Montreal Aunts*. Henry Van Dyke's *Keeping Christmas* calls on us to live noble lives, not just at Christmas, but always.

Art and literature are a perfect union for a celebration of Christmas, for what is Christmas if not an occasion when the nuances of our lives are revealed and illuminated? And what is a good story, or a stirring image, if not a revelation of some truth about ourselves? Christmas allows us pause to reflect on the passage of time, to slip into the delicious bliss of memory, where our minds can savor the scenes and events dear to the heart. It gives us the opportunity to take stock of our lives, to appreciate our blessings, and to provide charity and compassion for those less fortunate. Whether reading this book carries you on a nostalgic journey back to a happy time in your life, alights in you the joy of discovery, or inspires you to strive toward a higher level of humanity, we hope that in some way it imparts to you and your family a gift, one that will be opened again and again, year after year. We hope that reading this book rekindles in you the true spirit of Christmas, the spirit that warms and graces all who open their hearts to it.

I

CHRISTMAS
PREPARATIONS
AND
ANTICIPATION

FROM *Nutcracker*

E. T. A. HOFFMANN

The tale of the Nutcracker, *by German writer, composer, and painter E. T. A. Hoffmann (1776–1822), epitomizes the wonderment of the season. It is not without difficulty that these children wait for their parents to open the door to Christmas and all its magic.*

n the twenty-fourth of December Dr. Stahlbaum's children were not allowed to set foot in the small family parlor, much less the adjoining company parlor—not at any time during the day. Fritz and Marie sat huddled together in a corner of the little back room. An eerie feeling came over them when dusk fell and, as usual on Christmas Eve, no light was brought in. In whispers Fritz told his younger sister (she had just turned seven) that since early morning he had heard murmuring and shuffling and muffled hammer blows in the locked rooms. And a short while before, he confided, a small, dark man had crept down the hallway with a big box under his arm, and he, Fritz, felt pretty sure that this could only be Godfather Drosselmeier. At that, Marie clapped her little hands for joy and cried out:

"Oh, what do you think Godfather Drosselmeier has made for us?"

Judge Drosselmeier was anything but handsome. He was short and very thin, his face was seamed with wrinkles, he had a big black patch where his right eye should have been, and he had no hair at all, for which reason he wore a beautiful white wig, a real work of art. And Judge Drosselmeier was himself a skilled craftsman, able to make and repair clocks. When one of the fine clocks in the Stahlbaum house was sick and unable to sing, Godfather Drosselmeier would come over, remove his glass wig and yellow coat, and put on a blue apron. For a while he would

stick sharp instruments into the clock. Little Marie felt real pain at the sight. But it didn't hurt the clock in the least; on the contrary, it came back to life and made everyone happy by whirring and striking and singing merrily. Whenever he came, he had something in his pocket for the children—now a little man who would roll his eyes and bow in a most comical way, now a box that a little bird would hop out of, now something else. But every year at Christmas he took great pains to turn out a work of wonderful artistry, so precious that the children's parents always put it away in a safe place.

"Oh," Marie cried out, "what do you think Godfather Drosselmeier has made for us?"

Fritz said it was sure to be a fortress, with all kinds of soldiers marching up and down and drilling, and then other soldiers would come and try to get in but the brave defenders would fire their guns, which would boom and thunder wonderfully.

"No, no," Marie interrupted. "Godfather Drosselmeier said something to me about a beautiful garden with a big lake in it and lovely swans with golden necklaces swimming around on it and singing the most beautiful songs. And then a little girl comes across the garden to the lake and calls the swans and feeds them marzipan."

"Swans don't eat marzipan," said Fritz rather rudely, "and besides, Godfather Drosselmeier can't make a whole garden. And anyway, what good are his toys to us? They always get taken away before we know it. I like the things Mama and Papa give us a lot better, because we can keep them and do what we like with them."

Then the children tried to guess what their parents would give them this time. Marie remarked that Mistress Trude (her big doll) had changed for the worse. Clumsier than ever, she kept falling on the floor, which always left nasty marks on her face. And no amount of scolding would help, she just couldn't keep her clothes

clean. Marie also remembered how Mama had smiled at her for being so delight-ed with her doll Gretchen's little parasol. Fritz, on the other hand, observed that, as his father was well aware, a decent chestnut horse was needed for his royal sta-bles, and that his army had no cavalry at all.

So the children knew that their parents had bought them all sorts of lovely pres-ents, and were busy imagining them, but they were just as certain that the Christ Child was looking on with tender loving eyes, and that Christmas gifts, because he had blessed them, gave more pleasure than any others. The children, who kept whis-pering about the presents they expected, were reminded of this by their elder sis-ter, Louise, who added that it was always the Christ Child who, by the hands of their dear parents, brought children things that would give them true enjoyment, since he knew what those would be better than the children themselves. So, big sister Louise went on, instead of hoping and wishing for all sorts of things, they should wait quietly like well-behaved children for whatever the Christ Child would bring.

Marie sat deep in thought, but Fritz muttered, "All the same, I'd like a chestnut horse and some hussars."

By then it was very dark. Fritz and Marie pressed close together afraid to say another word; they had a feeling that gentle wings were passing over, and they seemed to hear beautiful music in the distance. When a flash of brightness flitted across the wall, they knew it was the Christ Child flying away on glowing clouds to other happy children.

At that moment a silvery-bright bell rang ding-a-ling, the doors flew open, and such a flood of light streamed in from the big parlor that the children cried aloud, "Oh! Oh!" and stood stock-still on the threshold. Papa and Mama appeared in the doorway, took their children by the hand, and said, "Come in, come in, dear chil-dren, and see what the Christ Child has brought you."

The Stage-Coach

WASHINGTON IRVING

*Washington Irving (1783–1859), called "the first American man of letters," is best known for his
short stories "The Legend of Sleepy Hollow" and "Rip Van Winkle." Here he captures the
charm and festivity of rural England at Christmastime.*

n the course of a December tour in Yorkshire, I rode for a
long distance in one of the public coaches, on the day pre-
ceding Christmas. The coach was crowded, both inside and
out, with passengers, who, by their talk, seemed principally
bound to the mansions of relations or friends, to eat the Christmas dinner. It
was loaded also with hampers of game, and baskets and boxes of delicacies; and
hares hung dangling their long ears about the coachman's box, presents from
distant friends for the impending feast. I had three fine rosy-cheeked boys for
my fellow-passengers inside, full of the buxom health and manly spirit which
I have observed in the children of this country. They were returning home for
the holidays in high glee, and promising themselves a world of enjoyment. It
was delightful to hear the gigantic plans of the little rogues, and the impracti-
cable feats they were to perform during their six weeks' emancipation from
the abhorred thraldom of book, birch, and pedagogue. They were full of antic-
ipations of the meeting with the family and household, down to the very cat
and dog; and of the joy they were to give their little sisters by the presents with
which their pockets were crammed; but the meeting to which they seemed
to look forward with the greatest impatience was with Bantam, which I found
to be a pony, and, according to their talk, possessed of more virtues than any

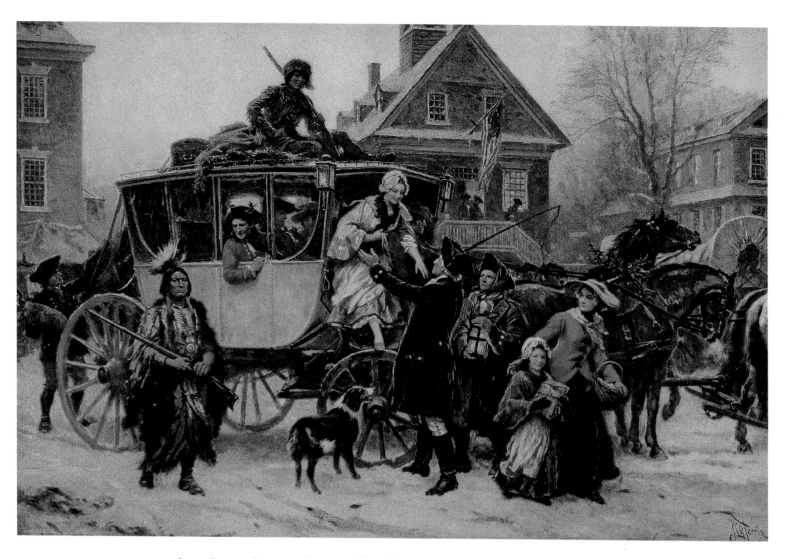

JEAN LEON GEROME FERRIS. *The Christmas Coach 1795*. Oil on canvas.
Reproduced1932; Copyright by The Fountain Press, Inc., Cleveland, Ohio, and
J. L. G. Ferris. Photograph courtesy of the Library of Congress.

Passing Out Christmas Presents Around the Tree. c. 1870.
American engraving. The Granger Collection, New York.

steed since the days of Bucephalus. How he could trot! how he could run! and then such leaps as he would take—there was not a hedge in the whole country that he could not clear.

They were under the particular guardianship of the coachman, to whom, whenever an opportunity presented, they addressed a host of questions, and pronounced him one of the best fellows in the world. Indeed, I could not but notice the more than ordinary air of bustle and importance of the coachman, who wore his hat a little on one side, and had a large bunch of Christmas greens stuck in the button-hole of his coat. He is always a personage full of mighty care and business, but he is particularly so during this season, having so many commissions to execute in consequence of the great interchange of presents. . . .

Perhaps the impending holiday might have given a more than usual animation to the country, for it seemed to me as if everybody was in good looks and good spirits. Game, poultry, and other luxuries of the table, were in brisk circulation in the villages; the grocers', butchers', and fruiterers' shops were thronged with customers. The housewives were stirring briskly about, putting their dwellings in order; and the glossy branches of holly, with their bright-red berries, began to appear at the windows. The scene brought to mind an old writer's account of Christmas preparations:—"Now capons and hens, beside turkeys, geese, and ducks, with beef and mutton—must all die—for in twelve days a multitude of people will not be fed with a little. Now plums and spice, sugar and honey, square it among pies and broth. Now or never must music be in tune, for the youth must dance and sing to get them a heat, while the aged sit by the fire. The country maid leaves half her market, and must be sent again, if she forgets a pack of cards on Christmas eve. Great is the con-

tention of holly and ivy, whether master or dame wears the breeches. Dice and cards benefit the butler; and if the cook do not lack wit, he will sweetly lick his fingers."

I was roused from this fit of luxurious meditation, by a shout from my little travelling companions. They had been looking out of the coach windows for the last few miles, recognizing every tree and cottage as they approached home, and now there was a general burst of joy—"There's John! and there's old Carlo! and there's Bantam!" cried the happy little rogues, clapping their hands. . . .

I was pleased to see the fondness with which the little fellows leaped about the steady old footman, and hugged the pointer; who wriggled his whole body for joy. But Bantam was the great object of interest; all wanted to mount at once, and it was with some difficulty that John arranged that they should ride by turns, and the eldest should ride first.

Off they set at last; one on the pony, with the dog bounding and barking before him, and the others holding John's hands; both talking at once, and overpowering him with questions about home, and with school anecdotes. I looked after them with a feeling in which I do not know whether pleasure or melancholy predominated; for I was reminded of those days when, like them, I had neither known care nor sorrow, and a holiday was the summit of earthly felicity.

The Christmas Tree

SAMUEL T. COLERIDGE

Samuel T. Coleridge (1772–1834) was an English lyrical poet, critic, and philosopher whose
Lyrical Ballads, written with William Wordsworth, heralded the English Romantic movement. This is
his account of the touching family Christmas celebration he observed in Ratzeburg, Germany, in 1799.

There is a Christmas custom here which pleased and interested me. The children make little presents to their parents, and to each other; and the parents to the children. For three or four months before Christmas the girls are all busy, and the boys save up their pocket-money, to make or purchase these presents. What the present is to be is cautiously kept secret, and the girls have a world of contrivances to conceal it—such as working when they are out on visits, and the others are not with them; getting up in the morning before day-light, and the like. Then, on the evening before Christmas Day, one of the parlours is lighted up by the children, into which the parents must not go. A great yew bough is fastened on the table at a little distance from the wall, a multitude of little tapers are fastened in the bough, but so as not to catch it till they are nearly burnt out, and coloured paper hangs and flutters from the twigs. Under this bough the children lay out in great order the presents they mean for their parents, still concealing in their pockets what they intend for each other. Then the parents are introduced, and each presents his little gift, and then bring out the rest one by one from their pockets, and present them with kisses and embraces. Where I witnessed this scene there were eight or nine children, and the eldest daughter and the mother wept aloud for joy and tenderness; and the tears ran

down the face of the father, and he clasped all his children so tight to his breast, it seemed as if he did it to stifle the sob that was rising within him. I was very much affected. The shadow of the bough and its appendages on the wall, and arching over on the ceiling, made a pretty picture; and then the raptures of the very little ones, when at last the twigs and their needles began to take fire and snap!—Oh, it was a delight for them! On the next day, in the great parlour, the parents lay out on the table the presents for the children: a scene of more sober joy succeeds, as on this day, after an old custom, the mother says privately to each of her daughters, and the father to his sons, that which he has observed most praiseworthy, and that which was most faulty in their conduct. Formerly, and still in all the smaller towns and villages throughout North Germany, these presents were sent by all the parents to some one fellow, who in high buskins, a white robe, a mask, and an enormous flax wig, personates *Knecht Rupert*, the servant Rupert. On Christmas night he goes round to every house, and says that Jesus Christ his master sent him thither; the parents and elder children receive him with great pomp of reverence, while the little ones are most terribly frightened. He then inquires for the children, and, according to the character which he hears from the parent, he gives them the intended presents, as if they came out of heaven from Jesus Christ. Or, if they should have been bad children, he gives the parents a rod, and in the name of his master recommends them to use it frequently. About seven or eight years old the children are let into the secret, and it is curious to observe how faithfully they keep it.

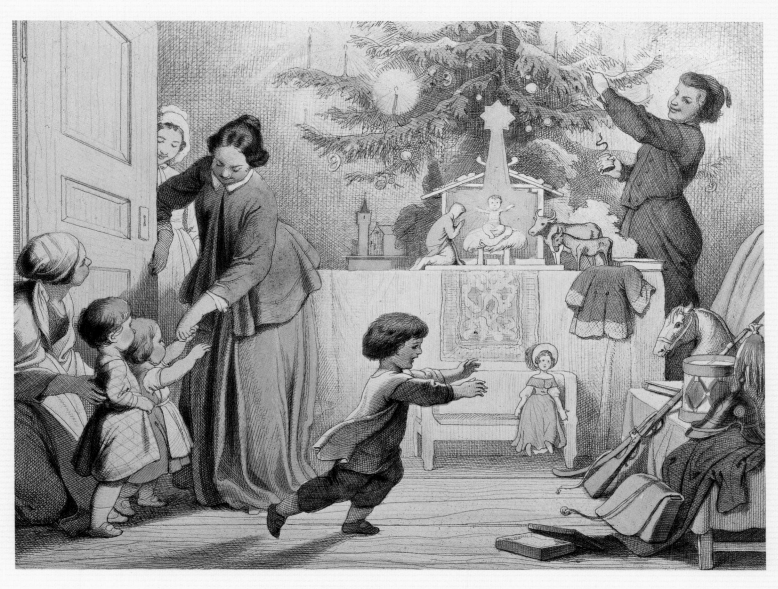

GERMAN SCHOOL. *Decorating the Christmas Tree*. 19th century.
Private collection/Bridgeman Art Library.

FROM *My Ántonia*

WILLA CATHER

Willa Cather (1873–1947), an American novelist noted for her portrayals of frontier life on the American plains, wrote from her own experience growing up among European immigrants in Nebraska. This family's Christmas celebration fuses traditions of the old country with those of the new.

We decided to have a country Christmas, without any help from town. I had wanted to get some picture books for Yulka and Ántonia; even Yulka was able to read a little now. Grandmother took me into the ice-cold storeroom, where she had some bolts of gingham sheeting. She cut squares of cotton cloth and we sewed them together into a book. We bound it between pasteboards, which I covered with brilliant calico, representing scenes from a circus. For two days I sat at the dining-room table, pasting this book full of pictures for Yulka. We had files of those good old family magazines which used to publish coloured lithographs of popular paintings, and I was allowed to use some of these. I took "Napoleon Announcing the Divorce to Josephine" for my frontispiece. On the white pages I grouped Sunday-School cards and advertising cards which I had brought from my "old country." Fuchs got out the old candle-moulds and made tallow candles. Grandmother hunted up her fancy cake-cutters and baked gingerbread men and roosters, which we decorated with burnt sugar and red cinnamon drops.

On the day before Christmas, Jake packed the things we were sending to the Shimerdas in his saddle-bags and set off on grandfather's grey gelding. When he mounted his horse at the door, I saw that he had a hatchet slung to

his belt, and he gave grandmother a meaning look which told me that he was planning a surprise for me. That afternoon I watched long and eagerly from the sitting-room window. At last I saw a dark spot moving on the west hill, beside the half-buried cornfield, where the sky was taking on a coppery flush from the sun that did not quite break through. I put on my cap and ran out to meet Jake. When I got to the pond, I could see that he was bringing in a little cedar tree across his pommel. He used to help my father cut Christmas trees for me in Virginia, and he had not forgotten how much I liked them.

By the time we had placed the cold, fresh-smelling little tree in a corner of the sitting-room, it was already Christmas Eve. After supper we all gathered there, and even grandfather, reading his paper by the table, looked up with friendly interest now and then. The cedar was about five feet high and very shapely. We hung it with gingerbread animals, strings of popcorn, and bits of candle which Fuchs had fitted into pasteboard sockets. Its real splendour, how-ever, came from the most unlikely place in the world—from Otto's cowboy trunk. I had never seen anything in that trunk but old boots and spurs and pis-tols, and a fascinating mixture of yellow leather thongs, cartridges, and shoe-maker's wax. From under the lining he now produced a collection of brilliantly coloured paper figures, several inches high and stiff enough to stand alone. They had been sent to him year after year, by his old mother in Austria. There was a bleeding heart, in tufts of paper lace; there were the three kings, gor-geously apparelled, and the ox and the ass and the shepherds; there was the Baby in the manger, and a group of angels, singing; there were camels and leopards, held by the black slaves of the three kings. Our tree became the talk-ing tree of the fairy tale; legends and stories nestled like birds in its branches. Grandmother said it reminded her of the Tree of Knowledge.

FROM
The Wind in the Willows

KENNETH GRAHAME

The Wind in the Willows, by Scottish author Kenneth Grahame (1859–1932), presents delightful animal characters with charming human traits. Here Mole's good friend, Rat, and some visiting field mice bring the spirit of Christmas to Mole's humble home.

he Rat, much excited, kept close to his heels as the Mole, with something of the air of a sleepwalker, crossed a dry ditch, scrambled through a hedge, and nosed his way over a field open and trackless and bare in the faint starlight.

Suddenly, without giving warning, he dived; but the Rat was on the alert, and promptly followed him down the tunnel to which his unerring nose had faithfully led him.

It was close and airless, and the earthy smell was strong, and it seemed a long time to Rat ere the passage ended and he could stand erect and stretch and shake himself. The Mole struck a match, and by its light the Rat saw that they were standing in an open space, neatly swept and sanded underfoot, and direct-ly facing them was Mole's little front door, with "Mole End" painted, in Gothic lettering, over the bell-pull at the side.

Mole reached down a lantern from a nail on the wall and lit it, and the Rat, looking round him, saw that they were in a sort of fore-court. A garden-seat stood on one side of the door, and on the other, a roller; for Mole, who was a tidy animal when at home, could not stand having his ground kicked up by

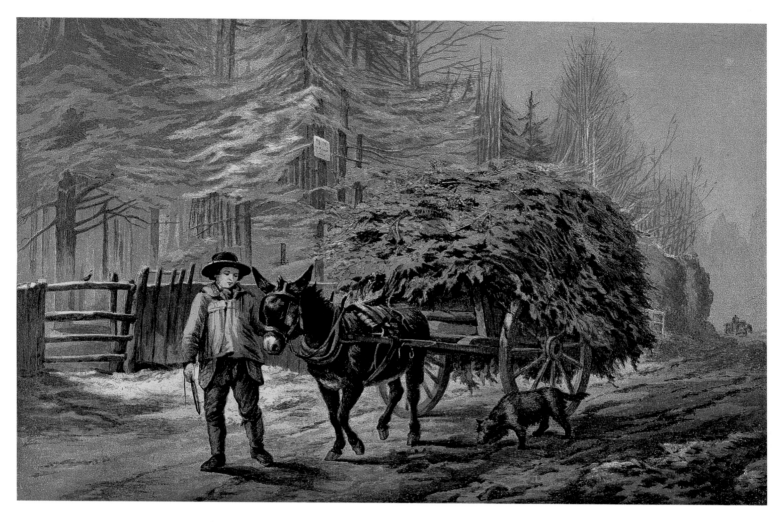

The Holly Cart. 1856. Color lithograph. English. The Granger Collection, New York.

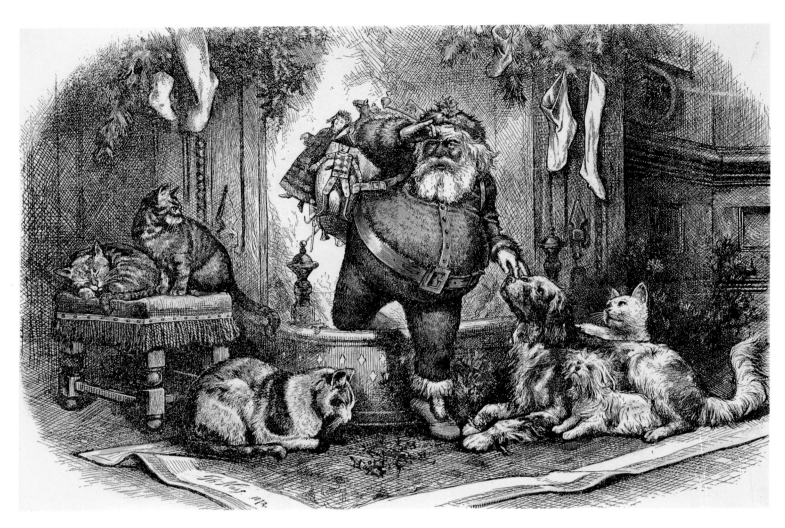

THOMAS NAST. *The Coming of Santa Claus.* 1872.
Colored engraving. The Granger Collection, New York.

other animals into little runs that ended in earth-heaps. On the walls hung wire baskets with ferns in them, alternating with brackets carrying plaster statuary—Garibaldi, and the infant Samuel, and Queen Victoria, and other heroes of modern Italy. Down one side of the fore-court ran a skittle-alley, with benches along it and little wooden tables marked with rings that hinted at beer-mugs. In the middle was a small round pond containing goldfish and surrounded by a cockle-shell border. Out of the centre of the pond rose a fanciful erection clothed in more cockle-shells and topped by a large silvered glass ball that reflected everything all wrong and had a very pleasing effect.

Mole's face beamed at the sight of all these objects so dear to him, and he hurried Rat through the door, lit a lamp in the hall, and took one glance around his old home. He saw the dust lying thick on everything, saw the cheerless, deserted look of the long-neglected house, and its narrow, meagre dimensions, its worn and shabby contents—and collapsed again on a hall-chair, his nose in his paws. "O, Ratty!" he cried dismally, "why ever did I do it? Why did I bring you to this poor, cold little place, on a night like this, when you might have been at River Bank by this time, toasting your toes before a blazing fire, with all your own nice things about you!"

The Rat paid no heed to his doleful self-reproaches. He was running here and there, opening doors, inspecting rooms and cupboards, and lighting lamps and candles and sticking them up everywhere. "What a capital little house this is!" he called out cheerily. "So compact! So well planned! Everything here and everything in its place! We'll make a jolly night of it. The first thing we want is a good fire; I'll see to that—I always know where to find things. So this is the parlour? Splendid! Your own idea, those little sleeping bunks in the wall? Capital! Now, I'll fetch the wood and the coals, and you get a duster, Mole—

you'll find one in the drawer of the kitchen table—and try and smarten things up a bit. Bustle about, old chap!"

Encouraged by his inspiriting companion, the Mole roused himself and dusted and polished with energy and heartiness, while the Rat, running to and fro with armfuls of fuel, soon had a cheerful blaze roaring up the chimney. He hailed the Mole to come and warm himself; but Mole promptly had another fit of the blues, dropping down on a couch in dark despair and burying his face in his duster.

"Rat," he moaned, "how about your supper, you poor, cold, hungry, weary animal? I've nothing to give you—nothing—not a crumb!"

"What a fellow you are for giving in!" said the Rat reproachfully. "Why, only just now I saw a sardine-opener on the kitchen dresser, quite distinctly; and everybody knows that means there are sardines about somewhere in the neighborhood. Rouse yourself! pull yourself together, and come with me and forage."

They went and foraged accordingly, hunting through every cupboard and turning out every drawer. The result was not so very depressing after all, though of course it might have been better; a tin of sardines—a box of captain's biscuits, nearly full—and a German sausage encased in silver paper.

"There's a banquet for you!" observed the Rat, as he arranged the table. "I know some animals who would give their ears to be sitting down to supper with us tonight!"

"No bread!" groaned the Mole dolorously; "no butter, no—"

"No *pâté de foie gras*, no champagne!" continued the Rat, grinning. "And that reminds me—what's that little door at the end of the passage? Your cellar, of course! Every luxury in this house! Just you wait a minute."

He made for the cellar door, and presently reappeared, somewhat dusty, with a bottle of beer in each paw and another under each arm. "Self-indulgent beggar you seem to be, Mole," he observed. "Deny yourself nothing. This is really the jolliest little place I ever was in. Now, wherever did you pick up those prints? Make the place look so home-like, they do. No wonder you're so fond of it, Mole. Tell us all about it, and how you came to make it what it is."

Then, while the Rat busied himself fetching plates, and knives and forks, and mustard which he mixed in an egg-cup, the Mole, his bosom still heaving with the stress of his recent emotion, related—somewhat shyly at first, but with more freedom as he warmed to his subject—how this was planned, and how that was thought out, and how this was got through a windfall from an aunt, and that was a wonderful find and a bargain, and this other thing was bought out of laborious savings and a certain amount of "going without." His spirits finally quite restored, he must needs go and caress his possessions, and take a lamp and show off their points to his visitor and expatiate on them, quite forgetful of the supper they both so much needed; Rat, who was desperately hungry but strove to conceal it, nodding seriously, examining with a puckered brow, and saying, "Wonderful," and "Most remarkable," at intervals, when the chance for an observation was given him.

At last the Rat succeeded in decoying him to the table, and had just got seriously to work with the sardine-opener when sounds were heard from the fore-court without—sounds like the scuffling of small feet in the gravel and a confused murmur of tiny voices, while broken sentences reached them— "Now, all in a line—hold the lantern up a bit, Tommy—clear your throats first—no coughing after I say one, two, three.—Where's young Bill?—Here, come on, do, we're all a-waiting—"

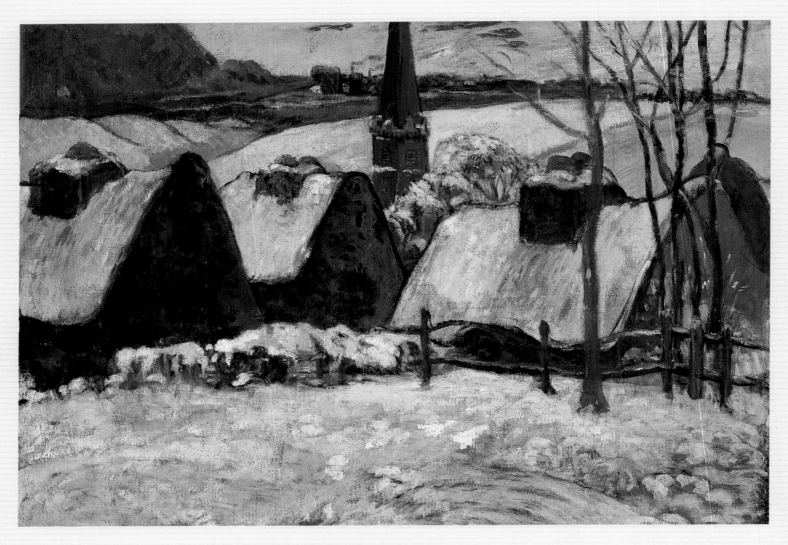

PAUL GAUGIN. *Breton Village under Snow*. 1894. Oil on canvas.
Musée d'Orsay, Paris, France. Copyright Réunion des Musées Nationaux/Art Resource, NY.
Photograph: Hervé Lewandowski.

"What's up?" inquired the Rat, pausing in his labours.

"I think it must be the field-mice," replied the Mole, with a touch of pride in his manner. "They go round carol-singing regularly at this time of year. They're quite an institution in these parts. And they never pass me over—they come to Mole End last of all; and I used to give them hot drinks, and supper too sometimes, when I could afford it. It will be like old times to hear them again."

"Let's have a look at them!" cried the Rat, jumping up and running to the door.

It was a pretty sight, and a seasonable one, that met their eyes when they flung the door open. In the fore-court, lit by the dim rays of a horn lantern, some eight or ten little field-mice stood in a semicircle, red worsted comforters round their throats, their fore-paws thrust deep into their pockets, their feet jigging for warmth. With bright beady eyes they glanced shyly at each other, sniggering a little, sniffing and applying coat-sleeves a good deal. As the door opened, one of the elder ones that carried the lantern was just saying, "Now then, one, two, three!" and forthwith their shrill little voices uprose on the air, singing one of the old-time carols that their forefathers composed in the fields that were fallow and held by frost, or when snow-bound in chimney corners, and handed down to be sung in the miry streets to lamp-lit windows at Yule-time.

THE WIND IN THE WILLOWS

CAROL

Villagers all, this frosty tide,

Let your doors swing open wide,

Though wind may follow, and snow beside,

Yet draw us in by your fire to bide;

　　Joy shall be yours in the morning!

Here we stand in the cold and the sleet,

Blowing fingers and stamping feet,

Come from far away you to greet

You by the fire and we in the street—

　　Bidding you joy in the morning!

For ere one half of the night was gone,

Sudden a star has led us on,

Raining bliss and benison—

Bliss to-morrow and more anon,

　　Joy for every morning!

Goodman Joseph toiled through the snow—

Saw the star o'er a stable low;

Mary she might not further go—

Welcome thatch, and litter below!

　　Joy was hers in the morning!

And then they heard the angels tell

"Who were the first to cry Nowell?

Animals all, as it befell,

In the stable where they did dwell!

Joy shall be theirs in the morning!"

The voices ceased, the singers, bashful but smiling, exchanged sidelong glances, and silence succeeded—but for a moment only. Then, from up above and far away, down the tunnel they had so lately traveled, was borne to their ears in a faint musical hum the sound of distant bells ringing a joyful and clangorous peal.

"Very well sung, boys!" cried the Rat heartily, "And now come along in, all of you, and warm yourselves by the fire, and have something hot!'

FROM
A Christmas Memory

Truman Capote

*Truman Capote (1924–1984), was born in New Orleans and spent most of his childhood
with relatives in Alabama. In this poignant reminiscence we accompany Capote and his eccentric
old cousin/caretaker on the triumphant gathering of the Christmas tree.*

know where we'll find pretty trees, Buddy. And holly, too. With berries big as your eyes. It's way off in the woods. Farther than we've ever been. Papa used to bring us Christmas trees from there: carry them on his shoulder. That's fifty years ago. Well, now: I can't wait for morning."

Morning. Frozen rime lusters the grass; the sun, round as an orange and orange as hot-weather moons, balances on the horizon, burnishes the silvered winter woods. A wild turkey calls. A renegade hog grunts in the undergrowth. Soon, by the edge of knee-deep, rapid-running water, we have to abandon the buggy. Queenie wades the stream first, paddles across barking complaints at the swiftness of the current, the pneumonia-making coldness of it. We follow, holding our shoes and equipment (a hatchet, a burlap sack) above our heads. A mile more: of chastising thorns, burs and briers that catch at our clothes; of rusty pine needles brilliant with gaudy fungus and molted feathers. Here, there, a flash, a flutter, an ecstasy of shrillings remind us that not all the birds have flown south. Always, the path unwinds through lemony sun pools and pitch vine tunnels. Another creek to cross: a disturbed armada of speckled trout froths the water

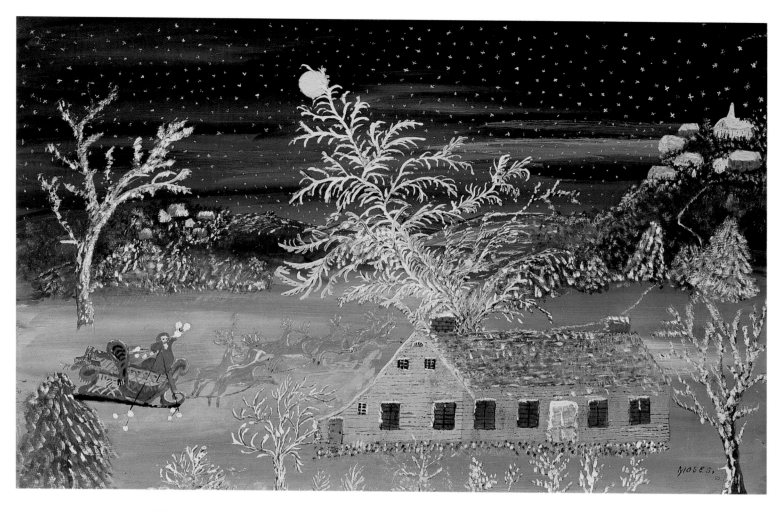

SERGEI CHEPIK. *Christmas in Staraya Ladoga*. 1985. Oil on canvas. Private collection/Bridgeman Art Library.

round us, and frogs the size of plates practice belly flops; beaver workmen are building a dam. On the farther shore, Queenie shakes herself and trembles. My friend shivers, too: not with cold but enthusiasm. One of her hat's ragged roses sheds a petal as she lifts her head and inhales the pine-heavy air. "We're almost there, can you smell it, Buddy?" she says, as though we were approaching an ocean.

And, indeed, it is a kind of ocean. Scented acres of holiday trees, prickly-leafed holly. Red berries shiny as Chinese bells: black crows swoop upon them screaming. Having stuffed our burlap sacks with enough greenery and crimson to garland a dozen windows, we set about choosing a tree. "It should be," muses my friend, "twice as tall as a boy. So a boy can't steal the star." The one we pick is twice as tall as me. A brave handsome brute that survives thirty hatchet strokes before it keels with a creaking rending cry. Lugging it like a kill, we commence the long trek out. Every few yards we abandon the struggle, sit down and pant. But we have the strength of triumphant huntsmen; that and the tree's virile, icy perfume revive us, goad us on. Many compliments accompany our sunset return along the red clay road to town; but my friend is sly and noncommittal when passers-by praise the treasure perched in our buggy: what a fine tree and where did it come from? "Yonderways," she murmurs vaguely. Once a car stops and the rich mill owner's lazy wife leans out and whines: "Giveya twobits cash for that ol tree." Ordinarily my friend is afraid of saying no; but on this occasion she promptly shakes her head: "We wouldn't take a dollar." The mill owner's wife persists. "A dollar, my foot! Fifty cents. That's my last offer. Goodness, woman, you can get another one." In answer, my friend gently reflects: "I doubt it. There's never two of anything."

Blue Christmas

Terry Andrews

In this autobiographical story, Terry Andrews, a contemporary writer, recalls one particular Christmas from her childhood, when she realized that the intangible aspects of the season— love, tradition, sharing, hope, and peace—are the true Christmas gifts.

his is a story about Christmas, and about a box under our Christmas tree one year that wasn't big enough, by a long shot, to hold a bicycle. That box, brightly wrapped in blue tissue with a tag "Merry Christmas, Terry—love, Mom and Dad," was the object of my considerable attention because I knew it held my main gift, and what I really wanted was a bicycle. Not any bicycle, but a particular blue bicycle from Johnston's Hardware Store on the Hill.

On the other side of the tree was another box, wrapped in red, with a tag "Merry Christmas, Steve—love, Mom and Dad." Steve, my nine-year-old brother, wanted an electric train, and he was sure that was what his package held.

It was 1958, my eleventh year, and we were living in Cedar Falls, a town I never really got to know because we moved from there to Iowa City the next fall.

We had a low, ranch-style house, pale green and brand new. It was a new street and a new neighborhood, dotted with expensive new homes.

The Hill was six blocks away and important to us, not only for its small shopping district but also because it was the site of the college my sister, Linda, seventeen, would attend next fall.

The Monday before Christmas, Steve and I headed for the Hill to do our Christmas shopping. Shivering, I plunged my hands as far into my pockets as they would go. The sky was ominously grey, and the cold wind which shook the bare branches of the trees overhead, seemed to cut right through my jacket.

"C'mon, Steve," I called impatiently to my brother. "We'll never get there if we don't hurry."

"Race ya," he cried.

We were off. I was a faster runner than he was, but sometimes with a head start he could beat me. I sprinted behind him, straining to catch up. He stopped at the corner, winded, his face red. "I won," he panted triumphantly.

Any other day I would have called him a cheater. But today was special, so I let him stay the victor. The Hill was in sight. Its lampposts were gaily strung with green cellophane chains and huge plastic candy canes that looked good enough to eat. Steve and I trudged up the hill that gave the small shopping area its name, past the soda shop where we sometimes got ice cream in the summer, past the pet store where we usually admired the parakeets and turtles. We were going to the five-and-dime to do our Christmas shopping—for the first time alone.

My brother had his savings from his piggy bank clutched in his hand, and I had four dollars, some of which I'd earned raking the neighbor's yard, in my pocket.

At the dime store we paused long enough to look in the window. There were a host of wonderful things there—chocolate Santas, dolls with long hair, miniature bright red fire trucks with a hose that sprayed water.

"You could get that for me," I announced to my brother, pointing to a round, blue sliding saucer which sat on a mound of artificial snow. "I'll share it with you."

"I only have sixty-five cents," he reminded me.

Then in we went. Steve stopped by a jar of colored combs and carefully examined one. Then he looked at me. "Don't you have shopping to do?" he demanded.

I headed for the aisle that held envelopes, notebooks and stationery. My sister would need stationery to write to us, I thought. It was a perfect gift. I debated about buying my father a notebook, since he would be going back to college in Iowa City. (At forty-five!) *Too ordinary*, I thought. I wanted to give him something special, not something silly, like the green beanie his friends were planning!

My brother came around the corner and began looking at the pencils. I picked up the stationery I'd chosen and headed for the cash register in front. I had made my mother a set of hot pads, but I wanted to give her something else as well. Suddenly I spotted the perfect gift, a pair of pale blue earrings that would just match her new dress.

I had enough money left to buy baseball cards, bubble gum and a miniature flashlight for Steve. After I paid for my presents I waited for him outside.

Soon he emerged, beaming, a small bag in one hand, a nickel in the other. "Let's go wrap them," he said.

We went home by way of the hardware store, so I could look at my bike. It wasn't my bike actually, but I was saving money to buy it. I wanted it more than anything else in the world. It was a slim blue Italian model; I'd never seen another one like it. I planned to ride it to school, to the ice cream shop, and to see my best friend Cathy, even though she only lived a half block away from me. Next fall, I'd ride it all over Iowa City.

The hardware store was busy, and Mr. Johnston was waiting on a customer. He wouldn't have time to talk today. I would take a quick look at my bike and

be on my way. My brother waited by the sporting goods while I went to the back where the bicycles were. There it was, on the end, as blue as the whole sky, just waiting to be ridden. I reached over to touch the blue and white seat, and stopped cold. Hanging from the handlebar was a tag, handwritten in capital letters, SOLD, it said.

It seemed like my heart stopped and time stood still. For three months, ever since the first day I saw it, I'd been saving my money to buy that blue bike.

I ran from the store, fighting back tears. Now somebody else would ride down College Street on my bike, somebody I knew, or, worse yet, a stranger who would carelessly leave it out in the rain and snow to rust and grow old.

On the way home, Steve and I walked slowly. I didn't notice the cold. He wanted to talk, but I was thinking about the bicycle that almost was, the bicycle that wouldn't be. One thing was certain, I could break open my bank. I no longer needed the twelve dollars I'd saved. I started to think of what I would buy with it.

This, our last Christmas in Cedar Falls, would be a truly blue Christmas now, I knew. Next year, we would no longer have the ranch house with its two fireplaces. Instead, we would have a tiny tin barrack left over from World War II, so small it was barely larger than my bedroom in Cedar Falls. Instead of a fireplace it would have an oilstove; instead of a picture window looking out over a spacious green lawn, it would have windows so high you couldn't see out and no lawn at all. My mother said we had to save money, and cut back. She was going to find a job while my father went to school.

I didn't look forward to the prospect of cutting back or moving. I liked Cedar Falls, the shops on the Hill, my school, and my best friend Cathy. But I knew education was important. It had brought us to the new ranch-style

with the huge sloping lawn planted with Russian olive trees and weeping willows. That house was miles and miles from the ramshackle houses my father had grown up in; dark, drafty tinderboxes bordering smelly, smokey factories. And it would take us even further—to the university town where my father hoped to get a Ph.D. degree, and then to some other university town where he would become a professor.

If I had my blue bike, I thought brightly, *I wouldn't mind moving so much.* Then, remembering how much my father had gone without as a boy, I decided to put the bicycle out of my mind. There was Christmas to think about, and presents to wrap.

By the time my brother and I got home, my spirits had picked up and we burst excitedly through the door, throwing off our jackets and hats. I heard Bing Crosby on the record player singing "White Christmas." That meant my father had gotten out his Christmas records while we were gone. He was sitting by the fireplace, where a fire was crackling, reading. Occasionally he'd sing a few bars, his off-key tenor voice echoing Crosby's.

My mother was baking, humming as she worked. She was making sugar cookies shaped like bells and reindeer, sprinkled with red and green sugar. My brother and I sat down and had two each, warm from the oven, at the picnic table we ate from in our kitchen. The tempting scent of cookies baking drifted through the warm and cozy house from room to room, as Bing Crosby sang and I wrapped my packages. When I put them under the tree I spotted several small rectangular packages that my brother had wrapped.

One was addressed to me, "Merry Christmas, Terry," the card read, "and no peeking."

A piece of tinsel had fallen off the tree and I put it back on a low branch,

then stepped back to admire the tree. Decorating it was a family affair, and each year we dragged out the box of ornaments and happily examined its contents. There were little candle-shaped lights with colored water inside that bubbled when you plugged them in. There was tinsel, which we carefully removed from the tree each year and saved.

At night, when the room was dark and the Christmas tree lights were on, the living room seemed to take on a special glow, as if that tree were the center of the universe and all the promise of the world lay in that room. That tree represented warmth, happiness and security.

"Look," my mother said, "it's snowing."

The sky that had threatened snow all day opened up, and soft flakes fell softly to the ground, piling up around the steps, blanketing the yard, and draping the small pine trees outside. A hush came over the neighborhood and in every picture window, it seemed, the colored lights of Christmas trees twinkled. Even the snow shimmered, catching and reflecting the blue lights strung on trees across the street.

After dinner my father told about Christmas when he was a boy. He told about the time there wasn't enough money for presents, or even food. It was a faraway world that I only knew through his stories, and even though I had seen the rundown houses where he had grown up, I had trouble feeling the reality of going hungry, of going without presents on Christmas day.

Some of his Christmases were happy, and those were the ones I liked to hear about best. I liked to hear about the year he and his brother got a wooden sled, which they found leaning in the snow against their house on a bright Christmas morning. I liked to imagine my father going downhill at top speed, laughing heartily, the snow flying in his face, momentarily blinding him.

But I would always think about going hungry. I secretly hoped I would never know a Christmas without date pinwheel cookies, and the oranges my mother always put in my stocking.

Suddenly I knew what I would give my father for Christmas—the money saved for my bicycle. I ran to my room, and on a piece of paper I wrote, "Dear Dad, this is for your education." I carefully folded the paper and in it I put the money I had saved for my bicycle—twelve one-dollar bills. I put the paper in a shoebox. He'd never guess in a million years what a shoebox as light as a feather held. Carefully I wrapped it and put it under the tree.

And then, it was Christmas! Christmas morning, and my brother and I were up at dawn, trying to rouse my parents from their bed. We waited impatiently while my mother made her way slowly to the kitchen and started the coffee in the percolator. My brother and I poked at the presents under the tree, and emptied our stockings of their ribbon candy, oranges, apples and trinkets. Couldn't my mother hurry? Why did they have to have coffee?

Finally the great moment came, as we all assembled around the tree. The anticipation was high. I had come to terms with the fact that there would be no bicycle, but the big box held something else, some wonderful surprise. I knew that. We began to open our presents. My grandmother had sent me pajamas. She had given my sister embroidered pillow cases. My sister had given my father a moustache cup for drinking his coffee. My brother opened a football, and whooped.

Then there was the big box for me, and I shook it to see if it rattled. It didn't.

"Try to guess," my mother said. I couldn't and finally ripped the paper from it. There inside was the big blue saucer from the five-and-dime. It had snowed

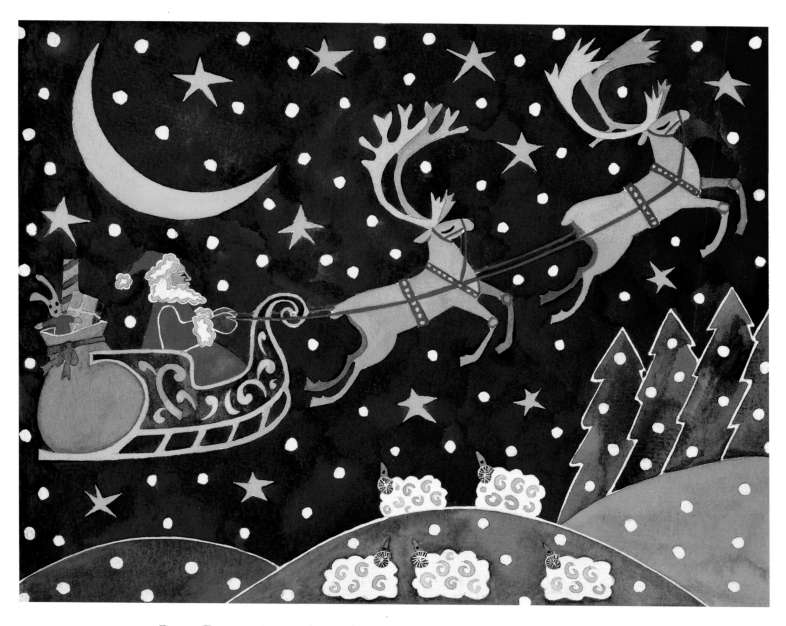

CATHY BAXTER. *Stars and Snowfall*. Private collection/Bridgeman Art Library.

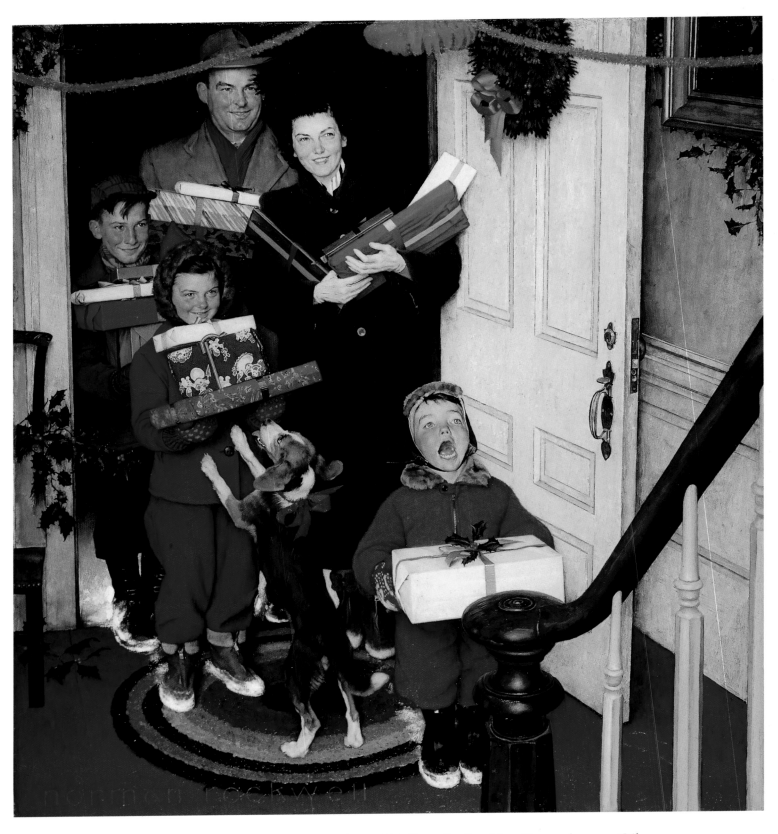

NORMAN ROCKWELL. *Merry Christmas, Grandma...We Came In Our New Plymouth.* 1950. Oil on canvas.
© Copyright 2002 National Museum of American Illustration, Newport, RI.
Courtesy of the Archives of the American Illustrators Gallery, NYC.
Photograph supplied by ASaP Worldwide.

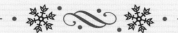

just in time. My father opened a red flannel shirt my sister had made, and my mother opened the comb from my brother and ran it appreciatively through her hair. "Thank you sweetheart," she said to Steve. My sister opened the stationery and laughed. "I guess this means I'll have to write," she said, giving me a big hug.

Finally, my brother picked up his big box. He started to say "A saucer for—" and then something in the box rattled. His eyes opened wide. With my mother cautioning him to save the paper, he gently opened the box. It was an electric train set with a cattle car and a yellow caboose.

"It's just like the Illinois Central," he said.

Then I saw my father holding the shoebox, a puzzled gleam in his eyes. Carefully he untied the ribbon. He reached inside and slowly withdrew the note.

For once he didn't say anything. When he finished reading what I had written, he looked at me, then my mother. His eyes seemed to fill with tears.

Had I ruined Christmas? We all watched him in uneasy silence. Then, as he handed the note to my mother, he stood up, put on his new shirt, tucked his new comb in one pocket and the money in the other. "Looks like I'm all ready for college," he said, laughing.

Then his expression changed and he looked at all of us. "This is the most wonderful Christmas I've ever had. I hope it is for you, too," he said. He winked at my mother.

My mother was smoothing the hot pads I had given her with her hands. She had put on the blue earrings. The way she smiled at me showed how pleased she was.

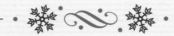

While my father was pretending to be drinking from his moustache cup, I picked up the coal black locomotive from my brother's train. "It's beautiful," I said.

He whispered, "Maybe you'll get a bike for your birthday."

"Maybe," I acknowledged. My birthday was eleven months off, and the coasting hills would have to do without me for now.

But then a realization came over me, suddenly, as I picked up the blue pencils my brother had given me. Christmas was more than giving presents, or receiving presents.

It was my brother stretching his allowance to buy us gifts. It was the care I had put into making those hot pads. It was my sister being there, before she went to college. It was my mother bustling in the kitchen, singing "Silent Night," and my father getting out his Bing Crosby record for the umpteenth time. It was carols and cookies and colored lights, a family in a small town on a morning when the snow fell thick and fast. It was love and sharing and being together. It was intangible stuff—memories, tradition, hope—it was catching, for a moment, a glimpse of peace.

My mother interrupted my thoughts. "Terry, could you please see if the coffee is ready?"

Dutifully I hurried to the kitchen, where I could smell a cinnamon coffee cake baking. My mouth watered. "It's ready," I called, and I took out two coffee cups. Then I turned to see if the plates were on the table for breakfast.

I could not believe my eyes. There, parked next to the picnic table, was the bicycle from the hardware store, shinier, sleeker and bluer than it had ever been before, shimmering like a vision. Taking a deep breath, I ran over and touched the gleaming chrome, the leather seat, the tires.

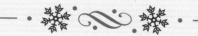

Softly then Bing Crosby began singing "White Christmas" in the living room. I smiled. It might be a white Christmas for everyone else, with plump snow-capped evergreens on soft white lawns. It was a blue Christmas for me. Blue was the color of promise and possibility, of next year and always, of the roads I would follow, on that bike and others. Blue was the top of the hill, the wind at my back, freedom. With a flourish I kicked up the kickstand and wheeled my bike toward the front door.

II

CHRISTMAS CUSTOMS, STORIES, AND LORE

Christmas Every Day

WILLIAM DEAN HOWELLS

William Dean Howells (1837–1920) was an American author and the first editor of
The Atlantic Monthly *magazine. In this redemptive tale, a little girl overcomes her greed and
learns that Christmas is best celebrated only once a year.*

he little girl came into her papa's study, as she always did Saturday morning before breakfast, and asked for a story. He tried to beg off that morning, for he was very busy, but she would not let him. So he began:

"Well, once there was a little pig—"

She put her hand over his mouth and stopped him at the word. She said she had heard little pig-stories till she was perfectly sick of them.

"Well, what kind of story *shall* I tell, then?"

"About Christmas. It's getting to be the season. It's past Thanksgiving already."

"It seems to me," her papa argued, "that I've told as often about Christmas as I have about little pigs."

"No difference! Christmas is more interesting."

"Well!" Her papa roused himself from his writing by a great effort. "Well, then, I'll tell you about the little girl that wanted it Christmas every day in the year. How would you like that?"

"First-rate!" said the little girl; and she nestled into comfortable shape in his lap, ready for listening.

"Very well, then, this little pig—Oh, what are you pounding me for?"

"Because you said little pig instead of little girl."

"I should like to know what's the difference between a little pig and a little girl that wanted it Christmas every day!"

"Papa," said the little girl, warningly, "if you don't go on, I'll *give* it to you!" At this her papa darted off like lightning, and began to tell the story as fast as he could.

Well, once there was a little girl who liked Christmas so much that she wanted it to be Christmas every day in the year; and as soon as Thanksgiving was over she began to send postal-cards to the old Christmas Fairy to ask if she mightn't have it. But the old Fairy never answered any of the postals; and after a while the little girl found out that the Fairy was pretty particular, and wouldn't notice anything but letters—not even correspondence cards in envelopes; but real letters on sheets of paper, and sealed outside with a monogram—or your initial, anyway. So, then, she began to send her letters; and in about three weeks—or just the day before Christmas, it was—she got a letter from the Fairy, saying she might have it Christmas every day for a year, and then they would see about having it longer.

The little girl was a good deal excited already, preparing for the old-fashioned, once-a-year Christmas that was coming the next day, and perhaps the Fairy's promise didn't make such an impression on her as it would have made at some other time. She just resolved to keep it to herself, and surprise everybody with it as it kept coming true; and then it slipped out of her mind altogether.

She had a splendid Christmas. She went to bed early, so as to let Santa Claus have a chance at the stockings, and in the morning she was up the first of anybody and went and felt them, and found hers all lumpy with packages of candy, and oranges and grapes, and pocketbooks and rubber balls, and all kinds of small presents, and her big brother's with nothing but the tongs in

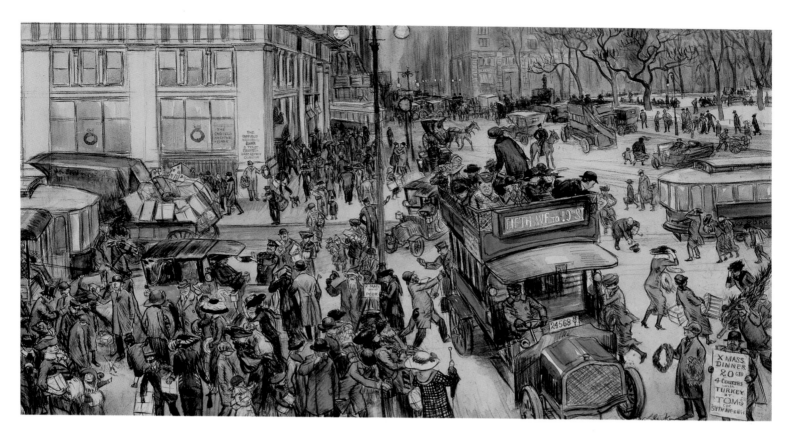

WILLIAM GLACKENS. *Christmas Shoppers, Madison Square.* 1912.
Crayon and watercolor on paper. Museum of Art, Fort Lauderdale, Ira Glackens Bequest.

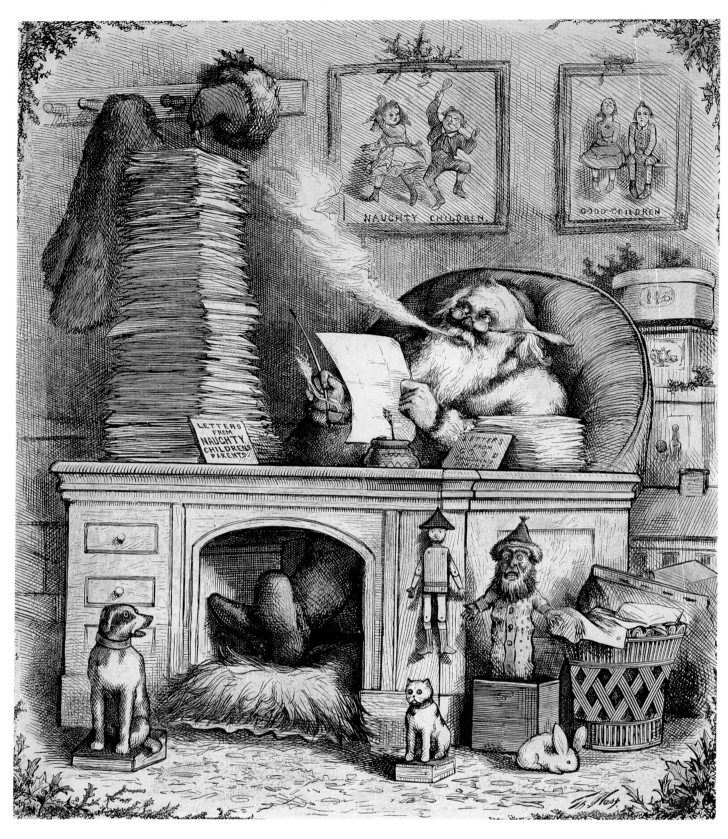

THOMAS NAST. *Santa Claus's Mail.* 1871.
Colored engraving. The Granger Collection, New York.

them, and her young lady sister's with a new silk umbrella, and her papa's and mamma's with potatoes and pieces of coal wrapped up in tissue-paper, just as they always had every Christmas. Then she waited around till the rest of the family were up, and she was the first to burst into the library, when the doors were opened, and look at the large presents laid out on the library-table— books, and portfolios, and boxes of stationery, and breastpins, and dolls, and little stoves, and dozens of handkerchiefs, and inkstands, and skates, and snow- shovels, and photograph-frames, and little easels, and boxes of water-colors, and Turkish paste, and nougat, and candied cherries, and dolls' houses, and waterproofs—and the big Christmas-tree, lighted and standing in a waste- basket in the middle.

She had a splendid Christmas all day. She ate so much candy that she did not want any breakfast; and the whole forenoon the presents kept pouring in that the expressman had not had time to deliver the night before; and she went round giving the presents she had got for other people, and came home and ate turkey and cranberry for dinner, and plum-pudding and nuts and raisins and oranges and more candy, and then went out and coasted, and came in with a stomach-ache, crying; and her papa said he would see if his house was turned into that sort of fool's paradise another year; and they had a light supper, and pretty early everybody went to bed cross.

Here the little girl pounded her papa in the back, again.

"Well, what now? Did I say pigs?"

"You made them *act* like pigs."

"Well, didn't they?"

"No matter; you oughtn't to put it into a story."

"Very well, then, I'll take it all out."

Her father went on:

The little girl slept very heavily, and she slept very late, but she was wakened at last by the other children dancing round her bed with their stockings full of presents in their hands.

"What is it?" said the little girl, and she rubbed her eyes and tried to rise up in bed.

"Christmas! Christmas! Christmas!" they all shouted, and waved their stockings.

"Nonsense! It was Christmas yesterday."

Her brothers and sisters just laughed. "We don't know about that. It's Christmas to-day, anyway. You come into the library and see."

Then all at once it flashed on the little girl that the Fairy was keeping her promise, and her year of Christmases was beginning. She was dreadfully sleepy, but she sprang up like a lark—a lark that had overeaten itself and gone to bed cross—and darted into the library. There it was again! Books, and portfolios, and boxes of stationery, and breastpins—

"You needn't go over it all, papa; I guess I can remember just what was there," said the little girl.

Well, and there was the Christmas-tree blazing away, and the family picking out their presents, but looking pretty sleepy, and her father perfectly puzzled, and her mother ready to cry. "I'm sure I don't see how I'm to dispose of all these things," said her mother, and her father said it seemed to him they had had something just like it the day before, but he supposed he must have dreamed it. This

struck the little girl as the best kind of a joke; and so she ate so much candy she didn't want any breakfast, and went round carrying presents, and had turkey and cranberry for dinner, and then went out and coasted, and came in with a—

"Papa!"

"Well, what now?"

"What did you promise, you forgetful thing?"

"Oh, oh, yes!"

Well, the next day, it was just the same thing over again, but everybody getting crosser; and at the end of a week's time so many people had lost their tempers that you could pick up lost tempers anywhere; they perfectly strewed the ground. Even when people tried to recover their tempers they usually got somebody else's, and it made the most dreadful mix.

The little girl began to get frightened, keeping the secret all to herself; she wanted to tell her mother, but she didn't dare to; and she was ashamed to ask the Fairy to take back her gift, it seemed ungrateful and ill-bred, and she thought she would try to stand it, but she hardly knew how she could, for a whole year. So it went on and on, and it was Christmas on St. Valentine's Day and Washington's Birthday, just the same as any day, and it didn't skip even the First of April, though everything was counterfeit that day, and that was some *little* relief.

After a while coal and potatoes began to be awfully scarce, so many had been wrapped up in tissue-paper to fool papas and mammas with. Turkeys got to be about a thousand dollars apiece—

"Papa!"

"Well, what?"

"You're beginning to fib."

"Well, two thousand, then."

And they got to passing off almost anything for turkeys—half-grown humming-birds, and even rocs out of the *Arabian Nights*—the real turkeys were so scarce. And cranberries—well, they asked a diamond apiece for cranberries. All the woods and orchards were cut down for Christmas-trees, and where the woods and orchards used to be it looked just like a stubble-field, with the stumps. After a while they had to make Christmas-trees out of rags, and stuff them with bran, like old-fashioned dolls; but there were plenty of rags, because people got so poor, buying presents for one another, that they couldn't get any new clothes, and they just wore their old ones to tatters. They got so poor that everybody had to go to the poor-house, except the confectioners, and the fancy-store keepers, and the picture-book sellers, and the expressmen; and *they* all got so rich and proud that they would hardly wait upon a person when he came to buy. It was perfectly shameful!

Well, after it had gone on about three or four months, the little girl, whenever she came into the room in the morning and saw those great ugly, lumpy stockings dangling at the fireplace, and the disgusting presents around everywhere, used to just sit down and burst out crying. In six months she was perfectly exhausted; she couldn't even cry anymore; she just lay on the lounge and rolled her eyes and panted. About the beginning of October she took to sitting down on dolls wherever she found them—French dolls, or any kind—she hated the sight of them so; and by Thanksgiving she was crazy, and just slammed her presents across the room.

By that time people didn't carry presents around nicely any more. They

flung them over the fence, or through the window, or anything; and, instead of running their tongues out and taking great pains to write "For dear Papa," or "Mamma," or "Brother," or "Sister," or "Susie," or "Sammie," or "Billie," or "Bobbie," or "Jimmie," or "Jennie," or whoever it was, and troubling to get the spelling right, and then signing their names, and "Xmas, 18—," they used to write in the gift-books, "Take it, you horrid old thing!" and then go and bang it against the front door. Nearly everybody had built barns to hold their presents, but pretty soon the barns overflowed, and then they used to let them lie out in the rain, or anywhere. Sometimes the police used to come and tell them to shovel the presents off the sidewalk, or they would arrest them.

"I thought you said everybody had gone to the poor-house," interrupted the little girl.

"They did go, at first," said her papa; "but after a while the poor-houses got so full that they had to send the people back to their own houses. They tried to cry, when they got back, but they couldn't make the least sound."

"Why couldn't they?"

"Because they had lost their voices, saying 'Merry Christmas' so much. Did I tell you how it was on the Fourth of July?"

"No; how was it?" And the little girl nestled closer, in expectation of something uncommon.

Well, the night before, the boys stayed up to celebrate, as they always do, and fell asleep before twelve o'clock, as usual, expecting to be awakened by the bells and cannon. But it was nearly eight o'clock before the first boy in the United States woke up, and then he found out what the trouble was. As soon as he could

get his clothes on he ran out of the house and smashed a big cannon-torpedo down on the pavement; but it didn't make any more noise than a damp wad of paper; and after he tried about twenty or thirty more, he began to pick them up and look at them. Every single torpedo was a big raisin! Then he just streaked it upstairs, and examined his firecrackers and toy pistol and two-dollar collection of fireworks, and found that they were nothing but sugar and candy painted up to look like fireworks! Before ten o'clock every boy in the United States found out that his Fourth of July things had turned into Christmas things; and then they just sat down and cried—they were so mad. There are about twenty million boys in the United States, and so you can imagine what a noise they made. Some men got together before night, with a little powder that hadn't turned into purple sugar yet, and they said they would fire off *one* cannon, anyway. But the cannon burst into a thousand pieces, for it was nothing but rock-candy, and some of the men nearly got killed. The Fourth of July orations all turned into Christmas carols, and when anybody tried to read the Declaration, instead of saying, "When in the course of human events it becomes necessary," he was sure to sing, "God rest you, merry gentlemen." It was perfectly awful.

The little girl drew a deep sigh of satisfaction.

"And how was it at Thanksgiving?"

Her papa hesitated. "Well, I'm almost afraid to tell you. I'm afraid you'll think it's wicked."

"Well, tell, anyway," said the little girl.

Well, before it came Thanksgiving it had leaked out who had caused all these Christmases. The little girl had suffered so much that she had talked about it in

her sleep; and after that hardly anybody would play with her. People just perfectly despised her, because if it had not been for her greediness it wouldn't have happened; and now, when it came Thanksgiving, and she wanted them to go to church, and have squash-pie and turkey, and show their gratitude, they said that all the turkeys had been eaten up for her old Christmas dinners, and if she would stop the Christmases, they would see about the gratitude. Wasn't it dreadful? And the very next day the little girl began to send letters to the Christmas Fairy, and then telegrams, to stop it. But it didn't do any good; and then she got to calling at the Fairy's house, but the girl that came to the door always said, "Not at home," or "Engaged," or "At dinner," or something like that; and so it went on till it came to the old once-a-year Christmas Eve. The little girl fell asleep, and when she woke up in the morning—

"She found it was all nothing but a dream," suggested the little girl.

"No, indeed!" said her papa. "It was all every bit true!"

"Well, what *did* she find out, then?

"Why, that it wasn't Christmas at last, and wasn't ever going to be, any more. Now it's time for breakfast."

The little girl held her papa fast around the neck.

"You sha'n't go if you're going to leave it *so!*"

"How do you want it left?"

"Christmas once a year."

"All right," said her papa; and he went on again.

Well, there was the greatest rejoicing all over the country, and it extended clear up into Canada. The people met together everywhere, and kissed and

cried for joy. The city carts went around and gathered up all the candy and raisins and nuts, and dumped them into the river; and it made the fish perfectly sick; and the whole United States, as far out as Alaska, was one blaze of bonfires, where the children were burning up their gift-books and presents of all kinds. They had the greatest *time!*

The little girl went to thank the old Fairy because she had stopped its being Christmas, and she said she hoped she would keep her promise and see that Christmas never, never came again. Then the Fairy frowned, and asked her if she was sure she knew what she meant; and the little girl asked her, Why not? and the old Fairy said that now she was behaving just as greedily as ever, and she'd better look out. This made the little girl think it all over carefully again, and she said she would be willing to have it Christmas about once in a thousand years; and then she said a hundred, and then she said ten, and at last she got down to one. Then the Fairy said that was the good old way that had pleased people ever since Christmas began, and she was agreed. Then the little girl said, "What're your shoes made of?" And the Fairy said, "Leather." And the little girl said, "Bargain's done forever," and skipped off, and hippity-hopped the whole way home, she was so glad.

"How will that do?" asked the papa.

"First-rate!" said the little girl; but she hated to have the story stop, and was rather sober.

However, her mamma put her head in at the door, and asked her papa, "Are you never coming to breakfast? What have you been telling that child?"

"Oh, just a moral tale."

The little girl caught him around the neck again.

"*We* know! Don't you tell *what*, papa! Don't you tell *what!*"

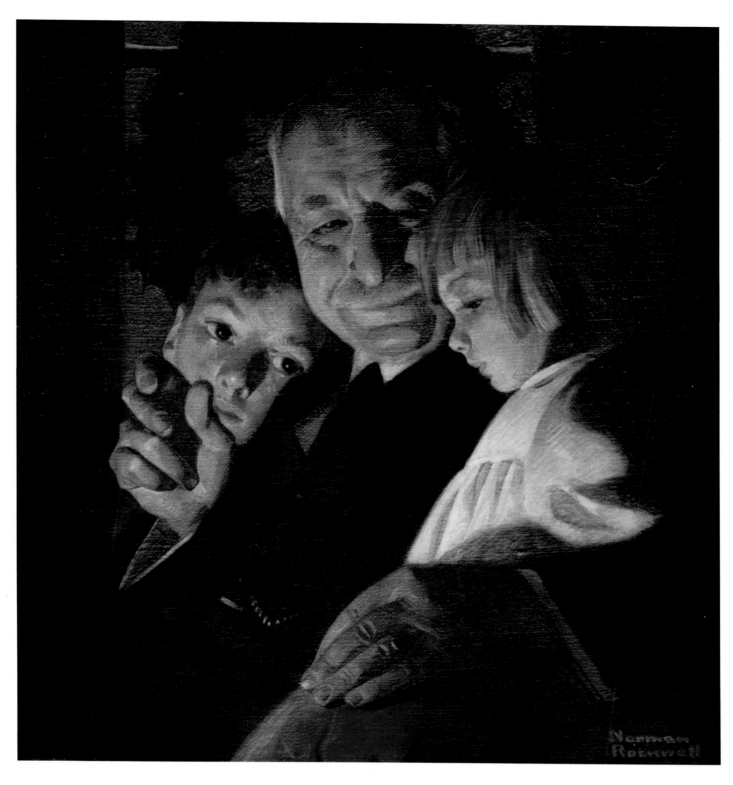

Norman Rockwell. *The Story of Christmas.* The Wagnalls Memorial Foundation.
Printed by permission of the Norman Rockwell Family Agency.
Copyright © 2003 the Norman Rockwell Family Entities.

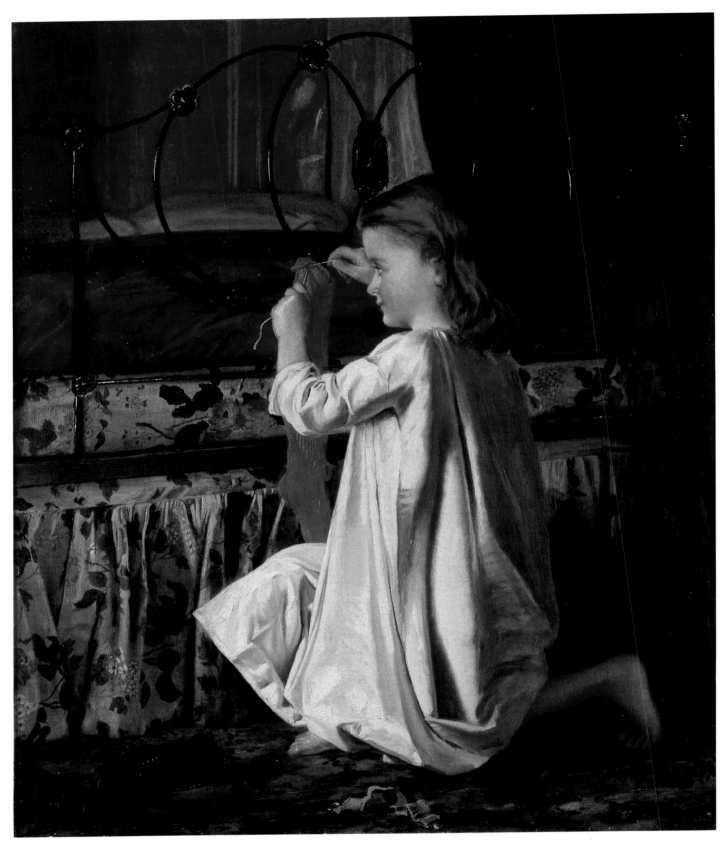

WALTER ANDERSON. *Christmas Eve.*
Private collection. Copyright Fine Art Photographic Library, London/Art Resource, NY.

FROM
The Christmas Box

RICHARD PAUL EVANS

Richard Paul Evans's The Christmas Box *has become a contemporary Christmas classic.
This tender family scene captures the warmth of shared Christmas remembrances—
with all the sounds and smells of the season.*

Mary set down her tea, pushed herself up, and walked over to the cherry wood bookshelf. She pulled a book from a high shelf, dusted it lightly, and handed it to me.

"Here is a charming Christmas tale. Read this to your little one." I took the book from her outstretched arm and examined the title, *Christmas Every Day* by William Dean Howells.

"Thank you, Mary, I will." I smiled at her, set the book down, and went back to my catalog. Her eyes never left me.

"No, right now. Read it to her now," she coaxed. Her voice was fervent, wavering only from her age. I laid my text down, examined the book again, then looked back up into her calm face. Her eyes shone with the importance of her request.

"All right, Mary."

I rose from the table and walked up into Jenna's room, wondering when I would catch up on my orders and what magic this old book contained to command such urgency. Upstairs Jenna lay quietly in the dark.

"Still awake, honey?" I asked.

"Daddy, you forgot to tuck me in tonight."

I switched on the light. "I did, didn't I. How about a bedtime story?"

She jumped up in her bed with a smile that filled the tiny room. "What story are you going to tell?" she asked.

"Mary gave me this book to read to you."

"Mary has good stories, Dad."

"Then it should be a good one," I said. "Does Mary tell you stories often?"

"Every day."

I sat on the edge of the bed and opened the old book. The spine was brittle and cracked a little as it opened. I cleared my throat and started reading aloud.

The little girl came into her papa's study, as she always did Saturday morning before breakfast, and asked for a story. He tried to beg off that morning, for he was very busy, but she would not let him . . .

"That's like you, Dad. You're real busy too," Jenna observed.

I grinned at her. "Yeah, I guess so." I continued reading.

"Well, once there was a little pig—" The little girl put her hand over his mouth and stopped him at the word. She said she had heard the pig stories till she was perfectly sick of them.

"Well, what kind of story shall I tell, then?"

"About Christmas. It's getting to be the season, it's past Thanksgiving already."

"It seems to me," argued her papa, "that I've told as often about Christmas as I have about little pigs."

"No difference! Christmas is more interesting."

Unlike her story's counterpart, Jenna was long asleep before I finished the tale. Her delicate lips were drawn in a gentle smile, and I pulled the covers up

tightly under her chin. Peace radiated from the tiny face. I lingered a moment, knelt down near her bed and kissed her on the cheek, then walked back down to finish my work.

I returned to the den to find the lavish drapes drawn tight, and the two women sitting together in the dim flickering light of the fireplace talking peacefully. The soothing tones of Mary's voice resonated calmly through the room. She looked up to acknowledge my entrance.

"Richard, your wife just asked the most intriguing question. She asked which of the senses I thought was most affected by Christmas."

I sat down at the table.

"I love everything about this season," she continued. "But I think what I love most about Christmas are its sounds. The bells of street-corner Santa Clauses, the familiar Christmas records on the phonograph, the sweet, untuned voices of Christmas carolers. And the bustling downtown noises. The crisp crinkle of wrapping paper and department store sacks and the cheerful Christmas greetings of strangers. And then there are the Christmas stories. The wisdom of Dickens and all Christmas storytellers." She seemed to pause for emphasis. "I love the sounds of this season. Even the sounds of this old house take on a different character at Christmas. These Victorian ladies seem to have a spirit all their own."

I heartily agreed but said nothing.

She reflected on the old home. "They don't build homes like this anymore. You've noticed the double set of doors in the front entryway?"

We both nodded in confirmation.

"In the old days—before the advent of the telephone . . ." She winked. "I'm an old lady," she confided, "I remember those days."

We smiled.

". . . Back in those days when people were receiving callers they would open the outer set of doors as a signal. And if the doors were closed it meant that they were not receiving callers. It seemed those doors were always open, all holiday long." She smiled longingly. "It seems silly now. You can imagine that the foyer was absolutely chilly." She glanced over to me. "Now I'm digressing. Tell us, Richard, which of the senses do you think are most affected by Christmas?"

I looked over at Keri. "The taste buds," I said flippantly. Keri rolled her eyes.

"No. I take it back. I would say the sense of smell. The smells of Christmas. Not just the food, but everything. I remember once, in grade school, we made Christmas ornaments by poking whole cloves into an orange. I remember how wonderful it smelled for the entire season. I can still smell it. And then there's the smell of perfumed candles, and hot wassail or creamy cocoa on a cold day. And the pungent smell of wet leather boots after my brothers and I had gone sledding. The smells of Christmas are the smells of childhood." My words trailed off into silence as we all seemed to be caught in the sweet glaze of Christmastime memories, and Mary nodded slowly as if I had said something wise.

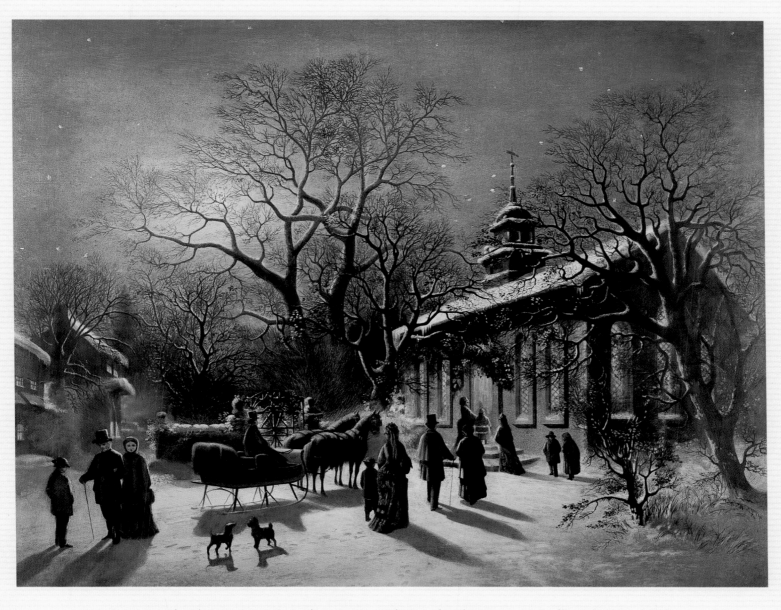

Going to Church on a Winter's Night. c. 1880. Lithograph. The Granger Collection, New York.

The Legend of the Christmas Tree

CLEMENT CLARK MOORE

Clement Clark Moore (1779–1863) was a preacher as well as a professor of religion, whose famous poem, "A Visit from St. Nicholas"—which he wrote for the amusement of his children in 1822—is a Christmas tradition. In this tale, generosity and goodwill bring forth a Christmas miracle.

 ost children have seen a Christmas tree, and many know that the pretty and pleasant custom of hanging gifts on its boughs comes from Germany; but perhaps few have heard or read the story that is told to little German children, respecting the origin of this custom. The story is called "The Little Stranger," and runs thus:

In a small cottage on the borders of a forest lived a poor laborer, who gained a scanty living by cutting wood. He had a wife and two children who helped him in his work. The boy's name was Valentine, and the girl was called Mary. They were obedient, good children, and a great comfort to their parents. One winter evening, this happy little family were sitting quietly round the hearth, the snow and the wind raging outside, while they ate their supper of dry bread, when a gentle tap was heard on the window, and a childish voice cried from without; "Oh, let me in, pray! I am a poor child, with nothing to eat, and no home to go to, and I shall die of cold and hunger unless you let me in."

Valentine and Mary jumped up from the table and ran to open the door, saying: "Come in, poor little child! We have not much to give you, but whatever we have we will share with you."

The stranger-child came in and warmed his frozen hands and feet at the fire, and the children gave him the best they had to eat, saying: "You must be tired, too, poor child! Lie down on our bed; we can sleep on the bench for one night."

Then said the little stranger-child: "Thank God for all your kindness to me!"

So they took their little guest into their sleeping-room, laid him on the bed, covered him over, and said to each other: "How thankful we ought to be! We have warm rooms and a cozy bed, while this poor child has only heaven for his roof and the cold earth for his sleeping-place."

When their father and mother went to bed, Mary and Valentine lay quite contentedly on the bench near the fire, saying, before they fell asleep: "The stranger-child will be so happy tonight in his warm bed!"

These kind children had not slept many hours before Mary awoke, and softly whispered to her brother: "Valentine, dear, wake, and listen to the sweet music under the window."

Then Valentine rubbed his eyes and listened. It was sweet music indeed, and sounded like beautiful voices singing to the tones of a harp:

> Oh holy Child, we greet thee! bringing
> Sweet strains of harp to aid our singing.
> Thou, holy Child, in peace art sleeping,
> While we our watch without are keeping.
> Blest be the house wherein Thou liest,
> Happiest on earth, to heaven the Highest.

The children listened, while a solemn joy filled their hearts; then they stepped softly to the window to see who might be without.

In the east was a streak of rosy dawn, and in its light they saw a group of children standing before the house, clothed in silver garments, holding golden harps in their hands. Amazed at this sight, the children were still gazing out of the window, when a light tap caused them to turn around. There stood the stranger-child before them clad in a golden dress, with a gleaming radiance round his curling hair. "I am the little Christ child," he said, "who wanders through the world bringing peace and happiness to good children. You took me in and cared for me when you thought me a poor child, and now you shall have my blessing for what you have done."

A fir tree grew near the house; and from this he broke a twig, which he planted in the ground, saying: "This twig shall become a tree, and shall bring forth fruit year by year for you."

No sooner had he done this than he vanished, and with him the little choir of angels. But the fir branch grew and became a Christmas tree, and on its branches hung golden apples and silver nuts every Christmastide.

Such is the story told to German children concerning their beautiful Christmas trees, though we know that the real little Christ child can never be wandering, cold and homeless, again in our world, inasmuch as He is safe in heaven by His Father's side; yet we may gather from this story the same truth which the Bible plainly tells us—that anyone who helps a child in distress, it will be counted unto him as if he had indeed done it unto Christ himself. "Inasmuch as ye have done it unto the least of these, my brethren, ye have done it unto me."

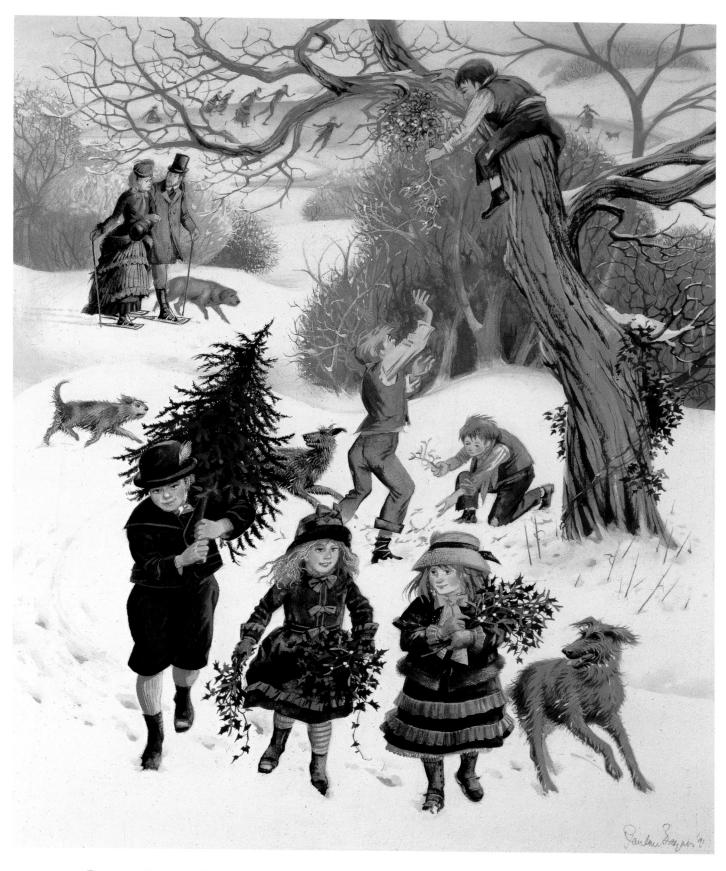

PAULINE BAYNES. *Christmas Preparations—1870*. Private collection/Bridgeman Art Library.

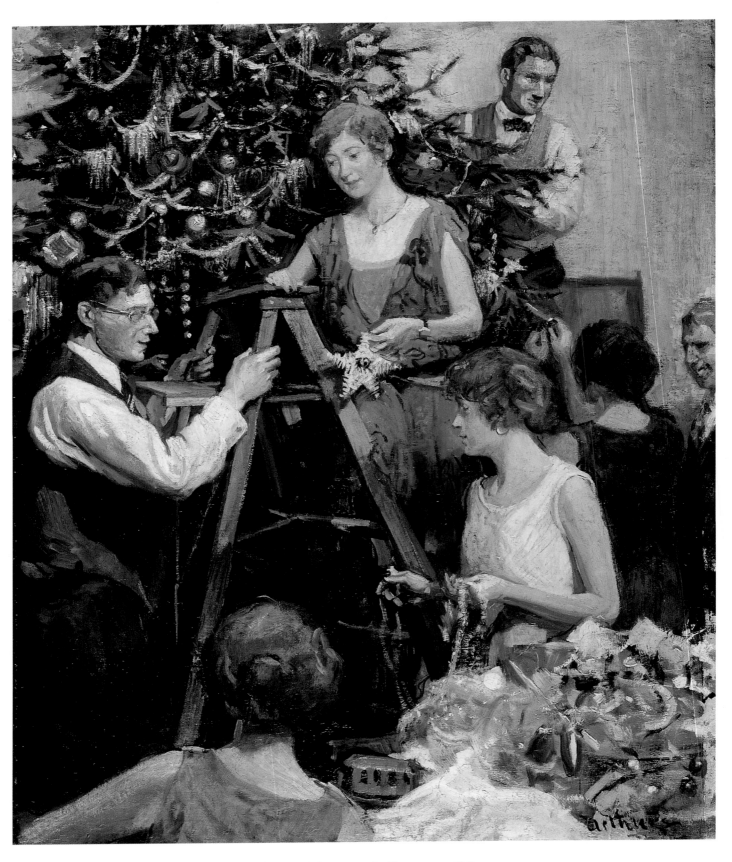

STANLEY ARTHURS. *Trimming the Tree*. 1912. Oil on canvas.
© Copyright 2002 National Museum of American Illustration, Newport, RI.
Courtesy of the Archives of the American Illustrators Gallery, NYC.
Photograph supplied by ASaP Worldwide.

The Legend of the Poinsettia

Pat Mora and Charles Ramírez Berg

Award winning author Pat Mora is a native of El Paso, Texas. Charles Ramírez Berg is a professor at the University of Texas, Austin. In this tender story, infused with Mexican tradition and lore, we can all rejoice in the gift of giving.

ong ago, in the little Mexican town of San Bernardo, there lived a boy named Carlos.

One cool night Carlos opened the heavy wooden door of his small home and peeked out. It was quiet. Chimney smoke danced from the roof of each adobe home. Carlos knew why families were eating early. Tonight was the first night of the *posadas.*

"Chico, come and look at the stars," Carlos said to his playful brown dog. "See how they glimmer. Even the heavens know the celebration begins tonight."

Carlos shut the door and looked at his aunt, Nina, who was roasting green chiles. Her hair was white and she moved slowly. She was Carlos' whole family and she was enough. They sang, they danced, they played, they talked. Their home was small and bare, but full of warm love that made the air sweet. . . .

"Carlos, when you are out under the stars, sing with your heart. When you return, I will make you hot chocolate, and you can tell me all you saw. You are my eyes tonight, Carlos. See everything. Here is your candle."

Outside Carlos took a deep breath and straightened his shoulders. He looked in the window of his home and saw Chico and Nina warming themselves by

the fire. He felt happy knowing he would return to share his adventure with his two friends.

Carlos joined a group of people gathered before a home that seemed to glow. There were candles in all the windows. Soon four men arrived carrying a large wooden tray on their shoulders. Carlos stood on tiptoes to see the statues of Joseph and of Mary riding the donkey.

A tall man spoke. "Time to start," he said. "Tonight we begin our journey. We are travelers seeking room in the inn, the *posada*, just as Mary and Joseph did. Each night for nine nights we will meet and carry the statues to the next house on our trip. We will knock and ask for shelter for the night. This special time is a time of preparing our hearts for Christmas, of deciding what gift each of us can offer the Infant Jesus."

Carlos looked at the people around him. Most wore better clothes and newer shoes, but tonight they all held hands.

The tall man knocked on the door and the group sang:

> Who will give them shelter?
> Who will help these two?

The family from inside the house answered:

> What if they are thieves?
> What are we to do?

> It is Mary and Joseph.
> They need a place to rest.

> Open all the doors
> For our very special guests!

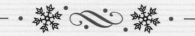
Slowly the door of the house opened. Carlos' eyes grew wide as he saw the mounds of food and the sparkling decorations. Nina had been right. The birth of Jesus was the best reason for a party.

The group knelt and prayed. Carlos squeezed his eyes shut and thought. A frown wrinkled his little face. On Christmas Ever he would go with the other children of San Bernardo to the church. Each child would place a special gift at the manger for the Baby Jesus. He had no money, neither did Nina. What gift could he give that would be special?

The prayer was over.

With a cheer the children hurried to the other side of the room to play the games and enjoy the food. The lady of the house said, "Come, Carlos. You play and eat too. Enjoy the *posada*."

"How much I will have to tell Nina and Chico," thought Carlos. "So that my story will not be too long, each night I will tell them about one little part of the *posada*. Tonight I will tell them of the statues, the songs, the prayers."

And so it was.

"Tonight it rained candy," said Carlos when he came home on the second night. Nina smiled. "Ah, a *piñata*," she said.

"Oh, Nina, it was so beautiful," Carlos said. "A star made of colored paper hanging from the ceiling. Whack! Whack! Whack! went the stick as one by one we tried to break the *piñata*. Finally a strong girl did break it and candy, delicious candy, poured out of it covering the floor. We all scrambled to grab some. Here, Nina," said Carlos, holding out his hand. "I brought us each a piece." . . .

On the third night Carlos returned carrying a small bundle. "Tonight I will tell you of a table like the tables in my dreams. There were mountains of steam-

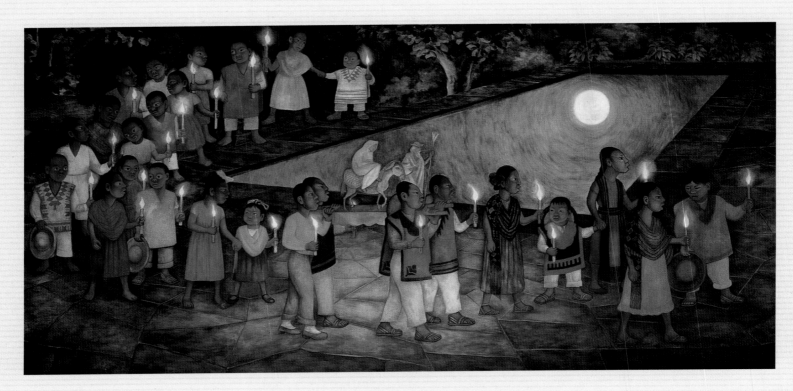

Diego Rivera. *Children Asking for Posada.* 1953.
Hospital Infantil "Francisco Gomez," Mexico City, D.F., Mexico. Copyright Schalkwijk/Art Resource, NY.
© 2003 Banco de México Diego Rivera & Frida Kahlo Museums Trust.
Av. Cinco de Mayo No. 2, Centro, Del. Cuauhtémoc 06059, México, D.F.

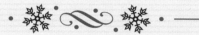
ing *tamales*, a huge pot of beans, plates of cookies, and a tower of thin, crisp, round *buñuelos* sparkling with sugar."

Carlos unwrapped his bundle and smiled at the look on Nina's face as she saw all the treats that had been sent to her. "Help me eat all this," she said. Carlos held up a bit of sweet *tamal* for Chico and Chico jumped and picked it from his hand and ate it. Even Chico enjoyed the food from the *posada*.

"What do you have there?" asked Nina when Carlos entered his home on the fourth night. His hand was closed in a tight fist.

"You'll see," he said with a wide grin. Carlos sat down and began his story with Chico's head in his lap. "Tonight I will tell you about my favorite game at the *posada*. The lady of the house gave the children special egg shells filled with confetti. We all ran about cracking eggs on heads but trying not to get hit. We laughed and laughed."

Carlos then held up one of the eggs to show Nina, but Chico thought it was another treat and jumped to bite it. The egg exploded and suddenly there was confetti everywhere in the air. All three of them were covered with tiny bits of red, yellow, green and blue paper.

Carlos placed a soft kiss on Nina's head. "You look pretty with paper jewels in your hair," he said.

"And you! said Nina, pointing at him and laughing.

"And Chico!" they said together and laughed.

The following night Carlos went to bed early after the *posada*. Nina tucked him in his snug bed. She knew something was troubling Carlos. But she said nothing.

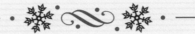

After Nina went to sleep, Chico began to lick Carlos' face. Carlos scratched Chico behind the ears and whispered, "My friend, what shall I do? I can bring Nina candy and *buñuelos* and confetti, but what can I take to Baby Jesus on Christmas Eve? These are magic nights. I want my gift to Jesus to glow like a jewel." Chico put his head on Carlos' shoulder.

On the sixth night Carlos walked home humming the carols he had sung. The stars were so bright that he sat on this favorite round rock to stare at them.

"I wish a star would drop into my hand," he thought. "I would carry it home and surprise Nina and Chico with the beautiful light. I would take it to the church Christmas Eve. I would set it before the manger."

Now that would be a gift to be proud of.

But no star fell. Carlos walked home and tried to sound cheerful when he sang carols to Nina.

"Look what the lady at this house gave me," Carlos said as he entered the house on the seventh night. He held two colored paper lanterns. "They are to make our town glow on Christmas Eve. They will light the way for the Christ child. On Christmas Eve we will light the lanterns. They will be in trees, on roofs, around the church. And this year, Nina, we too will have our own to hang outside our door. Oh, Nina, what a special night this Christmas Eve will be."

On the eighth night after the prayers and refreshments, the children were told that the Indians from the nearby hills would be coming to join the procession to the church.

Again the tall man spoke:

"On Christmas Eve the Indians will be like the shepherds at Bethlehem. After you children place your gifts before the manger, they will dance outside the church. They will chant. That will be their gift."

That night Carlos asked, "Tomorrow will you go with me, Nina? And Chico will guard our home. First we will light our lanterns. Then we will go carrying our candles to the last house of the *posada*. We will take the statues of Mary and Joseph and place them in the manger at the church. Their journey will be over."

Carlos became quiet.

"And then," said Nina, "you and the other children will each place a small gift before the manger."

Carlos said nothing.

"I know," said Nina, "we have not talked of your gift. I know you have been thinking of it. Does it make you so unhappy that we have no shiny coins or beautiful flowers to give?"

Carlos said nothing.

"Jesus was not a rich boy either, Carlos. He loved to run and play in the hills by his town just as you do. Go out tomorrow and collect the small plant that grows wild near the rock you watch the stars from. That will be your gift."

Carlos wanted to obey Nina's words but it would be hard. These nights of the *posadas* had made him so happy. He wanted his gift to show that happiness. He wanted his gift to shine. How could he give a king only a common plant, a simple weed people stepped over and ignored because it was everywhere?

"The Infant Jesus will understand," said Nina. "Love makes small gifts special."

Finally it was Christmas Eve. Carlos lit two candles and placed them in the paper lanterns. He hung them on either side of the door. He left Chico at the doorway. The lanterns swayed in the wind.

Carlos then took Nina's arm to escort her to join the *posada*. In his other hand he carried his gift, his small plant. The air was warmer, sweeter. The whole town of San Bernardo was aglow. The Indians quietly walked with the others to the church.

Carlos stood in line holding his little plant. Some of the children carried roses, fruit; others carried bread or cheese. Tears of shame slipped down Carlos' face. Such a small gift.

Then something happened. One of Carlos' tears fell on the plant and where it touched the green leaf it made a red dot. A bright, beautiful, spreading red. Carlos looked at Nina. When he looked back at the plant in his hand, another tear fell away from his eye. His tears were making the whole leaf red. He looked up at Nina again; she smiled.

When it was his turn, Carlos carefully placed his plant before the manger. Now the entire top of the plant had turned red. It was the most beautiful gift.

Outside Carlos looked at his town of San Bernardo. He saw the colored lanterns dancing in the trees. Tonight in his little town in Mexico he saw that all the small plants like the one he had given had changed color. They were like bright red stars. They too would light the way for the Christ child.

The Indians began their slow dance beating the rhythm by shaking gourds filled with seeds. As Carlos watched, he squeezed Nina's hand. She had been right again.

Love is magic.

Love does make small gifts special.

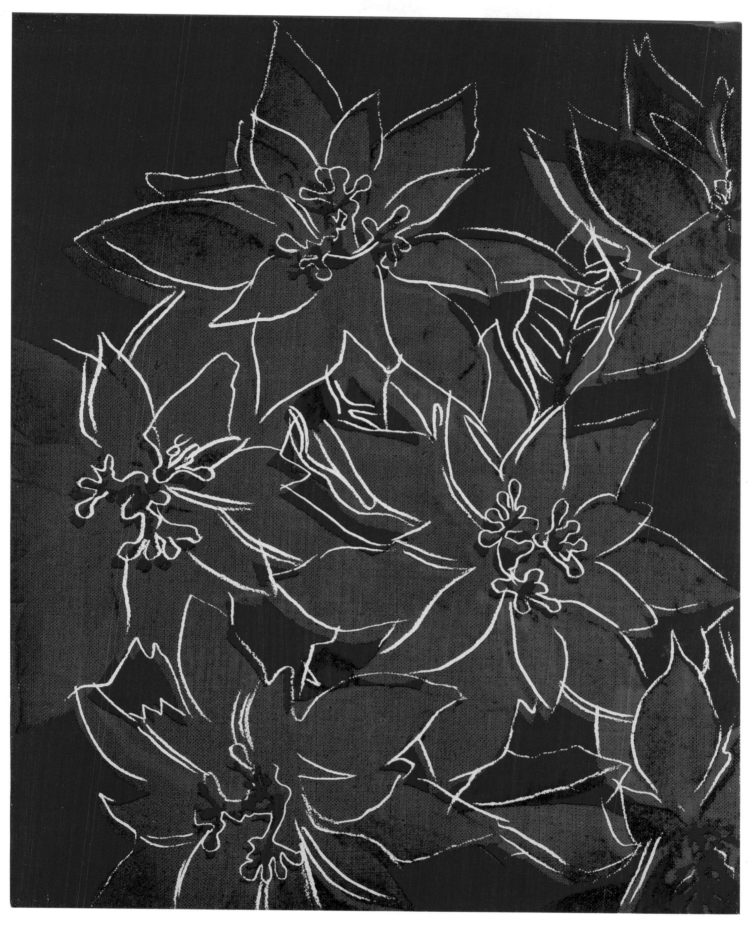

ANDY WARHOL. *Poinsettias.* c. 1982. Synthetic polymer paint and silkscreen ink on canvas.
© Copyright 2003 Andy Warhol Foundation for the Visual Arts/ARS, NY.
Copyright The Andy Warhol Foundation, Inc./Art Resource, NY.

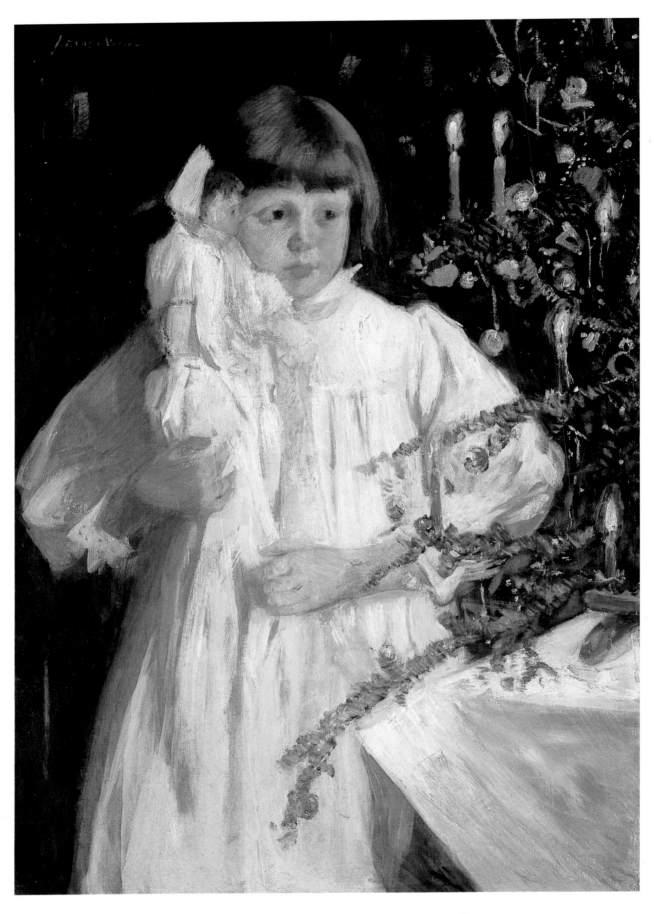

J. Alden Weir. *The Christmas Tree.* 1890. Private collection.

The Tree That Didn't Get Trimmed

CHRISTOPHER MORLEY

American novelist, poet, and playwright Christopher Morley (1890–1957) provides a happy ending for a young sapling unable to fulfill a lifelong dream of becoming a Christmas tree.

f you walk through a grove of balsam trees you will notice that the young trees are silent; they are listening. But the old tall ones—especially the firs—are whispering. They are telling the story of The Tree That Didn't Get Trimmed. It sounds like a painful story, and the murmur of the old trees as they tell it is rather solemn; but it is an encouraging story for young saplings to hear . . .

The tree in this story should never have been cut. He wouldn't have been, but it was getting dark in the Vermont woods, and the man with the ax said to himself, "Just one more." Cutting young trees with a sharp, beautiful balanced ax is fascinating; you go on and on; there's a sort of cruel pleasure in it. The blade goes through the soft wood with one whistling stroke and the boughs sink down with a soft swish.

He was a fine, well-grown youngster, but too tall for his age; his branches were rather scraggly. If he'd been left there he would have been an unusually big tree some day; but now he was in the awkward age and didn't have the tapering shape and the thick, even foliage that people like on Christmas trees. Worse still, instead of running up to a straight, clean spire, his top was a bit lop-sided, with a fork in it.

But he didn't know this as he stood with many others, leaning against the side wall of the green-grocer's shop. In those cold December days he was very happy, thinking of the pleasures to come. He had heard of the delights of Christmas Eve: the stealthy setting-up of the tree, the tinsel balls and coloured toys and stars, the peppermint canes and birds with spun-glass tails. Even that old anxiety of Christmas trees—burning candles—did not worry him, for he had been told that nowadays people use strings of tiny electric bulbs which cannot set one on fire. So he looked forward to the festival with a confident heart.

"I shall be very grand," he said. "I hope there will be children to admire me. It must be a great moment when the children hang their stockings on you!" He even felt sorry for the first trees that were chosen and taken away. It would be best, he considered, not to be bought until Christmas Eve. Then, in the shining darkness someone would pick him out, put him carefully along the running board of a car, and away they would go. The tire-chains would clack and jingle merrily on the snowy road. He imagined a big house with a fire glowing on a hearth; the hushed rustle of wrapping paper and parcels being unpacked. Someone would say, "Oh, what a beautiful tree!" How erect and stiff he would brace himself in his iron tripod stand.

But day after day went by, one by one the other trees were taken, and he began to grow troubled. For everyone who looked at him seemed to have an unkind word. "Too tall," said one lady. "No, this one wouldn't do, the branches are too skimpy," said another. "If I chop off the top," said the green-grocer, "it wouldn't be so bad?" The tree shuddered . . . Then he was shown to a lady who wanted a tree very cheap. "You can have this one for a dollar," said the grocer. This was only one third of what the grocer had asked for him at first, but even so the lady refused him . . .

THE TREE THAT DIDN'T GET TRIMMED

Now it was Christmas Eve. It was a foggy evening with a drizzling rain; the alley alongside the store was thick with trampled slush. As he lay there among broken boxes and fallen scraps of holly strange thoughts came to him. In the still northern forest already his wounded stump was buried in forgetful snow. He remembered the wintry sparkle of the woods, the big trees with crusts and clumps of silver on the broad boughs, the keen singing of the lonely wind. He remembered the strong, warm feeling of his roots reaching down into the safe earth. That is a good feeling; it means to a tree just what it means to you to stretch your toes down toward the bottom of a well-tucked bed. And he had given up all this to lie here, disdained and forgotten, in a littered alley. The splash of feet, the chime of bells, the cry of cars went past him. He trembled a little with self-pity and vexation. "No toys and stocking for me," he thought sadly, and shed some of his needles.

Late that night, after all the shopping was over, the grocer came out to clear away what was left. The boxes, the broken wreaths, the empty barrels, and our tree with one or two others that hadn't been sold, all were thrown through the side door into the cellar. The door was locked and he lay there in the dark. One of his branches, doubled under him in the fall, ached so he thought it must be broken. "So this is Christmas," he said to himself.

All that day it was very still in the cellar. There was an occasional creak as one of the bruised trees tried to stretch itself. Feet went along the pavement overhead, and there was a booming of church bells, but everything had a slow, disappointed sound. Christmas is always a little sad, after such busy preparations. The unwanted trees lay on the stone floor, watching the furnace light flicker on a hatchet that had been left there.

The day after Christmas a man came in who wanted some green boughs . . . The grocer took the hatchet, and seized the trees without ceremony. They were too disheartened to care. Chop, chop, chop, went the blade, and the sweet-smelling branches were carried away. The naked trunks were thrown into a corner.

And now our tree, what was left of him, had plenty of time to think. He no longer could feel anything, for trees feel with their branches, but they think with their trunks. What did he think about as he grew dry and stiff? He thought that it had been silly of him to imagine such a fine, gay career for himself, and he was sorry for other young trees, still growing in the fresh hilly country, who were enjoying the same fantastic dreams.

Now perhaps you don't know what happens to the trunks of left-over Christmas trees. You could never guess. Farmers come in from the suburbs and buy them at five cents each for bean-poles and grape arbours. So perhaps (here begins the encouraging part of the story) they are really happier, in the end, than the trees that get trimmed for Santa Claus. They go back into the fresh, moist earth of spring, and when the sun grows hot the quick tendrils of the vines climb up them and presently they are decorated with the red blossoms of the bean or the little blue globes of the grape, just as pretty as any Christmas trinkets.

So one day the naked, dusty fir-poles were taken out of the cellar, and thrown into a truck with many others, and made a rattling journey out into the land. The farmer unloaded them in his yard and was stacking them up by the barn when his wife came out to watch him.

"There!" she said. "That's just what I want, a nice long pole with a fork in it. Jim, put that one over there to hold up the clothesline." It was the first time that anyone had praised our tree, and his dried-up heart swelled with a tingle

of forgotten sap. They put him near one end of the clothesline, with his stump close to a flower bed. The fork that had been despised for a Christmas star was just the thing to hold up a clothesline. It was washday, and soon the farmer's wife began bringing out wet garments to swing and freshen in the clean, bright air. And the very first thing that hung near the top of the Christmas pole was a cluster of children's stockings.

That isn't quite the end of the story, as the old fir trees whisper it in the breeze. The Tree That Didn't Get Trimmed was so cheerful watching the stockings, and other gay little clothes that plumped out in the wind just as though waiting to be spanked, that he didn't notice what was going on—or going up—below him. A vine had caught hold of his trunk and was steadily twisting upward. And one morning when the farmer's wife came out intending to shift him, she stopped and exclaimed. "Why, I mustn't move this pole," she said. "The morning glory has run right up it." So it had, and our bare pole was blue and crimson with colour . . .

Kidnapped Santa Claus

L. FRANK BAUM

Best known as the author of The Wonderful Wizard of Oz, *L. Frank Baum (1856–1919)*
wrote modern American fairy tales for the young at heart. Here a masterful storyteller
compels us to imagine Christmas without Santa Claus.

anta Claus lives in the Laughing Valley, where stands the big rambling castle in which his toys are manufactured. His workmen, selected from the ryls, knooks, pixies and fairies, live with him, and everyone is as busy as can be from one year's end to another.

It is called the Laughing Valley because everything there is happy and gay. The brook chuckles to itself as it leaps rollicking between its green banks; the wind whistles merrily in the trees; the sunbeams dance lightly over the soft grass, and the violets and wild flowers look smilingly up from their green nests. To laugh one needs to be happy; to be happy one needs to be content. And throughout the Laughing Valley of Santa Claus contentment reigns supreme.

On one side is the mighty Forest of Burzee. At the other side stands the huge mountain that contains the Caves of the Daemons. And between them the Valley lies smiling and peaceful.

One would think that our good old Santa Claus, who devotes his days to making children happy, would have no enemies on all the earth; and, as a matter of fact, for a long period of time he encountered nothing but love wherever he might go.

But the Daemons who live in the mountain caves grew to hate Santa Claus very much, and all for the simple reason that he made children happy. . . .

It is well known that no harm can come to Santa Claus while he is in the Laughing Valley, for the fairies, and ryls, and knooks all protect him. But on Christmas Eve he drives his reindeer out into the big world, carrying a sleigh-load of toys and pretty gifts to the children; and this was the time and the occasion when his enemies had the best chance to injure him. So the Daemons laid their plans and awaited the arrival of Christmas Eve.

The moon shone big and white in the sky, and the snow lay crisp and sparkling on the ground as Santa Claus cracked his whip and sped away out of the Valley into the great world beyond. The roomy sleigh was packed full with huge sacks of toys, and as the reindeer dashed onward our jolly old Santa laughed and whistled and sang for very joy. For in all his merry life this was the one day in the year when he was the happiest—the day he lovingly bestowed the treasures of his workshop upon the little children.

It would be a busy night for him, he well knew. As he whistled and shouted and cracked his whip again, he reviewed in mind all the towns and cities and farmhouses where he was expected, and figured that he had just enough presents to go around and make every child happy. The reindeer knew exactly what was expected of them, and dashed along so swiftly that their feet scarcely seemed to touch the snow-covered ground.

Suddenly a strange thing happened: a rope shot through the moonlight and a big noose that was in the end of it settled over the arms and body of Santa Claus and drew tight. Before he could resist or even cry out he was jerked from the seat of the sleigh and tumbled head foremost into a snowbank, while the reindeer rushed onward with the load of toys and carried it quickly out of sight and sound.

Such a surprising experience confused old Santa for a moment, and when he collected his senses he found that the wicked Daemons had pulled him from the

snowdrift and bound him tightly with many coils of the stout rope. And then they carried the kidnapped Santa Claus away to their mountain, where they thrust the prisoner into a secret cave and chained him to the rocky wall so that he could not escape.

"Ha, ha!" laughed the Daemons, rubbing their hands together with cruel glee. "What will the children do now? How they will cry and scold and storm when they find there are no toys in their stockings and no gifts on their Christmas trees! And what a lot of punishment they will receive from their parents, and how they will flock to our caves of Selfishness, and Envy, and Hatred, and Malice! We have done a mighty clever thing, we Daemons of the Caves!"

Now it so chanced that on this Christmas Eve the good Santa Claus had taken with him in his sleigh Nuter the Ryl, Peter the Knook, Kilter the Pixie, and a small fairy named Wisk—his four favorite assistants. These little people he had often found very useful in helping him to distribute his gifts to the children, and when their master was so suddenly dragged from the sleigh they were all snugly tucked underneath the seat, where the sharp wind could not reach them.

The tiny immortals knew nothing of the capture of Santa Claus until some time after he had disappeared. But finally they missed his cheery voice, and as their master always sang or whistled on his journeys, the silence warned them that something was wrong.

Little Wisk stuck out his head from underneath the seat and found Santa Claus gone and no one to direct the flight of the reindeer.

"Whoa!" he called out, and the deer obediently slackened speed and came to a halt.

Peter and Nuter and Kilter all jumped upon the seat and looked back over the track made by the sleigh. But Santa Claus had been left miles and miles behind.

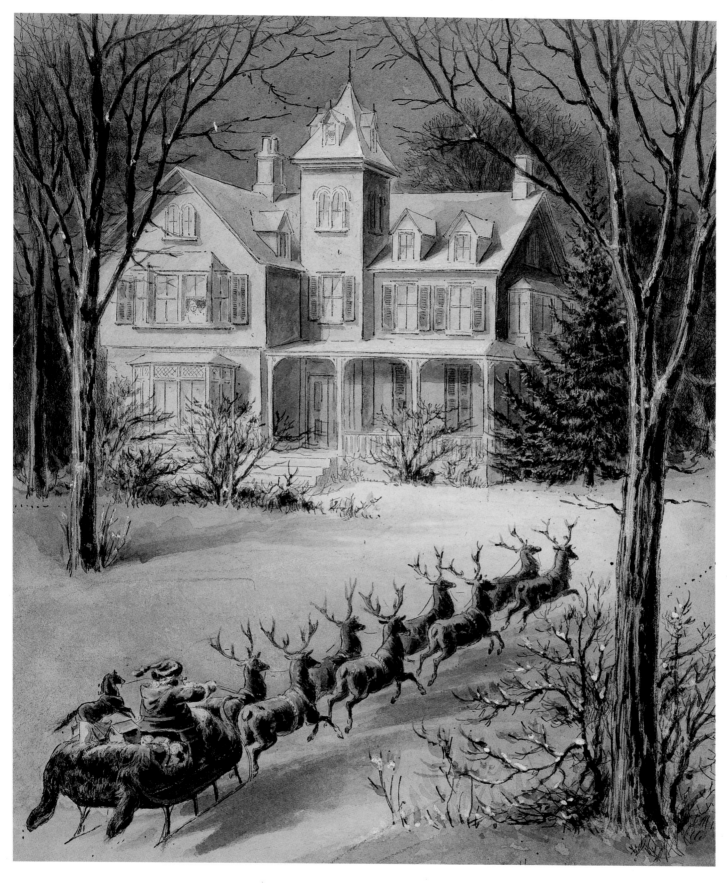

Night Before Christmas. Watercolor.
Courtesy of American Antiquarian Society.

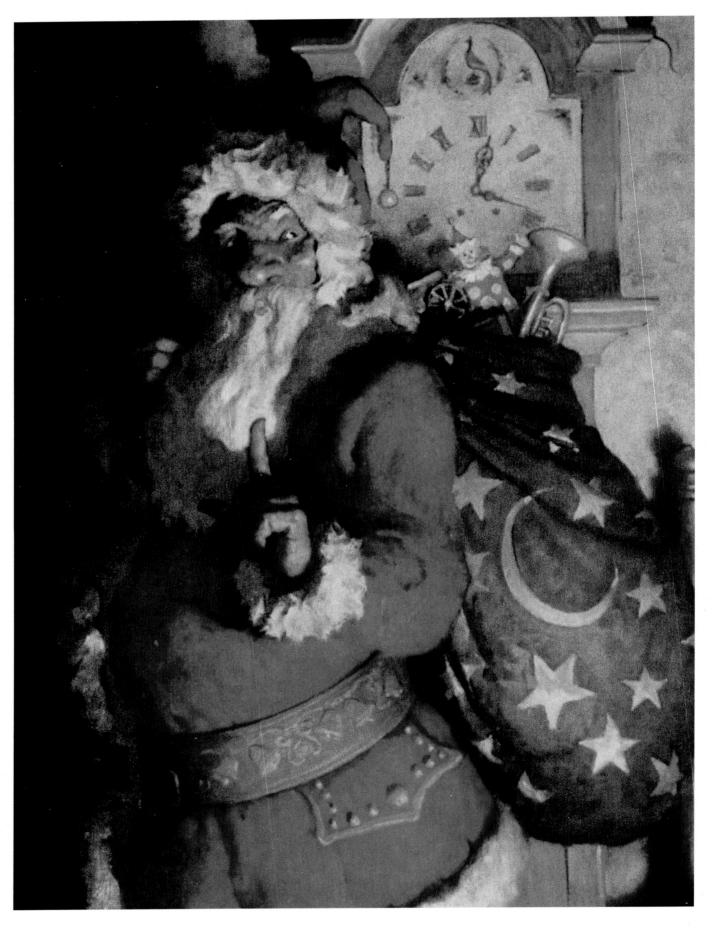

N.C. WYETH. *Santa With Sack of Toys.*

"What shall we do?" asked Wisk, anxiously, all the mirth and mischief banished from his wee face by this great calamity.

"We must go back at once and find our master," said Nuter the Ryl, who thought and spoke with much deliberation.

"No, no!" exclaimed Peter the Knook, who, cross and crabbed though he was, might always be depended upon in an emergency. "If we delay, or go back, there will not be time to get the toys to the children before morning; and that would grieve Santa Claus more than anything else."

"It is certain that some wicked creatures have captured him," added Kilter, thoughtfully; "and their object must be to make the children unhappy. So our first duty is to get the toys distributed as carefully as if Santa Claus were himself present. Afterward we can search for our master and easily secure his freedom."

This seemed such good and sensible advice that the others at once resolved to adopt it. So Peter the Knook called to the reindeer, and the faithful animals again sprang forward and dashed over hill and valley, through forest and plain, until they came to the houses wherein children lay sleeping and dreaming of pretty gifts they would find in their stockings on Christmas morning.

The little immortals had set themselves a difficult task; for although they had assisted Santa Claus on many of his journeys, their master had always directed and guided them and told them exactly what he wished them to do. But now they had to distribute the toys according to their own judgment, and they did not understand children as well as did old Santa. So it is no wonder they made some laughable errors.

Mamie Brown, who wanted a doll, got a drum instead; and a drum is of no use to a girl who loves dolls. And Charlie Smith, who delights to romp and play out of doors, and who wanted some new rubber boots to keep his feet dry, received

a sewing box filled with colored worsteds and threads and needles, which made him so provoked that he thoughtlessly called our dear Santa Claus a fraud.

Had there been many such mistakes the Daemons would have accomplished their evil purpose and made the children unhappy. But the little friends of the absent Santa Claus labored faithfully and intelligently to carry out their master's ideas, and they made fewer errors than might be expected under such unusual circumstances.

And, although they worked as swiftly as possible, day had begun to break before the toys and other presents were all distributed; so for the first time in many years the reindeer trotted into the Laughing Valley, on their return, in broad daylight, with the brilliant sun peeping over the edge of the forest to prove they were far behind their accustomed hour.

Having put the deer in the stable, the little folk began to wonder how they might rescue their master; and they realized they must discover, first of all, what had happened to him and where he was.

So Wisk the Fairy transported himself to the bower of the Fairy Queen, which was located deep in the heart of the Forest of Burzee; and once there, it did not take him long to find out all about the naughty Daemons and how they had kidnapped the good Santa Claus to prevent his making children happy. The fairy Queen also promised her assistance, and then, fortified by this powerful support, Wisk flew back to where Nuter and Peter and Kilter awaited him, and the four counseled together and laid plans to rescue their master from his enemies.

It is possible that Santa Claus was not as merry as usual during the night that succeeded his capture. For although he had faith in the judgment of his little friends he could not avoid a certain amount of worry, and an anxious look would creep at times into his kind old eyes as he thought of the disappointment that might await his dear little children. . . .

"The little ones will be greatly disappointed," murmured the Daemon of Repentance...

The fellow at once busied himself untying the knots that bound Santa Claus and unlocking the chains that fastened him to the wall. Then he led the way through a long tunnel until they both emerged in the Cave of Repentance.

"I hope you will forgive me," said the Daemon, pleadingly. "I am not really a bad person, you know; and I believe I accomplish a great deal of good in the world."

With this he opened a back door that let in a flood of sunshine, and Santa Claus sniffed the fresh air gratefully.

"I bear no malice," said he to the Daemon, in a gentle voice; "and I am sure the world would be a dreary place without you. So, good morning, and a Merry Christmas to you!"

With these words he stepped out to greet the bright morning, and a moment later he was trudging along, whistling softly to himself, on his way to his home in the Laughing Valley.

Marching over the snow toward the mountain was a vast army, made up of the most curious creatures imaginable. There were numberless knooks from the forest, as rough and crooked in appearance as the gnarled branches of the trees they ministered to. And there were dainty ryls from the fields, each one bearing the emblem of the flower or plant it guarded. Behind these were many ranks of pixies, gnomes and nymphs, and in the rear a thousand beautiful fairies floating along, all in gorgeous array.

This wonderful army was led by Wisk, Peter, Nuter and Kilter, who had assembled it to rescue Santa Claus from captivity and to punish the Daemons.

But lo! coming to meet his loyal friends appeared the imposing form of Santa

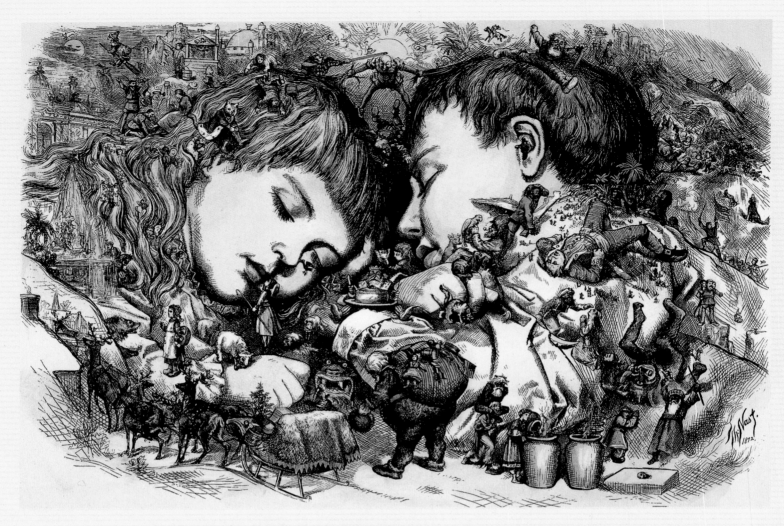

THOMAS NAST. *The Same Old Christmas Story Over Again*. Colored engraving.
The Granger Collection, New York.

Claus, his white beard floating in the breeze and his bright eyes sparkling with pleasure at this proof of the love and veneration he had inspired in the hearts of the most powerful creatures in existence.

And while they clustered around him and danced with glee at this safe return, he gave them earnest thanks for their support. . . .

Wisk had already rendered himself invisible and flown through the big world to see how the children were getting along on this bright Christmas morning; and by the time he returned, Peter had finished telling Santa Claus of how they had distributed the toys.

"We really did very well," cried the fairy, in a pleased voice; "for I found little unhappiness among the children this morning. Still, you must not get captured again, my dear master, for we might not be so fortunate another time in carrying out your ideas."

He then related the mistakes that had been made, and which he had not discovered until his tour of inspection. And Santa Claus at once sent him with rubber boots for Charlie Smith, and a doll for Mamie Brown; so that even those two disappointed ones became happy.

As for the wicked Daemons of the Caves, they were filled with anger and chagrin when they found that their clever capture of Santa Claus had come to naught. Indeed, no one on that Christmas Day appeared to be at all selfish, or envious, or hateful. And, realizing that while the children's saint had so many powerful friends it was folly to oppose him, the Daemons never again attempted to interfere with his journeys on Christmas Eve.

A Christmas Story

KATHERINE ANNE PORTER

This memoir by Katherine Anne Porter (1890–1980), one of America's finest short story writers, introduces us to a little girl, at once innocent and insightful, who seeks to perpetuate a Christmas tradition for her mother.

hen she was five years old, my niece asked me again why we celebrated Christmas. She had asked when she was three and when she was four, and each time had listened with a shining, believing face, learning the songs and gazing enchanted at the pictures which I displayed as proof of my stories. Nothing could have been more successful, so I began once more confidently to recite in effect the following:

The feast in the beginning was meant to celebrate with joy the birth of a Child, an event of such importance to this world that angels sang from the skies in human language to announce it and even, if we may believe the old painters, came down with garlands in their hands and danced on the broken roof of the cattle shed where He was born.

"Poor baby," she said, disregarding the angels, "didn't His papa and mama have a house?"

They weren't quite so poor as all that, I went on, slightly dashed, for last year the angels had been the center of interest. His papa and mama were able to pay taxes at least, but they had to leave home and go to Bethlehem to pay them, and they could have afforded a room at the inn, but the town was crowded

because everybody came to pay taxes at the same time. They were quite lucky to find a manger full of clean straw to sleep in. When the baby was born, a goodhearted servant girl named Bertha came to help the mother. Bertha had no arms, but in that moment she unexpectedly grew a fine new pair of arms and hands, and the first thing she did with them was to wrap the baby in swaddling clothes. We then sang together the song about Bertha the armless servant. Thinking I saw a practical question dawning in a pure blue eye, I hurried on to the part about how all the animals—cows, calves, donkeys, sheep . . .

"And pigs?"

Pigs perhaps even had knelt in a ring around the baby and breathed upon Him to keep Him warm through His first hours in this world. A new star appeared and moved in a straight course toward Bethlehem for many nights to guide three kings who came from far countries to place important gifts in the straw beside Him: gold, frankincense and myrrh.

"What beautiful clothes," said the little girl, looking at the picture of Charles the Seventh of France kneeling before a meek blond girl and a charming baby.

It was the way some people used to dress. The Child's mother, Mary, and His father, Joseph, a carpenter, were such unworldly simple souls they never once thought of taking any honor to themselves nor of turning the gifts to their own benefit.

"What became of the gifts?" asked the little girl.

Nobody knows, nobody seems to have paid much attention to them, they were never heard of again after that night. So far as we know, those were the only presents anyone ever gave to the Child while He lived. But He was not unhappy. Once He caused a cherry tree in full fruit to bend down one of his branches so His mother could more easily pick cherries. We then sang about

the cherry tree until we came to the words: "Then up spake old Joseph, so rude and unkind."

"Why was he so unkind?"

I thought perhaps he was just in a cross mood.

"What was he cross about?"

Dear me, what should I say now? After all, this was not my daughter, whatever would her mother answer to this? I asked her in turn what she was cross about when she was cross? She couldn't remember ever having been cross but was willing to let the subject pass. We moved on to *The Withy Tree*, which tells how the Child once cast a bridge of sunbeams over a stream and crossed upon it, and played a trick on John the Baptist, who followed Him, by removing the beams and letting John fall in the water. The Child's mother switched Him smartly for this with a branch of withy, and the Child shed loud tears and wished bad luck upon the whole race of withies for ever.

"What's a withy?" asked the little girl. I looked it up in the dictionary and discovered it meant osier, or willows.

"Just a willow like ours?" she asked, rejecting this intrusion of the commonplace. Yes, but once, when His father was struggling with a heavy piece of timber almost beyond his strength, the Child ran and touched it with one finger and the timber rose and fell properly into place. At night His mother cradled Him in a far place; and the Child, moved by her tears, spoke long before it was time for Him to speak and His first words were, "Don't be sad, for you shall be Queen of Heaven." And there she was in an old picture, with the airy jeweled crown being set upon her golden hair.

I thought how nearly all of these tender medieval songs and legends about this Child were concerned with trees, wood, timbers, beams, crosspieces; and

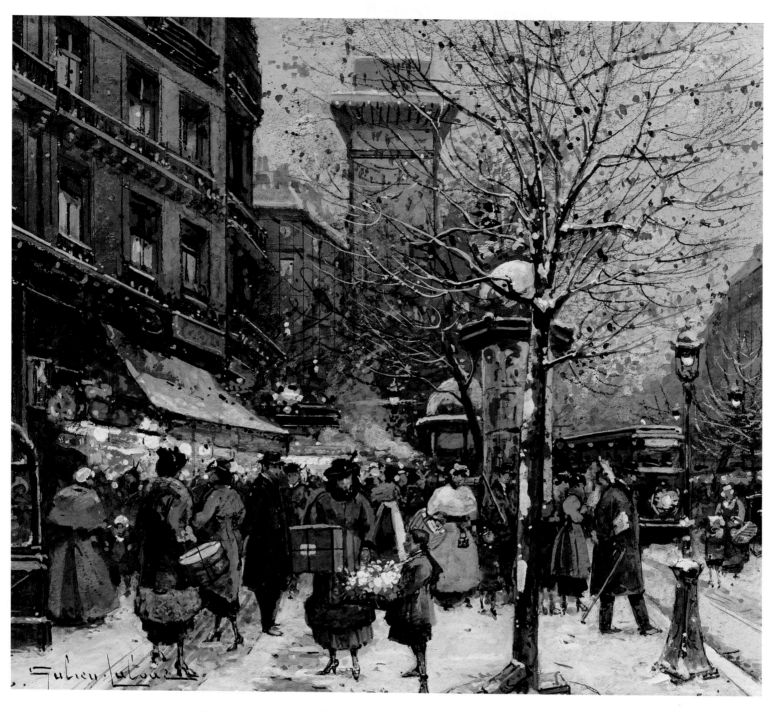

EUGENE LALOUE. *Christmas Shopping* (detail). Oil on canvas.
Collection Adam Levene, Albourne, Great Britain.
Copyright Fine Art Photographic Library, London/Art Resource, NY.

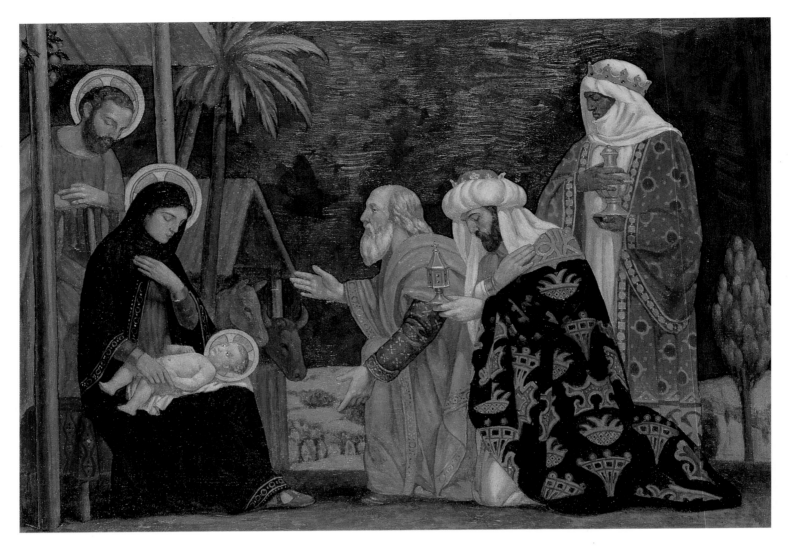

HARRY SIDDONS MOWBRAY. *The Magi.* c. 1915. Oil on canvas mounted on paperboard.
Smithsonian American Art Museum, Washington, DC. Gift of Mr. and Mrs. Waldron Faulkner.
Copyright Smithsonian American Art Museum, Washington, DC/Art Resource, NY.

even the pagan north transformed its great tree festooned with human entrails into a blithe festival tree hung with gifts for the Child, and some savage old man of the woods became a rollicking saint with a big bell. But I had never talked about Santa Claus, because myself I had not liked him from the first, and did not even then approve of the boisterous way he had almost crowded out the Child from His own birthday feast.

"I like the part about the sunbeam bridge the best," said the little girl, and then she told me she had a dollar of her own and would I take her to buy a Christmas present for her mother.

We wandered from shop to shop, and I admired the way the little girl, surrounded by tons of seductive, specially manufactured holiday merchandise for children, kept her attention fixed resolutely on objects appropriate to the grownup world. She considered seriously in turn a silver tea service, one thousand dollars; an embroidered handkerchief with lace on it, five dollars; a dressing-table mirror framed in porcelain flowers, eighty-five dollars; a preposterously showy crystal flask of perfume, one-hundred-twenty dollars; a gadget for curling the eyelashes, seventy-five cents; a large plaque of colored glass jewelry, thirty dollars; a cigarette case of some fraudulent material, two dollars and fifty cents. She weakened, but only for a moment, before a mechanical monkey with real fur who did calisthenics on a crossbar if you wound him up, one dollar and ninety-eight cents.

The prices of these objects did not influence their relative value to her and bore no connection whatever to the dollar she carried in her hand. Our shopping had also no connection with the birthday of the Child or the legends and pictures. Her air of reserve toward the long series of blear-eyed, shapeless old men wearing red flannel blouses and false, white-wool whiskers said all

too plainly that they in no way fulfilled her notions of Christmas merriment. She shook hands with all of them politely, could not be persuaded to ask for anything from them and seemed not to question the obvious spectacle of thousands of persons everywhere buying presents instead of waiting for one of the army of Santa Clauses to bring them, as they all so profusely promised.

Christmas is what we make it and this is what we have so cynically made of it: not the feast of the Child in the straw-filled crib, nor even the homely winter bounty of the old pagan with the reindeer, but a great glittering commercial fair, gay enough with music and food and extravagance of feeling and behavior and expense, more and more on the order of the ancient Saturnalia. I have nothing against Saturnalia, it belongs to this season of the year: but how do we get so confused about the true meaning of even our simplest-appearing pastimes?

Meanwhile, for our money we found a present for the little girl's mother. It turned out to be a small green pottery shell with a colored bird perched on the rim which the little girl took for an ash tray, which it may as well have been.

"We'll wrap it up and hang it on the tree and say it came from Santa Claus," she said, trustfully making of me a fellow conspirator.

"You don't believe in Santa Claus any more?" I asked carefully, for we had taken her credulity for granted. I had already seen in her face that morning a skeptical view of my sentimental legends, she was plainly trying to sort out one thing from another in them; and I was turning over in my mind the notion of beginning again with her on other grounds, of making an attempt to draw, however faintly, some boundary lines between fact and fancy, which is not so difficult; but also further to show where truth and poetry were, if not the same being, at least twins who could wear each other's clothes. But that couldn't be

done in a day nor with pedantic intention. I was perfectly prepared for the first half of her answer, but the second took me by surprise.

"No, I don't," she said, with the freedom of her natural candor, "but please don't tell my mother, for she still does."

For herself, then, she rejected the gigantic hoax which a whole powerful society had organized and was sustaining at the vastest pains and expense, and she was yet to find the grain of truth lying lost in the gaudy debris around her, but there remained her immediate human situation, and that she could deal with, or so she believed: her mother believed in Santa Claus, or she would not have said so. The little girl did not believe in what her mother had told her, she did not want her mother to know she did not believe, yet her mother's illusions must not be disturbed. In that moment of decision her infancy was gone forever, it had vanished there before my eyes.

Very thoughtfully I took the hand of my budding little diplomat, whom we had so lovingly, unconsciously prepared for her career, which no doubt would be quite a successful one; and we walked along in the bright sweet-smelling Christmas dusk, myself for once completely silenced.

III

CHRISTMAS MEMORIES

FROM *A Child's Christmas in Wales*

DYLAN THOMAS

The poetry and prose of Dylan Thomas (1914-1953) is known for its outrageous exuberance, rhapsodic lilt, and intense emotion. Here we are witness to a Welsh family Christmas through the acute observations of a spirited young boy.

or dinner we had turkey and blazing pudding, and after dinner the Uncles sat in front of the fire, loosened all buttons, put their large moist hands over their watch chains, groaned a little and slept. Mothers, aunts and sisters scuttled to and fro, bearing tureens. Auntie Bessie, who had already been frightened, twice, by a clock-work mouse, whimpered at the sideboard and had some elderberry wine. The dog was sick. Auntie Dosie had to have three aspirins, but Auntie Hannah, who liked port, stood in the middle of the snowbound back yard, singing like a big-bosomed thrush.

I would blow up balloons to see how big they would blow up to; and, when they burst, which they all did, the Uncles jumped and rumbled. In the rich and heavy afternoon, the Uncles breathing like dolphins and the snow descending, I would sit among festoons and Chinese lanterns and nibble dates and try to make a model man-o'-war, following the Instructions for Little Engineers, and produce what might be mistaken for a sea-going tramcar.

Or I would go out, my bright new boots squeaking, into the white world, on to the seaward hill, to call on Jim and Dan and Jack and to pad through the

still streets, leaving huge deep footprints on the hidden pavements.

"I bet people will think there's been hippos."

"What would you do if you saw a hippo coming down our street?"

"I'd go like this, bang! I'd throw him over the railings and roll him down the hill and then I'd tickle him under the ear and he'd wag his tail."

"What would you do if you saw *two* hippos?"

Iron-flanked and bellowing he-hippos clanked and battered through the scudding snow toward us as we passed Mr. Daniel's house.

"Let's post Mr. Daniel a snowball through his letter box."

"Let's write things in the snow."

"Let's write, 'Mr. Daniel looks like a spaniel' all over his lawn."

Or we walked on the white shore. "Can the fishes see it's snowing?"

The silent one-clouded heavens drifted on to the sea. Now we were snow-blind travelers lost on the north hills, and vast dewlapped dogs, with flasks round their necks, ambled and shambled up to us, baying "Excelsior." We returned home through the poor streets where only a few children fumbled with bare red fingers in the wheel-rutted snow and cat-called after us, their voices fading away, as we trudged uphill, into the cries of the dock birds and the hooting of ships out in the whirling bay. And then, at tea the recovered Uncles would be jolly; and the ice cake loomed in the center of the table like a marble grave. Auntie Hannah laced her tea with rum, because it was only once a year.

Bring out the tall tales now that we told by the fire as the gaslight bubbled like a diver. Ghosts whooed like owls in the long nights when I dared not look over my shoulder; animals lurked in the cubbyhole under the stairs where the gas meter ticked. And I remember that we went singing carols once, when

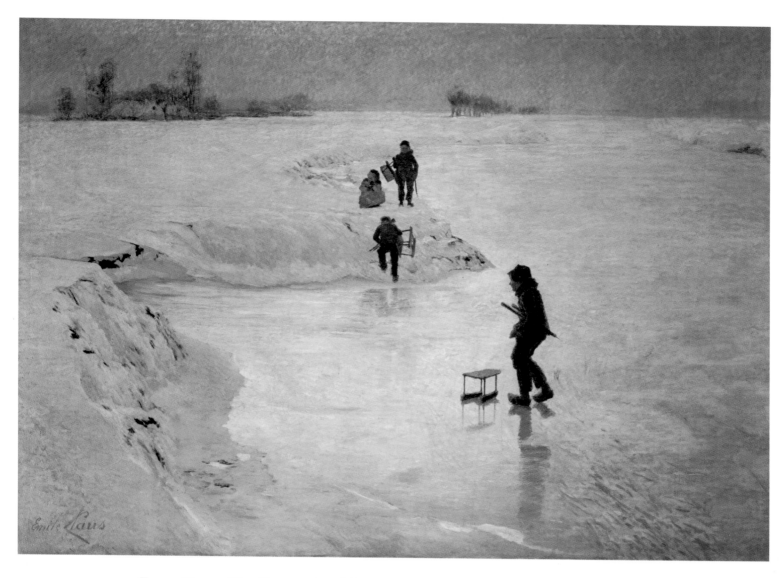

EMILE CLAUS. *The Skaters*. 1891. Museum voor Schone Kunsten, Ghent, Belgium.
Copyright Erich Lessing/Art Resource, NY.

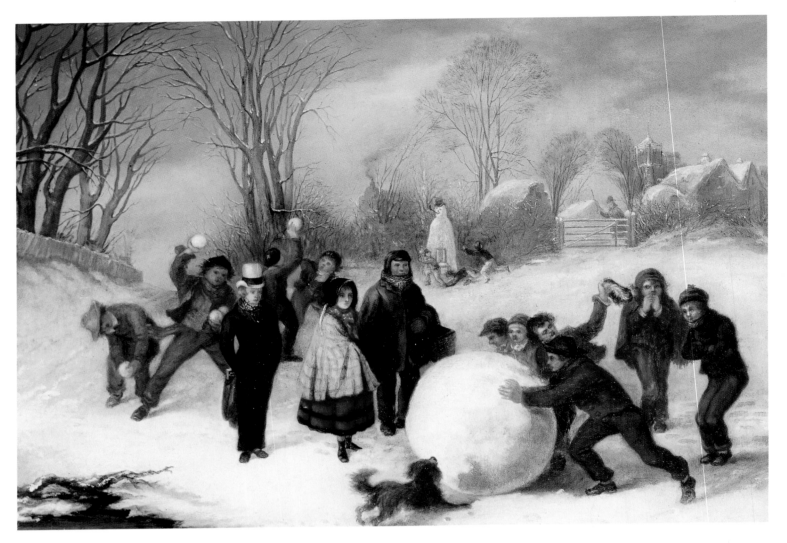

CORNELIUS KIMMEL. *Snowballing*. Gavin Graham Gallery, London, UK/Bridgeman Art Library.

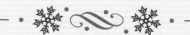

there wasn't the shaving of a moon to light the flying streets. At the end of a long road was a drive that led to a large house, and we stumbled up the darkness of the drive that night, each one of us afraid, each one holding a stone in his hand in case, and all of us too brave to say a word. The wind through the trees made noises as of old and unpleasant and maybe webfooted men wheezing in caves. We reached the black bulk of the house.

"What shall we give them? Hark the Herald?"

"No," Jack said, "Good King Wenceslas. I'll count three."

One, two, three, and we began to sing, our voices high and seemingly distant in the snow-felted darkness round the house that was occupied by nobody we knew. We stood close together, near the dark door.

Good King Wenceslas looked out
On the Feast of Stephen…

And then a small, dry voice, like the voice of someone who has not spoken for a long time, joined our singing: a small, dry, eggshell voice from the other side of the door: a small dry voice through the keyhole. And when we stopped running we were outside *our* house; the front room was lovely; balloons floated under the hot-water-bottle-gulping gas; everything was good again and shone over the town.

"Perhaps it was a ghost," Jim said.

"Perhaps it was trolls," Dan said, who was always reading.

"Let's go in and see if there's any jelly left," Jack said. And we did that.

Always on Christmas night there was music. An uncle played the fiddle, a cousin sang "Cherry Ripe," and another uncle sang "Drake's Drum." It was

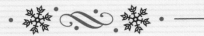

very warm in the little house. Auntie Hannah, who had got on to the parsnip wine, sang a song about Bleeding Hearts and Death, and then another in which she said her heart was like a Bird's Nest; and then everybody laughed again; and then I went to bed.

Looking through my bedroom window, out into the moonlight and the unending smoke-colored snow, I could see the lights in the windows of all the other houses on our hill and hear the music rising from them up the long, steadily falling night. I turned the gas down, I got into bed. I said some words to the close and holy darkness, and then I slept.

Christmas in Maine

ROBERT P. TRISTRAM COFFIN

*Robert P. Tristram Coffin (1892–1955) was a professor, author, and Pulitzer Prize–winning poet.
Here he fondly remembers the beautiful New England winters of his childhood,
and the magic that his father brought to Christmas.*

f you want to have a Christmas like the one we had on Paradise Farm when I was a boy, you will have to hunt up a salt-water farm on the Maine coast, with bays on both sides of it, and a road that goes around all sorts of bays, up over Misery Hill and down, and through the fir trees so close together that they brush you and your horse on both cheeks. That is the only kind of place a Christmas like that grows. You must have a clear December night, with blue Maine stars snapping like sapphires with the cold, and the big moon flooding full over Misery, and lighting up the snowy spruce boughs like crushed diamonds. You ought to be wrapped in a buffalo robe to your nose, and be sitting in a family pung, and have your breath trailing along with you as you slide over the dry, whistling snow. You will have to sing the songs we sang, "God Rest You Merry, Gentlemen" and "Joy to the World," and you will be able to see your songs around you in the air like blue smoke. That's the only way to come to a Paradise Christmas.

And you really should cross over at least one broad bay on the ice, and feel the tide rifts bounce you as the runners slide over them. And if the whole bay booms out, every now and then, and the sound echoes around the wooded islands for miles, you will be having the sort of ride we loved to take from town, the night before Christmas.

I won't insist on your having a father like ours to drive you home to your Christmas. One with a wide moustache full of icicles, and eyes like the stars of the morning. That would be impossible, anyway, for there has been only one of him in the world. But it is too bad, just the same. For you won't have the stories we had by the fireplace. You won't hear about Kitty Wells who died beautifully in song just as the sun came over the tops of the eastern mountains and just after her lover had named the wedding day, and you will not hear how Kitty's departure put an end to his mastering the banjo:

> "But death came in my cabin door
>
> "And took from me my joy, my pride,
>
> "And when they said she was no more,
>
> "I laid my banjo down and cried."

But you will be able to have the rooms of the farmhouse banked with emerald jewels clustered on bayberry boughs, clumps of everlasting roses with gold spots in the middle of them, tree evergreens, and the evergreen that runs all over the Maine woods and every so often puts up a bunch of palm leaves. And there will be rose-hips stuck in pine boughs. And caraway seeds in every crust and cookie in the place.

An aunt should be on hand, an aunt who believes in yarrow tea and the Bible as the two things needed to keep children well. She will read the Nativity story aloud to the family, hurrying over the really exciting parts that happened at the stable, and bearing down hard on what the angels had to say and the more edifying points that might be supposed to improve small boys who like to lie too long abed in the mornings. She will put a moral even into Christmas greens, and she will serve well as a counter-irritant to the overeat-

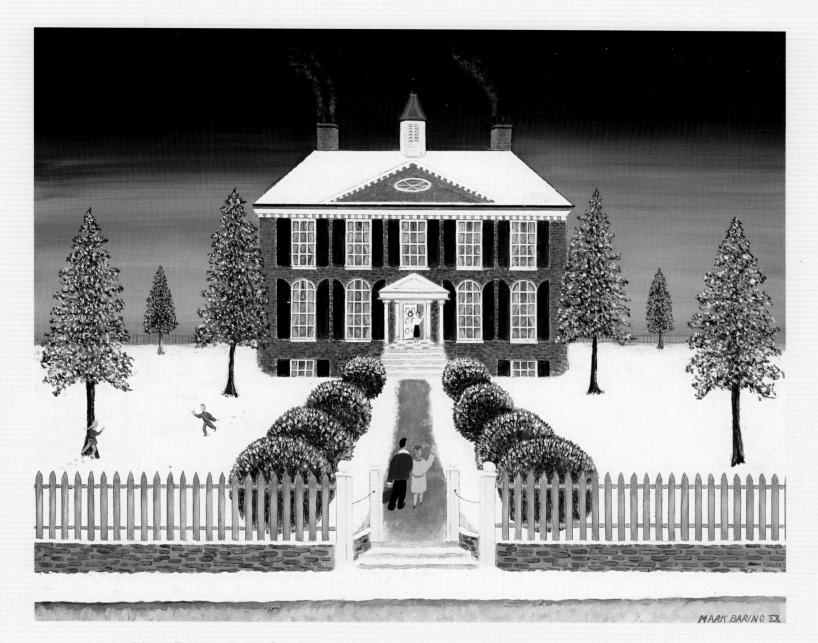

MARK BARING. *Home for Christmas*. RONA Gallery, London, UK/Bridgeman Art Library.

ing of mince pies. She will insist on all boys washing behind their ears, and that will keep her days full to the brim.

The Christmas tree will be there, and it will have a top so high that it will have to be bent over and run along the ceiling of the sitting room. It will be the best fir tree of the Paradise forests, picked from ten thousand almost perfect ones, and every bough on it will be like old-fashioned fans wide open. You will have brought it home that very morning, on the sled, from Dragonfly Spring.

Dragonfly Spring was frozen solid to the bottom, and you could look down into it and see the rainbows where you dented it with your copper-toed boots, see whole ferns caught motionless in the crystal deeps, and a frog, too, down there, with hands just like a baby's on him. Your small sister—the one with hair like new honey laid open in the middle of a honeycomb—had cried out, "Let's dig him up and take him home and warm his feet!" (She is the same sister who ate up all your more vivid pastel crayons when you were away at school, and then ate up all the things you had been pretty sure were toadstools in Bluejay Woods, when you were supposed to be keeping an eye on her, but were buried so deep in "Mosses from an Old Manse" that you couldn't have been dug up with horses and oxen.)

Your dog, Snoozer, who is a curious and intricate combination of many merry pugs and many mournful hound-dogs, was snuffling all the time, hot on the feather-stitching the mice had made from bush to bush while you were felling the Christmas tree. A red squirrel was taking a white-pine cone apart on a hemlock bough, and telling Snoozer what he thought of him and all other dogs, the hour or so you were there.

There will be a lot of aunts in the house besides the Biblical one. Aunts of every complexion and cut. Christmas is the one time that even the most

dubious of aunts take on value. One of them can make up wreaths, another can make rock candy that puts a tremble on the heart, and still another can steer your twelve-seater bob-sled—and turn it over, bottom up, with you all in just the right place for a fine spill.

There will be uncles, too, to hold one end of the molasses taffy you will pull sooner or later, yanking it out till it flashes and turns into cornsilk that almost floats in the air, tossing your end of it back and probably lassoing your uncle around his neck as you do it, and pulling out a new rope of solid honey.

The uncles will smoke, too, and that will be a help to all the younger brothers who have been smoking their acorn-pipes out in the woodshed, and who don't want their breaths to give them away. The uncles will make themselves useful in other ways. They will rig up schooners no bigger than your thumb, with shrouds like cobwebs; they will mend the bob-sled, tie up cut fingers, and sew on buttons after you shin up to the cupola in the barn; and—if you get on the good side of them—they will saw you up so much birch wood that you won't have to lay hand to a bucksaw till after New Year's.

There will be cousins by the cart load. He-ones and she-ones. The size you can sit on, and the size that can sit on you. Enough for two armies, on Little Round Top and on Big, up in the haymow. You will play Gettysburg there till your heads are full of hay chaff that will keep six aunts busy cleaning it out. And then you will come in to the house and down a whole crock of molasses cookies—the kind that go up in peaks in the middle—which somebody was foolish enough to leave the cover off.

Every holiday that came along, in my father's house, was the gathering of an Anglo-Saxon clan. My father was built for lots of people 'round him. But Christmas was a whole assembly of the West Saxons! My father wanted

people in squads. There were men with wide moustaches and men with smooth places on top of their heads, women wide and narrow. Cousins of the second and third water, even, were there. Hired men, too. They were special guests and had to be handled with kid gloves, as New England hired men must. They had to have the best of everything, and you could not find fault with them, as you could with uncles, if they smacked you for upsetting their coffee into their laps. Babies were underfoot in full cry. The older children hunted in packs. The table had to be pieced out with flour barrels and bread boards and ironing boards. It was a house's length from the head of the table, where your father sat and manufactured the roast up into slivers, to your mother dishing out the pork gravy. Whole geese disappeared on the way down. The Christmas cake, which had been left sweetly to itself for a month to age into a miracle, was a narrow isthmus when it got to Mother. But Mother always said that Christmas, to her, was watching other people eat. She was the kind of mother who claimed that the neck and the back of the chicken were the tastiest parts.

The prize goose, whom you had brought up by hand and called Oliver Cromwell, Old Ironsides, or some such distinguished title, was duly carved. And Father found his wishbone snow-white and you all applauded, for that meant lots of snow and two more months of coasting on your sleds. There were mince pies by the legion. And if Uncle Tom were there, a whole raccoon baked just for him and girt around with browned sweet potatoes. Mother's wild strawberry jam was there on deck, winking at you like rubies from the holes in tarts that melted away like bubbles in the mouth. That dinner was three hours in Beulah Land!

Of course, there will be an apple pudding at such a season. Steamed in a lard bucket, and cut open with a string. A sauce of oranges and lemons to make

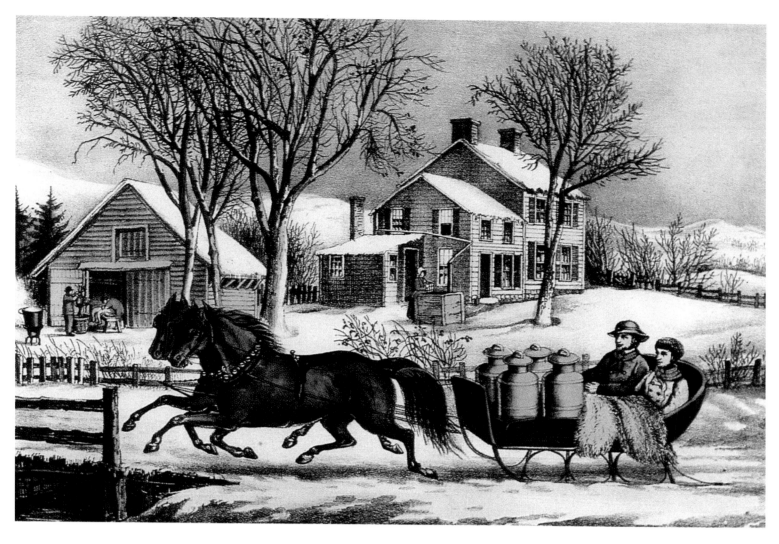

CURRIER & IVES STAFF. *Winter Morning in the Country*. Published 1873 Currier & Ives.
Hand colored lithograph on paper. Image provided by the Currier & Ives Foundation.

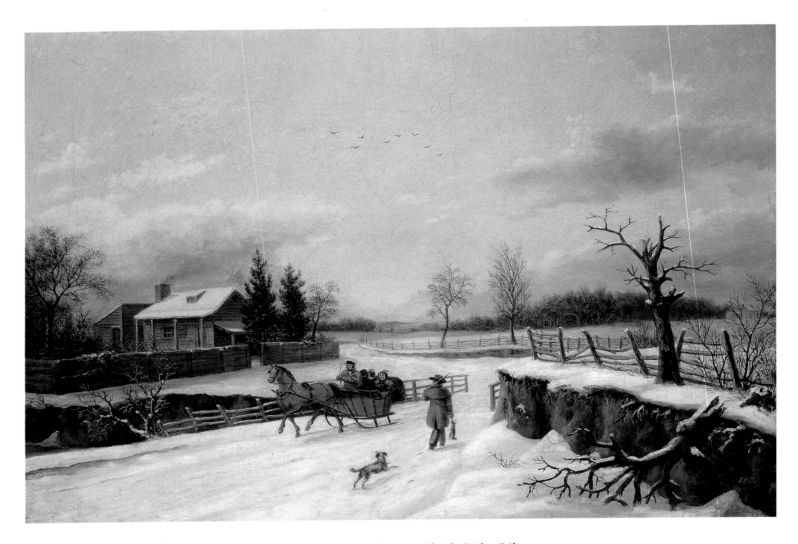

THOMAS BIRCH. *Country Sleigh Ride*. Oil on canvas.
© Shelburne Museum, Shelburne, Vermont.

an ocean around each steaming volcano of suet and russet apples as it falls crumbling from the loop of twine. It will have to be steamed in the boiler, if your Christmas is to be the size of ours, and cooked in a ten-pound lard pail. Better use a cod line instead of the twine of other holidays, to parcel it out to the members of the clan.

The whole nation of you in the house will go from one thing to another. The secret of the best Christmases is everybody doing the same things all at the same time. You will all fall to and string cranberries and popcorn for the tree, and the bright lines each of you has a hold on will radiate from the tree like ribbons on a maypole. Everybody will have needles and thread in the mouth, you will all get in each other's way, but that is the art of doing Christmas right. You will all bundle up together for the ride in the afternoon. You had better take the horse-sled, as the pung will not begin to hold you. And even then a dozen or so of assorted uncles and aunts and cousins will have to come trooping after through the deep snow, and wait for their turn on the straw in the sled. Smaller cousins will fall off over the sides in great knots and never be missed, and the hullabaloo will roar on and send the rabbits flying away through the woods, showing their bobbing scuts.

'Twas the Night b4 Christmas

Mary Marcdante

*In this touching remembrance, contemporary American author Mary Marcdante
expresses gratitude for her father's special Christmas legacy.*

wo Decembers ago my dad called wanting to know what I
wanted for Christmas. I mentioned a particular book and
then interrupted myself and said, "No, what I'd really like is
for you to put *The Night Before Christmas* on audiotape."

There was this long pause and then Dad said with familiar stern
emphasis in his voice, "Oh for God's sake, Mary. What in Sam Hill do you
want that for? You're forty years old!"

I paused, feeling embarrassed yet determined, "Dad, I remember how
good it felt when you used to cuddle us all up next to you on the couch
when we were little and read *The Night Before Christmas*. I can still remem-
ber how strong your voice was, how safe I felt and how well you acted out
all the different sounds. I'd really appreciate you doing this, since I live
2,500 miles away and I'm not coming home for Christmas. It would be
nice to have you with me.

Dad said, with a little more softness but still incredulously, "You mean
you want me to read just like I did when you were kids, with all the bells
and whistles and everything?!"

"Yaaaaah, just like that," I said.

Again, he paused a long time and then said, "I'll get you the book."

I heard the clarity of his decision in his voice and resignedly said, "Okay. Talk to you on Christmas." We said our "I love yous" and hung up. I felt bad but tried to understand. I assumed it was too much sentimentalism for a seventy-six-year-old to bear, and that in his mind it was a foolish request for an adult to ask. Maybe. Maybe not. All I knew was that each time I talked to Dad his voice sounded more tired, and I was beginning to accept that it was no longer if, but when, the day would come that I wouldn't hear it anymore.

On Christmas Eve day, a small, brown, heavily recycled padded envelope with lots of staples and tape all over it arrived. My name and address were written out in my dad's memorable architect's lettering with thick black magic marker. Inside was a tape, with a handwritten label, "'Twas the Night b4 Christmas."

I popped the tape in my recorder and heard my father's words come roaring out. "'Twas the niiiiiiiiiiiiight before Christmas when allllllllllllllllllll-llllllll through the howwwwwwwse," just like when we were children! When he finished, he went on to say, "And now I'm going to read from *The Little Engine That Could*." I guess Dad had another message in mind when he included one of our favorite childhood bedtime stories. It was the same story we read to my mom when she was dying of cancer three years ago.

He continued with the Mormon Tabernacle Choir singing "Silent Night," our family's favorite Christmas Eve song we sang together before bedtime. And then "Oh Come All Ye Faithful" . . . song after song until the tape ran out. I went to sleep safe and sound Christmas Eve, thanking God for giving me another Christmas miracle with my dad.

Christmas in Plains

JIMMY CARTER

The 39th president of the United States, Jimmy Carter (b. 1924), grew up in Plains, Georgia, where his father worked as a peanut farmer. Here he nostalgically remembers the simple joys of the small-town family Christmases of his youth.

hroughout the year, Daddy and I were on the lookout in our woods for a relatively rare wild red cedar that would make a good Christmas tree, one that was perfect in size and shape. It was something of a ceremony when we went out a few days before Christmas to bring it home. My father was meticulous about its quality, and if there were unsightly gaps anywhere in the foliage we would drill a small hole into the tree trunk and insert an extra limb or two. During our hunt for a tree, there was time to cut enough broom sedge that grew wild in the fields to make Christmas gifts for our kinfolks in town and to use for sweeping around our own fireplaces. Daddy taught me how to use a dull knife to strip away the slender leaves, beat a bundle of the remaining stalks to get rid of all the fluffy seedpods, and then bind them tightly together to make straw brooms.

Decorating our house for Christmas added to the excitement of the season. We children would paint different-colored magnolia leaves at school, and these were mixed with the green leaves and red berries of holly to decorate our mantelpiece, table tops, and around the base of the tree. There was an enormous American holly tree in the middle of one of our fields, and since we and interlopers had long ago removed the lower leaves and berries, I would climb

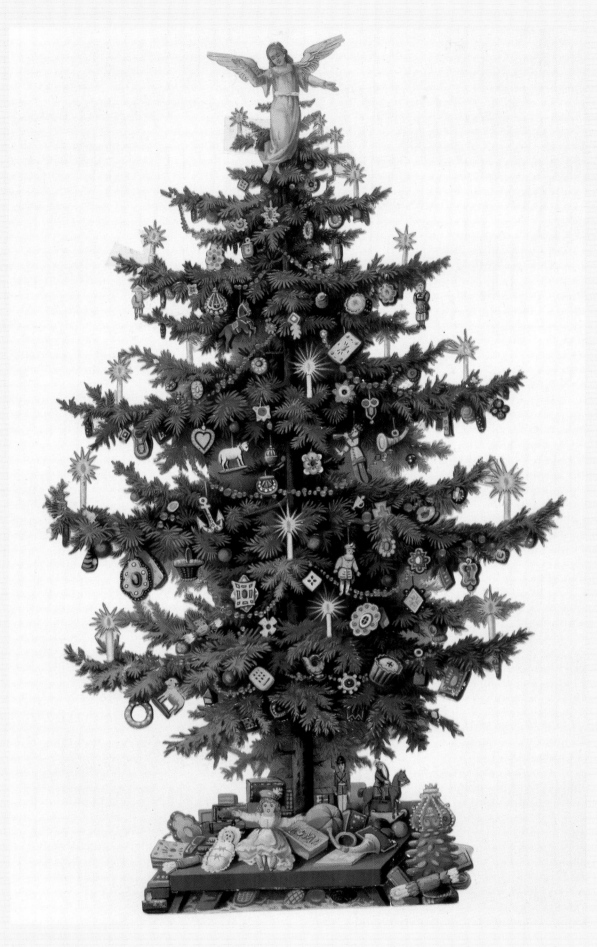

Decorated Christmas Tree. Victorian Christmas card. Private collection/Bridgeman Art Library.

high enough with a hatchet or machete to send what we needed down to my waiting sisters and parents. My favorite way to get mistletoe, usually at the top of oak or pecan trees and on the ends of slender limbs, was to shoot into the clump and let the bullets or buckshot cut off some sprigs.

We made Christmas-tree decorations in our classrooms at school, and proudly presented them to our parents. The most common were long chains of circled and glued paper strips of different colors to be draped over the tree limbs, and these were supplemented with ropes of popcorn or cranberries strung on long slender threads. We contrived all kinds of dangling ornaments, either flat or three-dimensional, and affixed them to the limbs with small strings or hay wire. There was tinfoil in each package of cigarettes (my father smoked several packs a day), which we painstakingly cut into very narrow strips to use as tinsel, or "icicles."

All of us were proud to learn how to make a perfect five-pointed star with one scissor snip if the heavy paper was folded correctly, and then we covered it with tinfoil. Either this or an angel was mounted on top of our tree as the crowning ornament. Much later, when Rosalynn and I had a family of our own, someone gave us a really fancy store-bought star, and our children insisted on suspending it from the ceiling to be raised or lowered each Christmas to match the exact height of succeeding trees. (We still leave the ornament hanging there all year, as a great reminder of past and future holidays.)

Even without electricity, the decorations could be beautiful. I believe the most admired tree we ever saw in Plains was a small holly cut by the family of one of my friends, perfectly shaped, covered with red berries, and strung just with threaded popcorn.

The Christmas Tree in Brooklyn

BETTY SMITH

In this amusing excerpt from Betty Smith's well-loved novel, A Tree Grows in Brooklyn, *a valiant young girl and her little brother bring unexpected delight to a neighborhood in need of Christmas cheer, transforming even the most cynical characters.*

hristmas was a charmed time in Brooklyn. It was in the air, long before it came. The first hint of it was Mr. Morton going around the schools teaching Christmas carols, but the first sure sign was the store windows.

You have to be a child to know how wonderful is a store window filled with dolls and sleds and other toys. And this wonder came free to Francie. It was nearly as good as actually having the toys to be permitted to look at them through the glass window.

Oh, what a thrill there was for Francie when she turned a street corner and saw another store all fixed up for Christmas! Ah, the clean shining window with cotton batting sprinkled with star dust for a carpet! There were flaxen-haired dolls and others which Francie liked better who had hair the color of good coffee with lots of cream in it. Their faces were perfectly tinted and they wore clothes the like of which Francie had never seen on earth. The dolls stood upright in flimsy cardboard boxes. They stood with the help of a bit of tape passed around the neck and ankles and through holes at the back of the box. Oh, the deep blue eyes framed by thick lashes that stared straight into a little

girl's heart and the perfect miniature hands extended, appealingly asking, "Please, won't *you* be my mama?" And Francie had never had a doll except a two-inch one that cost a nickel.

And the sleds! (Or, as the Williamsburg children called them, the sleighs.) There was a child's dream of heaven come true! A new sled with a flower someone had dreamed up painted on it—a deep blue flower with bright green leaves—the ebony-black painted runners, the smooth steering bar made of hard wood and gleaming varnish over all! And the names painted on them! "Rosebud!" "Magnolia!" "Snow King!" "The Flyer!" Thought Francie, "If I could only have one of those, I'd never ask God for another thing as long as I live."

There were roller skates made of shining nickel with straps of good brown leather and silvered nervous wheels, tensed for rolling, needing but a breath to start them turning, as they lay crossed one over the other, sprinkled with mica snow on a bed of cloudlike cotton.

There were other marvelous things. Francie couldn't take them all in. Her head spun and she was dizzy with the impact of all the seeing and all the making up of stories about the toys in the shop windows.

The spruce trees began coming into Francie Nolan's neighborhood the week before Christmas. Their branches were corded to make shipping easier. Vendors rented space on the curb before a store and stretched a rope from pole to pole and leaned the trees against it. All day they walked up and down this one-sided avenue of aromatic leaning trees, blowing on stiff ungloved fingers. And the air was cold and still, and full of the pine smell and the smell of tangerines which appeared in the stores only at Christmastime and the mean street was truly wonderful for a little while.

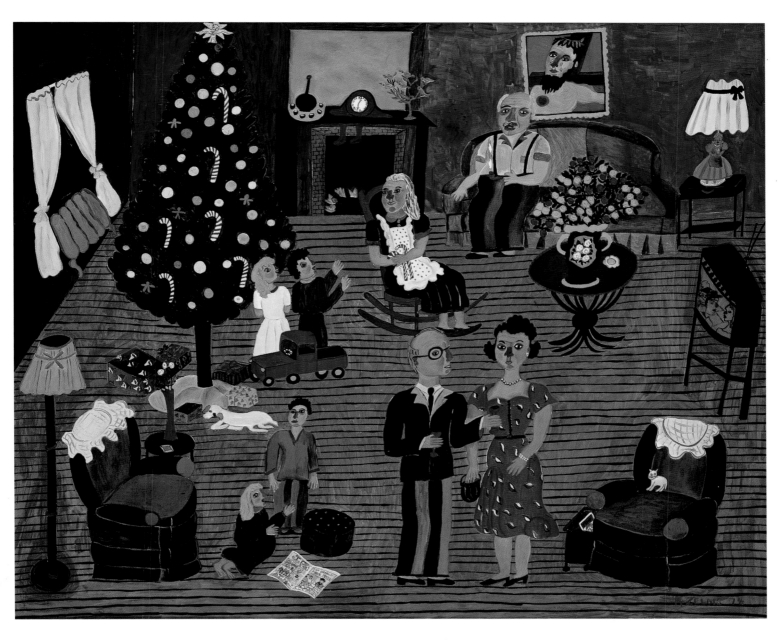

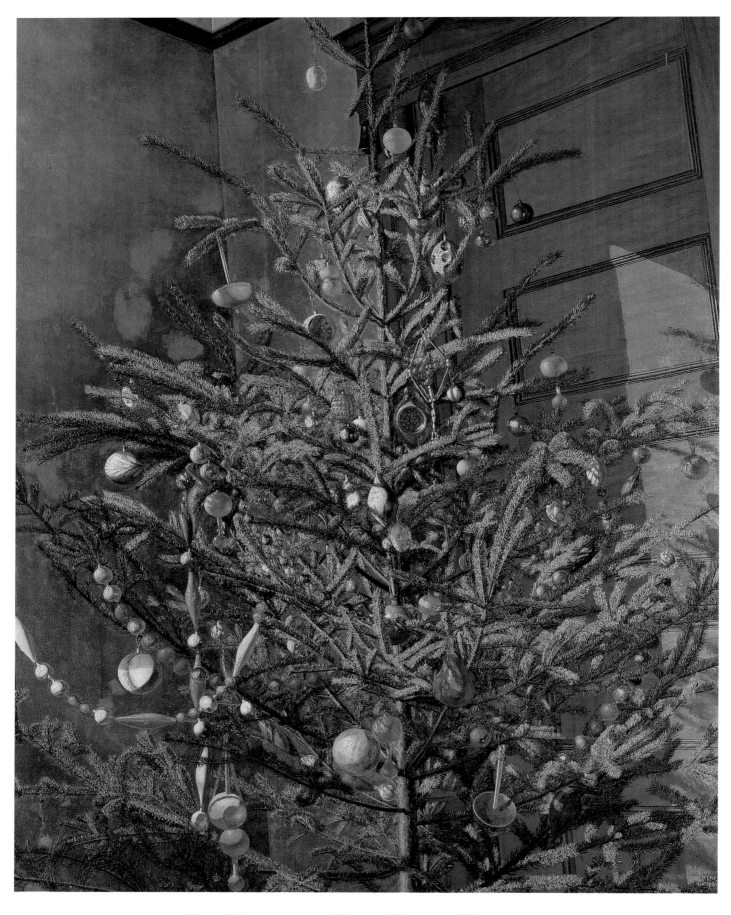

HANS WEINGAERTNER. *Christmas Tree*. 1941. Oil on canvas.
Collection of The Newark Museum, Newark, NJ: 41.819. Copyright The Newark Museum/Art Resource, NY.

There was a cruel custom in the neighborhood. At midnight on the Eve of our dear Saviour's birth, the kids gathered where there were unsold trees. There was a saying that if you waited until then, you wouldn't have to buy a tree, that "they'd chuck 'em at you." This was literally true. The man threw each tree in turn, starting with the biggest. Kids volunteered to stand up against the throwing. If a boy didn't fall down under the impact, the tree was his. If he fell, he forfeited his chance at winning a tree. Only the roughest boys and some of the young men elected to be hit by the big trees. The others waited shrewdly until a tree came up that they could stand against. The littlest kids waited for the tiny, foot-high trees and shrieked in delight when they won.

On the Christmas Eve when Francie was ten and her brother Neeley, nine, Mama consented to let them go down and have their first try for a tree. Francie had picked out her tree earlier in the day. She had stood near it all afternoon and evening praying that no one would buy it. To her joy, it was still there at midnight. It was ten feet tall and its price was so high that no one could afford to buy it. Its branches were bound with new white rope and it came to a sure pure point at the top.

The man took this tree out first. Before Francie could speak up, a neighborhood bully, a boy of eighteen known as Punky Perkins, stepped forward and ordered the man to chuck the tree at him. The man hated the way Punky was so confident. He looked around and asked, "Anybody else wanna take a chance on it?"

Francie stepped forward. "Me, Mister."

A spurt of derisive laughter came from the tree man. The kids snickered. A few adults who had gathered to watch the fun guffawed. "Aw g'wan. You're too little," the tree man objected.

"Me and my brother—we're not too little together."

She pulled Neeley forward. The man looked at them—a thin girl of ten with starving hollows in her cheeks but with the chin still baby-round. He looked at the little boy with his fair hair and round eyes—Neeley Nolan, just nine years old, all innocence and trust.

"Two ain't fair," yelped Punky.

"Shut your lousy trap," advised the man, who held all power in that hour. "These here kids is got nerve. Stand back, the rest of youse. These kids is goin' to have a show at this tree."

The others made a wavering lane, a human funnel with Francie and her brother making the small end of it. The big man at the other end flexed his great arms to throw the great tree. He noticed how tiny the children looked at the end of the short lane. For the split part of a moment, the tree thrower went through a kind of Gethsemane.

Oh, Jesus Christ, his soul agonized, why don't I just give 'em the tree and say Merry Christmas? I can't sell it no more this year and it won't keep till next year. The kids watched him solemnly as he stood there in his moment of thought. But then, he rationalized, if I did that, all the others would expect to get 'em handed to 'em. And next year, nobody a-tall would buy a tree off of me. I ain't a big enough man to give this tree away for nothin'. No, I gotta think of myself and my own kids. He finally came to his conclusion. Oh, what the hell! Them two kids is gotta live in this world. They *got* to learn to give and to take punishment. As he threw the tree with all his strength, his heart wailed out, It's a rotten, lousy world!

Francie saw the tree leave his hands. The whole world stood still as something dark and monstrous came through the air. There was nothing but pun-

gent darkness and something that grew and grew as it rushed at her. She staggered as the tree hit them. Neeley went to his knees but she pulled him up fiercely before he could go down. There was a mighty swishing sound as the tree settled. Everything was dark, green and prickly. Then she felt a sharp pain at the side of her head where the trunk of the tree had hit her. She felt Neeley trembling.

When some of the older boys pulled the tree away, they found Francie and her brother standing upright, hand in hand. Blood was coming from scratches on Neeley's face. He looked more like a baby than ever with his bewildered blue eyes and the fairness of his skin made more noticeable because of the clear red blood. But they were smiling. Had they not won the biggest tree in the neighborhood? Some of the boys hollered, "Hooray!" A few adults clapped. The tree man eulogized them by screaming, "And now get the hell out of here with your tree."

Such phrases could mean many things according to the tone used in saying them. So Francie smiled tremulously at the kind man. She knew that he was really saying, "Good-bye—God bless you."

It wasn't easy dragging that tree home. They were handicapped by a boy who ran alongside yelping, "Free ride! All aboard!" who'd jump on and make them drag him along. But he got sick of the game eventually and went away.

In a way, it was good that it took them so long to get the tree home. It made their triumph more drawn out. Francie glowed when a lady said, "I never saw such a big tree!" The cop of their corner stopped them, examined the tree, and solemnly offered to buy it for fifteen cents if they'd deliver it to his home. Francie nearly burst with pride although she knew he was joking.

They had to call to Papa to help them get the tree up the narrow stairs.

Papa came running down. His amazement at the size of the tree was flattering. He pretended to believe that it wasn't theirs. Francie had a lot of fun convincing him although she knew all the while that the whole thing was make-believe. Papa pulled in front and Francie and Neeley pushed in back and they began forcing the big tree up the two narrow flights of stairs. Papa started singing, not caring that it was rather late at night. He sang "Holy Night." The narrow walls took up his clear sweet voice, held it for a breath and gave it back with doubled sweetness. Doors creaked open and families gathered on the landings, pleased and amazed at something unexpected being added to that moment of their lives.

Francie saw the Tynmore sisters, who gave piano lessons, standing together in their doorway, their gray hair in crimpers, and ruffled, starched nightgowns showing under the voluminous wrappers. They added their thin poignant voices to Papa's. Floss Gaddis, her mother and her brother, Henny, who was dying of consumption, stood in their doorway. Henny was crying and when Papa saw him he let the song trail off; he thought maybe it made Henny too sad.

Flossie was in a Klondike-dance-hall-girl costume waiting for an escort to take her to a masquerade ball which started soon after midnight. More to make Henny smile than anything else, Papa said, "Floss, we got no angel for the top of this Christmas tree. How about you obliging?

Floss was all ready to make a smart-alecky reply, but there was something about the big proud tree, the beaming children and the rare goodwill of the neighbors that changed her mind. All she said was, "Gee, ain't you the kidder, Mr. Nolan."

They set the tree up in the front room after Mama had spread a sheet to protect the carpet from falling pine needles. The tree stood in a big tin bucket

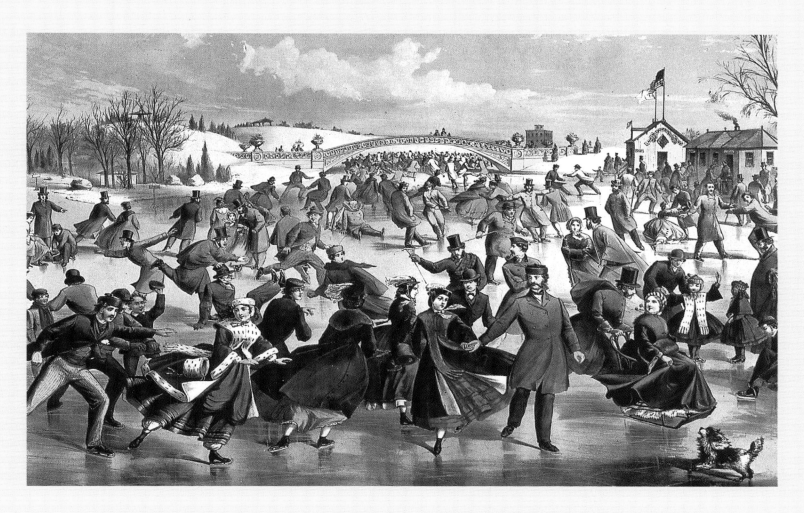

LYMAN W. ATWATER, after a painting by CHARLES R. PARSONS. *Central Park, Winter. The Skating Pond*.
Published 1862 Currier & Ives. Hand colored lithograph on paper.
Image provided by the Currier & Ives Foundation.

with broken bricks to hold it upright. When the rope was cut away, the branches spread out to fill the room. They draped over the piano and some of the chairs stood among the branches. There was no money to buy decorations or lights. But the great tree standing there was enough. The room was cold. It was a poor year, that one—too poor for them to buy extra coal for the front-room stove. The room smelled cold and clean and aromatic.

Every day, during the week the tree stood there, Francie put on her sweater and stocking cap and went in and sat under the tree. She sat there and enjoyed the smell and the dark greenness of it.

Oh, the mystery of a great tree, a prisoner in a tin wash bucket in a tenement front room!

Christmas at Sea

ROBERT LOUIS STEVENSON

Best known for his novels Treasure Island, Kidnapped, *and* The Strange Case of Dr. Jekyll and Mr. Hyde, *Scottish author Robert Louis Stevenson (1850–1894) here poignantly expresses the heartache of being away from home and family at Christmas.*

he sheets were frozen hard, and they cut the naked hand;
The decks were like a slide, where a seaman scarce could stand
The wind was a nor'-wester, blowing squally off the sea;
And the cliffs and spouting breakers were the only things a-lee.

They heard the surf a-roaring before the break of day;
But 'twas only with the peep of light we saw how ill we lay.
We tumbled every hand on deck instanter, with a shout,
And we gave her the maintops'l, and stood by to go about.

All day we tack'd and tack'd between the South Head and the North;
All day we haul'd the frozen sheets, and got no further forth;
All day as cold as charity, in bitter pain and dread,
For very life and nature we tack'd from head to head.

CHRISTMAS AT SEA

We gave the South a wider berth, for there the tide-race roar'd;

But every tack we made we brought the North Head close aboard;

So's we saw the cliffs and houses and the breakers running high,

And the coastguard in his garden, with his glass against his eye.

The frost was on the village roofs as white as ocean foam;

The good red fires were burning bright in every longshore home;

The windows sparkled clear, and the chimneys volley'd out;

And I vow we sniff'd the victuals as the vessel went about.

The bells upon the church were rung with a mighty jovial cheer

For it's just that I should tell you how (of all days in the year)

This day of our adversity was blessèd Christmas morn,

And the house above the coastguard's was the house where I was born.

O well I saw the pleasant room, the pleasant faces there,

My mother's silver spectacles, my father's silver hair;

And well I saw the firelight, like a flight of homely elves,

Go dancing round the china plates that stand upon the shelves.

And well I knew the talk they had, the talk that was of me,

Of the shadow on the household and the son that went to sea;

And O the wicked fool I seem'd, in every kind of way,

To be here and hauling frozen ropes on blessèd Christmas Day.

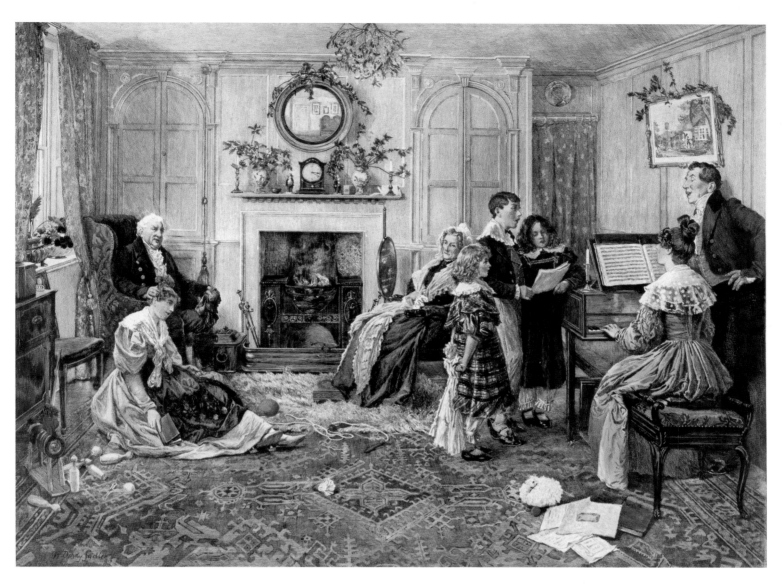

WALTER DENDY SADLER. *Christmas Carols*. c. 1900. Etching.
Copyright Historical Picture Archives/CORBIS.

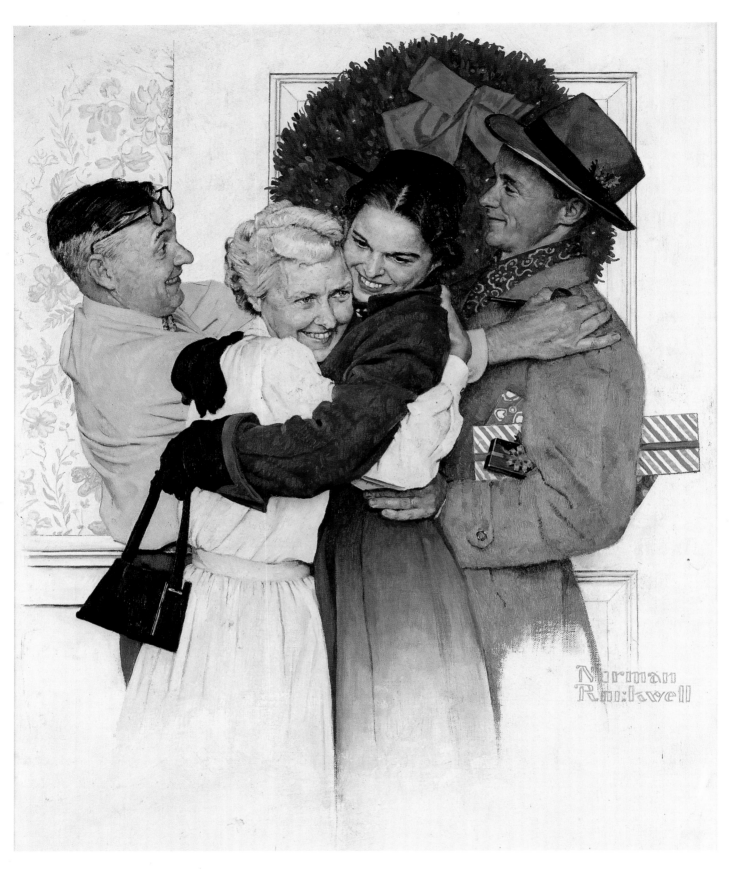

NORMAN ROCKWELL. *Home for Christmas*. 1955. Sheaffer: pen & pencil advertisement. Oil on canvas.
Printed by permission of the Norman Rockwell Family Agency.
Copyright © 2003 the Norman Rockwell Family Entities.
Photograph courtesy of the Collection of The Norman Rockwell Museum at Stockbridge.

They lit the high sea–light, and the dark began to fall.

"All hands to loose topgallant sails," I heard the captain call.

"By the Lord, she'll never stand it," our first mate Jackson cried.

. . . "It's the one way or the other, Mr. Jackson," he replied.

She stagger'd to her bearings, but the sails were new and good,

And the ship smelt up to windward just as though she understood.

As the winter's day was ending, in the entry of the night,

We clear'd the weary headland, and pass'd below the light.

And they heaved a mighty breath, every soul on board but me,

As they saw her nose again pointing handsome out to sea;

But all that I could think of, in the darkness and the cold,

Was just that I was leaving home and my folks were growing old.

IV

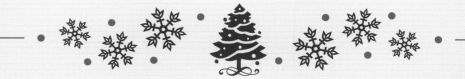

THE SPIRIT OF
CHRISTMAS

FROM
A Christmas Carol

CHARLES DICKENS

Charles Dickens (1812–1870), the great English novelist of the Victorian era, created fiction that encouraged compassion and benevolence. This beloved Christmas tale exemplifies how the spirit of Christmas can bring out the good in everyone, and how one kind gesture generates others.

unning to the window, he opened it, and put out his head. No fog, no mist; clear, bright, jovial, stirring, cold; cold, piping for the blood to dance to; Golden sunlight; Heavenly sky; sweet fresh air; merry bells. Oh, glorious! Glorious!

"What's to-day?" cried Scrooge, calling downward to a boy in Sunday clothes, who perhaps had loitered in to look about him.

"EH?" returned the boy, with all his might of wonder.

"What's to-day, my fine fellow?" said Scrooge.

"To-day!" replied the boy. "Why, CHRISTMAS DAY."

"It's Christmas Day!" said Scrooge to himself. "I haven't missed it. The Spirits have done it all in one night. They can do anything they like. Of course they can. Of course they can. Hallo, my fine fellow!"

"Hallow!" returned the boy.

"Do you know the Poulterer's, in the next street but one at the corner?" Scrooge inquired.

"I should hope I did," replied the lad.

"An intelligent boy!" said Scrooge. "A remarkable boy! Do you know whether

they've sold the prize Turkey that was hanging up there?—Not the little prize Turkey: the big one?"

"What, the one as big as me?" returned the boy.

"What a delightful boy!" said Scrooge. "It's a pleasure to talk to him. Yes, my buck!"

"It's hanging there now," replied the boy.

"Is it?" said Scrooge. "Go and buy it."

"Walk-ER!" exclaimed the boy.

"No, no," said Scrooge, "I am in earnest. Go and buy it, and tell 'em to bring it here, that I may give them the direction where to take it. Come back with the man, and I'll give you a shilling. Come back with him in less than five minutes and I'll give you half-a-crown!"

The boy was off like a shot. He must have had a steady hand at a trigger who could have got a shot off half so fast.

"I'll send it to Bob Cratchit's!" whispered Scrooge, rubbing his hands, and splitting with a laugh. "He sha'n't know who sends it. It's twice the size of Tiny Tim. Joe Miller never made such a joke as sending it to Bob's will be!"

The hand in which he wrote the address was not a steady one, but write it he did, somehow, and went down-stairs to open the street door, ready for the coming of the poulterer's man. As he stood there, waiting his arrival, the knocker caught his eye.

"I shall love it, as long as I live!" cried Scrooge, patting it with his hand. "I scarcely ever looked at it before. What an honest expression it has in its face! It's a wonderful knocker!—Here's the Turkey. Hallo! Whoop! How are you! Merry Christmas!"

It *was* a Turkey! He never could have stood upon his legs, that bird. He

would have snapped 'em short off in a minute, like sticks of sealing-wax.

"Why, it's impossible to carry that to Camden Town," said Scrooge. "You must have a cab."

The chuckle with which he said this, and the chuckle with which he paid for the Turkey, and the chuckle with which he paid for the cab, and the chuckle with which he recompensed the boy, were only to be exceeded by the chuckle with which he sat down breathless in his chair again, and chuckled till he cried.

Shaving was not an easy task, for his hand continued to shake very much; and shaving requires attention, even when you don't dance while you are at it. But if he had cut the end of his nose off, he would have put a piece of sticking-plaister over it, and been quite satisfied.

He dressed himself "all in his best," and at last got out into the streets. The people were by this time pouring forth, as he had seen them with the Ghost of Christmas Present; and walking with his hands behind him, Scrooge regarded every one with a delighted smile. He looked so irresistibly pleasant, in a word, that three or four good-humoured fellows said, "Good morning, Sir! A merry Christmas to you!" And Scrooge said often afterwards, that of all the blithe sounds he had ever heard, those were the blithest in his ears.

He had not gone far, when coming on towards him he beheld the portly gentleman, who had walked into his counting-house the day before, and said, "Scrooge and Marley's, I believe?" It sent a pang across his heart to think how this old gentleman would look upon him when they met; but he knew what path lay straight before him, and he took it.

"My dear sir," said Scrooge, quickening his pace, and taking the old gentleman by both his hands. "How do you do? I hope you succeeded yesterday. It was very kind of you. A merry Christmas to you, sir!"

"Mr. Scrooge?"

"Yes," said Scrooge. "That is my name, and I fear it may not be pleasant to you. Allow me to ask your pardon. And will you have the goodness"—here Scrooge whispered in his ear.

"Lord bless me!" cried the gentleman, as if his breath were taken away. "My dear Mr. Scrooge, are you serious?"

"If you please," said Scrooge. "Not a farthing less. A great many back-payments are included in it, I assure you. Will you do me that favour?"

"My dear sir," said the other, shaking hands with him. "I don't know what to say to such munifi—"

"Don't say anything, please," retorted Scrooge. "Come and see me. Will you come and see me?"

"I will!" cried the old gentleman. And it was clear he meant to do it.

"Thank'ee," said Scrooge. "I am much obliged to you. I thank you fifty times. Bless you!"

He went to church, and walked about the streets, and watched the people hurrying to and fro, and patted children on the head, and questioned beggars, and looked down into the kitchens of houses, and up to the windows, and found that everything could yield him pleasure. He had never dreamed that any walk—that anything—could give him so much happiness. In the afternoon he turned his steps towards his nephew's house.

He passed the door a dozen times, before he had the courage to go up and knock. But he made a dash, and did it:

"Is your master at home, my dear?" said Scrooge to the girl. Nice girl! Very.

"Yes, sir."

"Where is he, my love?" said Scrooge.

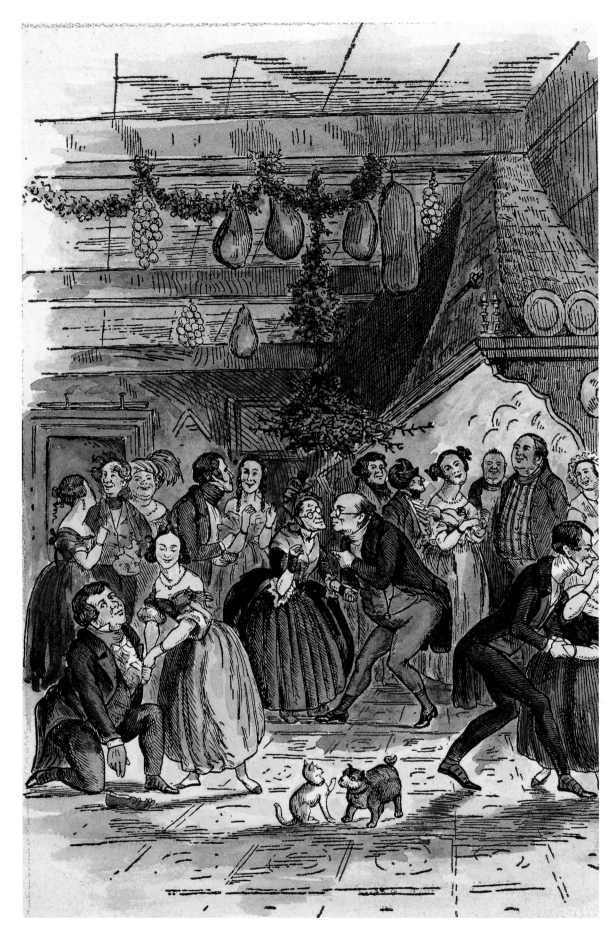

A Christmas Carol. Watercolor drawing. Courtesy of American Antiquarian Society.

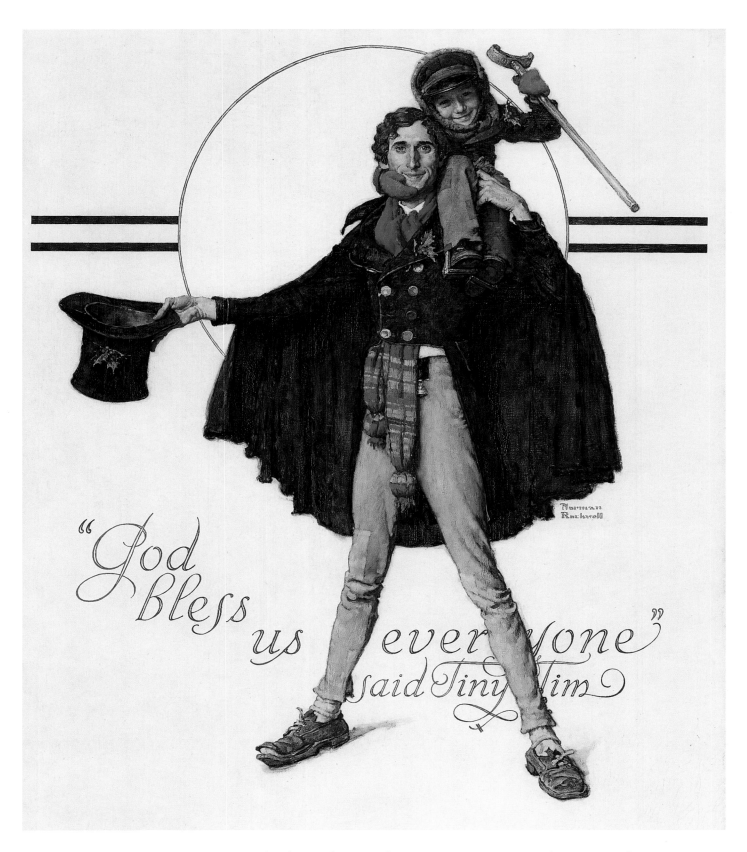

"God bless us every one" said Tiny Tim

NORMAN ROCKWELL. *Tiny Tim and Bob Cratchit. Saturday Evening Post:* 15 December 1934. Oil on canvas.
Printed by permission of the Norman Rockwelll Family Agency.
Copyright © 2003 the Norman Rockell Family Entities.
Photograph courtesy of The Norman Rockwell Museum at Stockbridge.

"He's in the dining-room, sir, along with mistress. I'll show you up-stairs, if you please."

"Thank'ee. He knows me," said Scrooge, with his hand already on the dining-room lock. "I'll go in here, my dear."

He turned it gently, and sidled his face in, round the door. They were looking at the table (which was spread out in great array); for these young housekeepers are always nervous on such points, and like to see that everything is right.

"Fred!" said Scrooge.

Dear heart alive, how his niece by marriage started! Scrooge had forgotten, for the moment, about her sitting in the corner with the footstool, or he wouldn't have done it, on any account.

"Why bless my soul!" cried Fred, "who's that?"

"It's I. Your uncle Scrooge. I have come to dinner. Will you let me in, Fred?"

Let him in! It is a mercy he didn't shake his arm off. He was at home in five minutes. Nothing could be heartier. His niece looked just the same. So did Topper when *he* came. So did the plump sister when *she* came. So did every one when *they* came. Wonderful party, wonderful games, wonderful unanimity, won-der-ful happiness!

But he was early at the office next morning. Oh, he was early there. If he could only be there first, and catch Bob Cratchit coming late! That was the thing he had set his heart upon.

And he did it; yes, he did! The clock struck nine. No Bob. A quarter past. No Bob. He was full eighteen minutes and a half behind his time. Scrooge sat with his door wide open, that he might see him come into the Tank.

His hat was off, before he opened the door; his comforter too. He was on

his stool in a jiffy; driving away with his pen, as if he were trying to overtake nine o'clock.

"Hallow!" growled Scrooge, in his accustomed voice, as near as he could feign it. "What do you mean by coming here at this time of day?"

"I am very sorry, sir," said Bob. "I *am* behind my time."

"You are?" repeated Scrooge. "Yes. I think you are. Step this way, sir, if you please."

"It's only once a year, sir," pleaded Bob, appearing from the Tank. "It shall not be repeated. I was making rather merry yesterday, sir."

"Now, I'll tell you what, my friend," said Scrooge, "I am not going to stand this sort of thing any longer. And therefore," he continued, leaping from his stool, and giving Bob such a dig in the waistcoat that he staggered back into the Tank again; "and therefore I am about to raise your salary!"

Bob trembled, and got a little nearer to the ruler. He had a momentary idea of knocking Scrooge down with it, holding him, and calling to the people in the court for help and a strait-waistcoat.

"A merry Christmas, Bob!" said Scrooge, with an earnestness that could not be mistaken, as he clapped him on the back. "A merrier Christmas, Bob, my good fellow, than I have given you for many a year! I'll raise your salary, and endeavour to assist your struggling family, and we will discuss your affairs this very afternoon, over a Christmas bowl of smoking bishop, Bob! Make up the fires, and buy another coal-scuttle before you dot another i, Bob Cratchit!"

Scrooge was better than his word. He did it all, and infinitely more; and to Tiny Tim, who did NOT die, he was a second father. He became as good a friend, as good a master, and as good a man, as the good old city knew, or any

other good old city, town, or borough, in the good old world. Some people laughed to see the alteration in him, but he let them laugh, and little heeded them; for he was wise enough to know that nothing ever happened on this globe, for good, at which some people did not have their fill of laughter in the outset; and knowing that such as these would be blind anyway, he thought it quite as well that they should wrinkle up their eyes in grins, as have the malady in less attractive forms. His own heart laughed; and that was quite enough for him.

He had no further intercourse with the Spirits, but lived upon the Total Abstinence Principle, ever afterwards; and it was always said of him, that he knew how to keep Christmas well, if any man alive possessed the knowledge. May that be truly said of us, and all of us! And so, as Tiny Tim observed, God bless Us, Every One!

FROM
Little Women

LOUISA MAY ALCOTT

Drawing on her own life, Louisa May Alcott (1832–1888) created one of the most cherished families in American literature. In this Christmas scene from her classic novel, Little Women, *the March girls— Amy, Beth, Jo, and Meg—sacrifice their own Christmas breakfast to feed a neighboring family in need.*

o was the first to wake in the gray dawn of Christmas morning. No stockings hung at the fireplace, and for a moment she felt as much disappointed as she did long ago, when her little sock fell down because it was so crammed with goodies. Then she remembered her mother's promise, and slipping her hand under her pillow, drew out a little crimson-covered book. She knew it very well, for it was that beautiful old story of the best life ever lived, and Jo felt that it was a true guide-book for any pilgrim going the long journey. She woke Meg with a "Merry Christmas," and bade her see what was under her pillow. A green-covered book appeared, with the same picture inside, and a few words written by their mother, which made their one present very precious in ther eyes. Presently Beth and Amy woke, to rummage and find their little books also,—one dove-colored, the other blue; and all sat looking at and talking about them, while the East grew rosy with the coming day.

In spite of her small vanities, Margaret had a sweet and pious nature, which unconsciously influenced her sisters, especially Jo, who loved her very tenderly, and obeyed her because her advice was so gently given.

"Girls," said Meg, seriously, looking from the tumbled head beside her to the two little night-capped ones in the room beyond, "mother wants us to read and love and mind these books, and we must begin at once. We used to be faithful about it; but since father went away, and all this war trouble unsettled us, we have neglected many things. You can do as you please; but *I* shall keep my book on the table here, and read a little every morning as soon as I wake, for I know it will do me good, and help me through the day."

Then she opened her new book and began to read. Jo put her arm round her, and, leaning cheek to cheek, read also, with the quiet expression so seldom seen on her restless face.

"How good Meg is! Come, Amy, let's do as they do. I'll help you with the hard words, and they'll explain things if we don't understand," whispered Beth, very much impressed by the pretty books and her sisters' example.

"I'm glad mine is blue," said Amy; and then the rooms were very still while the pages were softly turned, and the winter sunshine crept in to touch the bright heads and serious faces with a Christmas greeting.

"Where is mother?" asked Meg, as she and Jo ran down to thank her for their gifts, half an hour later.

"Goodness only knows. Some poor creeter come a-beggin', and your ma went straight off to see what was needed. There never *was* such a woman for givin' away vittles and drink, clothes and firin'," replied Hannah, who had lived with the family since Meg was born, and was considered by them all more as a friend than a servant.

"She will be back soon, I guess; so do your cakes, and have everything ready," said Meg, looking over the presents which were collected in a basket and kept under the sofa, ready to be produced at the proper time. "Why, where is Amy's

bottle of Cologne?" she added, as the little flask did not appear.

"She took it out a minute ago, and went off with it to put a ribbon on it, or some such notion," replied Jo, dancing about the room to take the first stiffness off the new army-slippers.

"How nice my handkerchiefs look, don't they? Hannah washed and ironed them for me, and I marked them all myself," said Beth, looking proudly at the somewhat uneven letters which had cost her such labor.

"Bless the child, she's gone and put 'Mother' on them instead of 'M. March;' how funny!" cried Jo, taking up one.

"Isn't it right? I thought it was better to do it so, because Meg's initials are 'M.M.,' and I don't want any one to use these but Marmee," said Beth, looking troubled.

It's all right, dear, and a very pretty idea; quite sensible, too, for no one can ever mistake now. It will please her very much, I know," said Meg, with a frown for Jo, and a smile for Beth.

"There's mother; hide the basket, quick!" cried Jo, as a door slammed, and steps sounded in the hall.

Amy came in hastily, and looked rather abashed when she saw her sisters all waiting for her.

"Where have you been, and what are you hiding behind you?" asked Meg, surprised to see, by her hood and cloak, that lazy Amy had been out so early.

"Don't laugh at me, Jo, I didn't mean any one should know till the time came. I only meant to change the little bottle for a big one, and I gave *all* my money to get it, and I'm truly trying not to be selfish any more."

As she spoke, Amy showed the handsome flask which replaced the cheap one; and looked so earnest and humble in her little effort to forget herself, that Meg

hugged her on the spot, and Jo pronounced her "a trump," while Beth ran to the window, and picked her finest rose to ornament the stately bottle.

"You see I felt ashamed of my present, after reading and talking about being good this morning, so I ran around the corner and changed it the minute I was up; and I'm *so* glad, for mine is the handsomest now."

Another bang of the street-door sent the basket under the sofa, and the girls to the table eager for breakfast.

"Merry Christmas, Marmee! Lots of them! Thank you for our books; we read some, and mean to every day," they cried, in chorus.

"Merry Christmas, little daughters! I'm glad you began at once, and hope you will keep on. But I want to say one word before we sit down. Not far away from here lies a poor woman with a little new-born baby. Six children are huddled into one bed to keep from freezing, for they have no fire. There is nothing to eat over there; and the oldest boy came to tell me they were suffering hunger and cold. My girls, will you give them your breakfast as a Christmas present?"

They were all unusually hungry, having waited nearly an hour, and for a minute no one spoke; only a minute, for Jo explained impetuously,—

"I'm so glad you came before we began!"

"May I go and help carry the things to the poor little children?" asked Beth, eagerly.

"*I* shall take the cream and the muffins," added Amy, heroically giving up the articles she most liked.

Meg was already covering the buckwheats, and piling the bread into one big plate.

"I thought you'd do it," said Mrs. March, smiling as if satisfied. "You shall all go and help me, and when we come back we will have bread and milk for

breakfast, and make it up at dinner-time."

They were soon ready, and the procession set out. Fortunately it was early, and they went through back streets, so few people saw them, and no one laughed at the funny party.

A poor, bare, miserable room it was, with broken windows, no fire, ragged bed-clothes, a sick mother, wailing baby, and a group of pale, hungry children cuddled under one old quilt, trying to keep warm. How the big eyes stared, and the blue lips smiled, as the girls went in!

"Ach, mein Gott! It is good angels come to us!" cried the poor woman, crying for joy.

"Funny angels in hoods and mittens," said Jo, and set them laughing.

In a few minutes it really did seem as if kind spirits had been at work there. Hannah, who had carried wood, make a fire, and stopped up the broken panes with old hats, and her own shawl. Mrs. March gave the mother tea and gruel, and comforted her with promises of help, while she dressed the little baby as tenderly as if it had been her own. The girls, meantime, spread the table, set the children round the fire, and fed them like so many hungry birds; laughing, talking, and trying to understand the funny broken English.

"Das ist gute!" "Der angel-kinder!" cried the poor things, as they ate, and warmed their purple hands at the comfortable blaze. The girls had never been called angel children before, and thought it very agreeable, especially Jo, who had been considered "a Sancho" ever since she was born. That was a very happy breakfast, though they didn't get any of it; and when they went away, leaving comfort behind, I think there were not in all the city four merrier people than the hungry little girls who gave away their breakfasts, and contented themselves with bread and milk on Christmas morning.

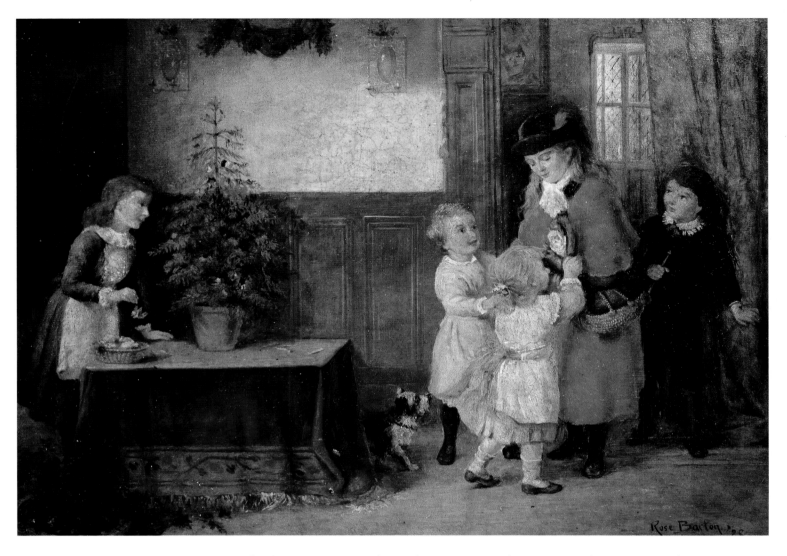

ROSE MAYNARD BARTON. *Christmas Eve*. 1925. Christie's Images, London, UK/Bridgeman Art Library.

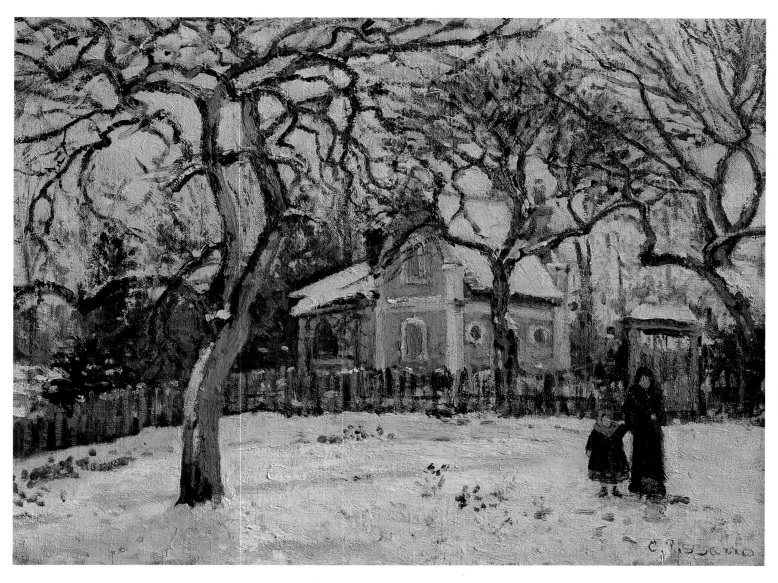

CAMILLE PISSARRO. *Chestnut Trees at Louveciennes.* c. 1872.
Musée d'Orsay, Paris, France. Copyright Erich Lessing/Art Resource, NY.

The Good Fairy

Harriet Beecher Stowe

Harriet Beecher Stowe (1811–1896) was an American writer and philanthropist whose novel
Uncle Tom's Cabin *significantly influenced popular feeling against slavery in America.*
Here a young woman uses her affluence and ingenuity to help others in need at Christmas time.

"Oh, dear! Christmas is coming in a fortnight, and I have got to think up presents for everybody!" said young Ellen Stuart, as she leaned languidly back in her chair. "Dear me, it's so tedious! Everybody has got everything that can be thought of."

"Oh, no," said her confidential adviser, Miss Lester, in a soothing tone. "You have means of buying everything you can fancy; and when every shop and store is glittering with all manner of splendors, you cannot surely be at a loss."

"Well, now, just listen. To begin with, there's mamma. What can I get for her? I have thought of ever so many things. She has three card cases, four gold thimbles, two or three gold chains, two writing desks of different patterns; and then as to rings, brooches, boxes, and all other things, I should think she might be sick of the sight of them. I am sure I am," said she, languidly gazing on her white and jeweled fingers.

This view of the case seemed rather puzzling to the adviser, and there was silence for a few minutes, when Ellen, yawning, resumed: "And then there's cousins Jane and Mary; I suppose they will be coming down on me with a whole load of presents; and Mrs. B. will send me something—she did last year; and then there's cousins William and Tom—I must get them something; and I would like to do it well enough, if I only knew what to get."

"Well," said Eleanor's aunt, who had been sitting quietly rattling her knitting needles during this speech, "it's a pity that you had not such a subject to practice on as I was when I was a girl. Presents did not fly about in those days as they do now. I remember when I was ten years old, my father gave me a most marvelously ugly sugar dog for a Christmas gift, and I was perfectly delighted with it, the very idea of a present was so new to us."

"Dear aunt, how delighted I should be if I had any such fresh, unsophisticated body to get presents for! But to get and get for people that have more than they know what to do with now; to add pictures, books and gilding when the center tables are loaded with them now, and rings and jewels when they are a perfect drug! I wish myself that I were not sick, and sated, and tired with having everything in the world given me."

"Well, Eleanor," said her aunt, "if you really do want unsophisticated subjects to practice on, I can put you in the way of it. I can show you more than one family to whom you might seem to be a very good fairy, and where such gifts as you could give with all ease would seem like a magic dream."

"Why, that would really be worth while, aunt."

"Look over in that back alley," said her aunt. "You see those buildings?"

"That miserable row of shanties? Yes."

"Well, I have several acquaintances there who have never been tired of Christmas gifts or gifts of any other kind. I assure you, you could make quite a sensation over there."

"Well, who is there? Let us know."

"Do you remember Owen, that used to make your shoes?"

"Yes, I remember something about him."

"Well, he has fallen into a consumption, and cannot work anymore; and he,

and his wife, and three little children live in one of the rooms."

"How do they get along?"

"His wife takes in sewing sometimes, and sometimes goes out washing. Poor Owen! I was over there yesterday; he looks thin and wasted, and his wife was saying that he was parched with constant fever, and had very little appetite. She had, with great self-denial, and by restricting herself almost of necessary food, got him two or three oranges; and the poor fellow seemed so eager after them."

"Poor fellow!" said Eleanor, involuntarily.

"Now," said her aunt, "suppose Owen's wife should get up on Christmas morning and find at the door a couple dozen of oranges, and some of those nice white grapes, such as you had at your party last week; don't you think it would make a sensation?"

"Why, yes, I think very likely it might; but who else, aunt? You spoke of a great many."

"Well, on the lower floor there is a neat little room, that is always kept perfectly trim and tidy; it belongs to a young couple who have nothing beyond the husband's day wages to live on. They are, nevertheless, as cheerful and chipper as a couple of wrens; and she is up and down half a dozen times a day, to help poor Mrs. Owen. She has baby of her own about five months old, and of course does all the cooking, washing, and ironing for herself and husband; and yet, when Mrs. Owen goes out to wash, she takes her baby, and keeps it whole days for her."

"I'm sure she deserves that the good fairies should smile on her," said Eleanor; "one baby exhausts my stock of virtues very rapidly."

"But you ought to see her baby," said Aunt E.; "so plump, so rosy, and good-natured, and always clean as a lily. This baby is a sort of household shrine; noth-

ing is too sacred or too good for it; and I believe the little thrifty woman feels only one temptation to be extravagant, and that is to get some ornaments to adorn this little divinity."

"Why, did she ever tell you so?"

"No; but one day, when I was coming down stairs, the door of their room was partly open, and I saw a peddler there with open box. John, the husband, was standing with a little purple cap on his hand, which he was regarding with mystified, admiring air, as if he didn't quite comprehend it, and trim little Mary gazing at it with longing eyes."

"'I think we might get it,' said John.

"'Oh, no,' said she, regretfully; 'yet I wish we could, it's so pretty!'"

"Say no more, aunt. I see the good fairy must pop a cap into the window on Christmas morning. Indeed, it shall be done. How they will wonder where it came from, and talk about it for months to come!"

"Well, then," continued her aunt, "in the next street to ours there is a miserable building, that looks as if it were just going to topple over; and away up in the third story, in a little room just under the eaves, live two poor, lonely old women. They are both nearly on to ninety. I was in there day before yesterday. One of them is constantly confined to her bed with rheumatism; the other, weak and feeble, with failing sight and trembling hands, totters about, her only helper; and they are entirely dependent on charity."

"Can't they do anything? Can't they knit?" said Eleanor.

"You are young and strong, Eleanor, and have quick eyes and nimble fingers; how long would it take you to knit a pair of stockings?"

"I?" said Eleanor. "What an idea! I never tried, but I think I could get a pair done in a week, perhaps."

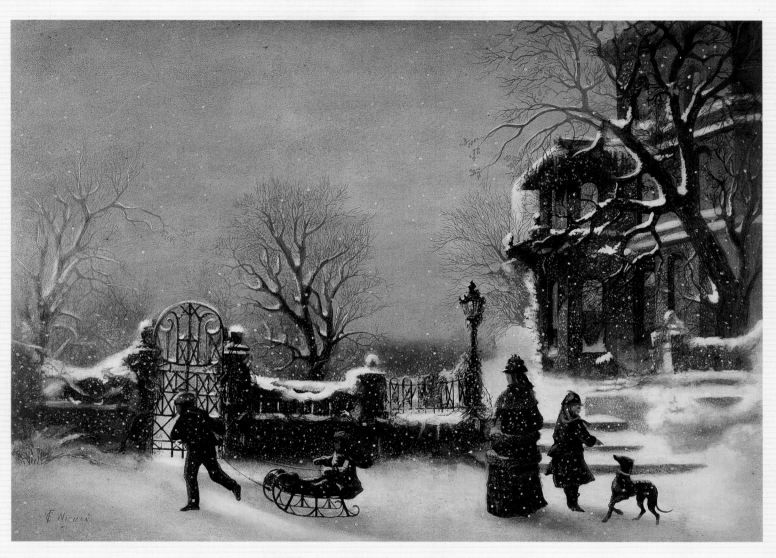

JOSEPH HOOVER. *The First Snow.* 1877. Lithograph.
The Granger Collection, New York.

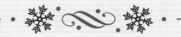
"And if somebody gave you twenty-five cents for them, and out of this you had to get food, and pay room rent, and buy coal for your fire, and oil for your lamp—"

"Stop, aunt, for pity's sake!"

"Well, I will stop; but they can't: they must pay so much every month for that miserable shell they live in, or be turned into the street. The meal and flour that some kind person sends goes off for them just as it does for others, and they must get more or starve; and coal is now scarce and high priced."

"O aunt, I'm quite convinced, I'm sure; don't run me down and annihilate me with all these terrible realities. What shall I do to play good fairy to these old women?"

"If you will give me full power, Eleanor, I will put up a basket to be sent to them that will give them something to remember all winter."

"Oh, certainly I will. Let me see if I can't think of something myself."

"Well, Eleanor, suppose, then, some fifty or sixty years hence, if you were old, and if your father, and mother, and aunts, and uncles, now so thick around you, lay cold and silent in so many graves—you have somehow got away off to a strange city, where you were never known—you live in a miserable garret, where snow blows at night through the cracks, and the fire is very apt to go out in the old cracked stove—you sit crouching over the dying embers the evening before Christmas—nobody to speak to you, nobody to care for you, except another poor soul who lies moaning in the bed. Now, what would you like to have sent to you?"

"Oh aunt, what a dismal picture!"

"And yet, Ella, all poor, forsaken old women are made of young girls, who expected it in their youth as little as you do, perhaps."

"Say no more, aunt. I'll buy—let me see—a comfortable warm shawl for

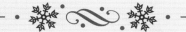

each of these poor women; and I'll send them—let me see—oh, some tea—nothing goes down with old women like tea; and I'll make John wheel some coal over to them; and, aunt, it would not be a very bad thought to send them a new stove, I saw some nice ones for two or three dollars."

"For a new hand, Ella, you work up the idea very well," said her aunt.

"But how much ought I to give, for any one case, to these women, say?"

"How much did you give last year for any single Christmas present?"

"Why, six or seven dollars for some; those elegant souvenirs were seven dollars; that ring I gave Mrs. B. was twenty."

"And do you suppose Mrs. B. was any happier for it?"

"No, really, I don't think she cared much about it; but I had to give her something, because she had sent me something the year before, and I did not want to send a paltry present to one in her circumstances."

"Then, Ella, give the same to any poor, distressed, suffering creature who really needs it, and see in how many forms of good such a sum will appear. That one hard, cold, glittering ring, that now cheers nobody, and means nothing, that you give because you must, and she takes because she must, might, if broken up into smaller sums, send real warm and heartfelt gladness through many a cold and cheerless dwelling, through many an aching heart."

"You are getting to be an orator, aunt; but don't you approve of Christmas presents, among friends and equals?"

"Yes, indeed," said her aunt, fondly stroking her head. "I have had some Christmas presents that did me a world of good—a little book mark, for instance, that a certain niece of mine worked for me, with wonderful secrecy, three years ago, when she was not a young lady with a purse full of money—that book mark was a true Christmas present; and my young couple across the way are

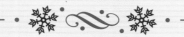
plotting a profound surprise to each other on Christmas morning. John has contrived, by an hour of extra work every night, to lay by enough to get Mary a new calico dress; and she, poor soul, has bargained away the only thing in the jewelry line she ever possessed, to be laid out on a new hat for him.

"I know, too, a washerwoman who has a poor lame boy—a patient, gentle little fellow—who has lain quietly for weeks and months in his little crib, and his mother is going to give him a splendid Christmas present."

"What is it, pray?"

"A whole orange! Don't laugh. She will pay ten whole cents for it; for it shall be none of your common oranges, but a picked one of the very best going! She has put by the money, a cent at a time, for a whole month; and nobody knows which will be happiest in it, Willie or his mother. These are such Christmas presents as I like to think of—gifts coming from love, and rending to produce love; these are the appropriate gifts of the day."

"But don't you think that it's right for those who have money to give expensive presents, supposing always, as you say, they are given from real affection?"

"Sometimes, undoubtedly. The Saviour did not condemn her who broke an alabaster box of ointment—very precious—simply as proof of love, even though the suggestion was made, 'This might have been sold for three hundred pence, and given to the poor.' I have thought he would regard with sympathy the fond efforts which human love sometimes makes to express itself by gifts, the rarest and most costly. How I rejoiced with all my heart, when Charles Elton gave his poor mother that splendid Chinese shawl and gold watch! because I knew they came from the very fullness of his heart to a mother that he could not do too much for—a mother that has done and suffered everything for him. In some cases, when resources are ample, a costly gift seems to

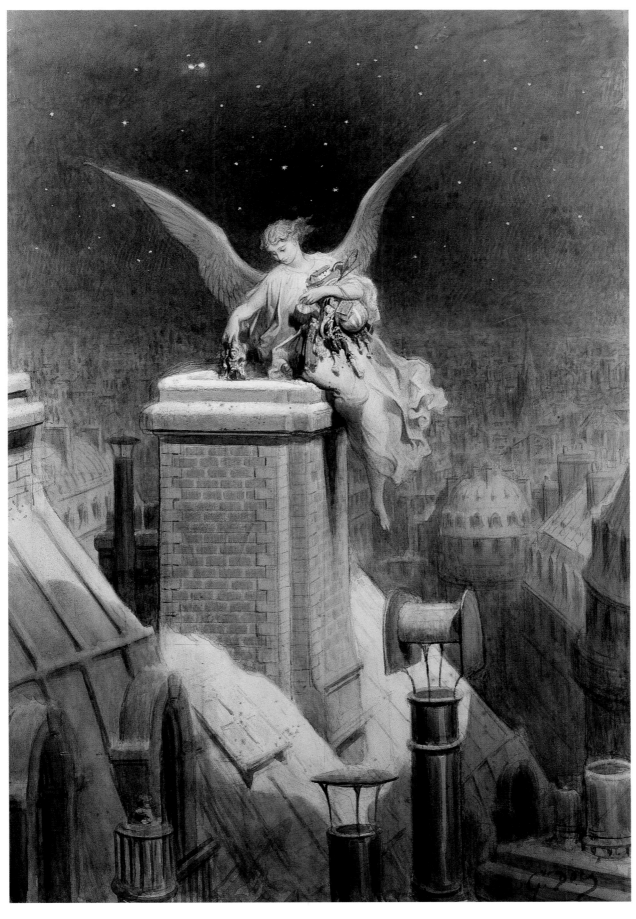

GUSTAVE DORE. *Christmas Eve.* Watercolor and gouache, over traces of crayon.
Louvre, Paris, France. Copyright Réunion des Musées Nationaux/Art Resource, NY.

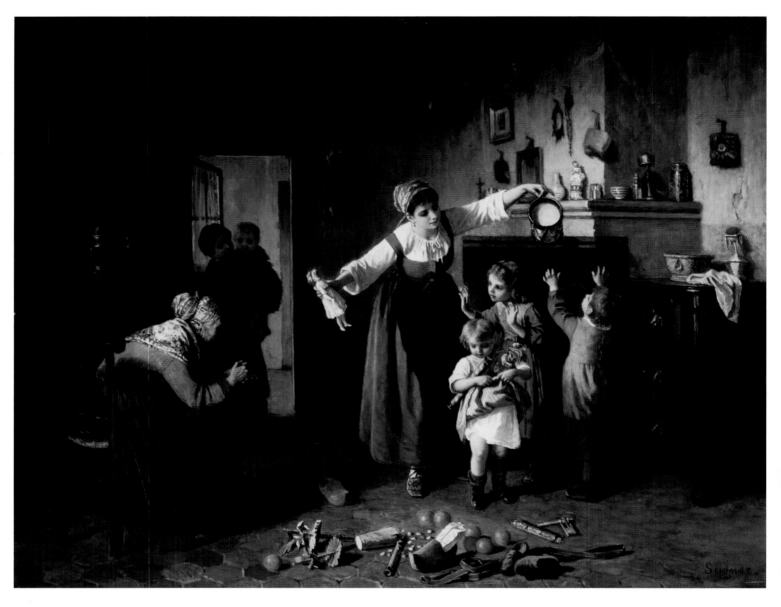

PAUL SEIGNAC. *Christmas Morning*. Oil on canvas. Copyright Christie's Images/CORBIS.

have a graceful appropriateness; but I cannot approve of it if it exhausts all the means of doing for the poor; it is better, then, to give a simple offering, and to do something for those who really need it."

Eleanor looked thoughtful; her aunt laid down her knitting, and said, in a tone of gentle seriousness, "Whose birth does Christmas commemorate, Ella?"

"Our Saviour's, certainly, aunt."

"Yes," said her aunt. "And when and how was he born? In a stable! laid in a manger; thus born, that in all ages he might be known as the brother and friend of the poor. And surely, it seems but appropriate to commemorate his birthday by an especial remembrance of the lowly, the poor, the outcast, and distressed; and if Christ should come back to our city on a Christmas day, where should we think it most appropriate to his character to find him? Would he be carrying splendid gifts to splendid dwellings, or would he be gliding about in the cheerless haunts of the desolate, the poor, the forsaken, and the sorrowful?"

And here the conversation ended.

From Sassafrass, Cypress & Indigo

NTOZAKE SHANGE

Ntozake Shange (b. 1948) has written a number of highly acclaimed works and has taught at several colleges and universities. Here is the thoughtfulness, tenderness, and love of a mother who seeks to honor the special relationship she has with each of her children on Christmas.

ilda Effania always left notes for the girls, explaining where their Christmas from Santa was. This practice began the first year Sassafrass had doubted that a fat white man came down her chimney to bring her anything. Hilda solved that problem by leaving notes from Santa Claus for all the children. That way they had to go search the house, high & low, for their gifts. Santa surely had to have been there. Once school chums & reality interfered with this myth, Hilda continued the practice of leaving her presents hidden away. She liked the idea that each child experienced her gift in privacy. The special relationship she nurtured with each was protected from rivalries, jokes & Christmas confusions. Hilda Effania loved thinking that she'd managed to give her daughters a moment of their own.

My Oldest Darling, Sassafrass,

In the back of the pantry is something from Santa. In a red box by the attic window is something your father would want you to have. Out by the shed in a bucket covered with straw is a gift from your Mama.

Love to you,

Mama

Darling Cypress,

Underneath my hat boxes in the 2nd floor closet is your present from Santa. Look behind the tomatoes I canned last year for what I got you in your Papa's name. My own choice for you is under your bed.

XOXOX,

Mama

Sweet Little Indigo,

This is going to be very simple. Santa left you something outside your violin. I left you a gift by the outdoor stove on the right-hand side. Put your coat on before you go out there. And the special something I got you from your Daddy is way up in the china cabinet. Please, be careful.

I love you so much,

Mama

In the back of the pantry between the flour & rice, Sassafrass found a necklace of porcelain roses. Up in the attic across from Indigo's mound of resting dolls, there was a red box all right, with a woven blanket of mohair, turquoise & silver. Yes, her father would have wanted her to have a warm place to sleep. Running out to the shed, Sassafrass knocked over the bucket filled with straw. There on the ground lay eight skeins of her mother's finest spun cotton, dyed so many colors. Sassafrass sat out in the air feeling her yarns.

Cypress wanted her mother's present first. Underneath her bed, she felt tarlatan. A tutu. Leave it to Mama. Once she gathered the whole thing out where she could see it, Cypress started to cry. A tutu juponnage, reaching to her ankles,

rose & lavender. The waist was a wide sash with the most delicate needlework she'd ever seen. Tiny toe shoes in white & pink graced brown ankles tied with ribbons. Unbelievable. Cypress stayed in her room dancing in her tutu till lunchtime. Then she found *The Souls of Black Folk* by Du Bois near the tomatoes from her Papa's spirit. She was the only one who'd insisted on calling him Papa, instead of Daddy or Father. He didn't mind. So she guessed he wouldn't mind now. "Thank you so much, Mama & Papa." Cypress slowly went to the second-floor closet where she found Santa'd left her a pair of opal earrings. To thank her mother Cypress did a complete *port de bras*, in the Cecchetti manner, by her mother's vanity. The mirrors inspired her.

Indigo had been very concerned that anything was near her fiddle that she hadn't put there. Looking at her violin, she knew immediately what her gift from Santa was. A brand-new case. No secondhand battered thing from Uncle John. Indigo approached her instrument slowly. The case was of crocodile skin, lined with white velvet. Plus, Hilda Effania had bought new rosin, new strings. Even cushioned the fiddle with cleaned raw wool. Indigo carried her new case with her fiddle outside to the stove where she found a music stand holding *A Practical Method for Violin* by Nicolas Laoureux. "Oh, my. She's right about that. Mama would be real mad if I never learned to read music." Indigo looked through the pages, understanding nothing. Whenever she was dealing with something she didn't understand, she made it her business to learn. With great difficulty, she carried her fiddle, music stand & music book into the house. Up behind the wine glasses that Hilda Effania rarely used, but dusted regularly, was a garnet bracelet from the memory of her father. Indigo figured the bracelet weighed so little, she would definitely be able to wear it every time she played her fiddle. Actually, she could wear it while conversing with the Moon.

ANDY WARHOL. *Untitled (Fairy and Christmas Ornaments)*. c. 1953–1955. Graphite, ink and ink wash on paper.
© Copyright 2003 Andy Warhol Foundation for the Visual Arts/ARS, NY.
Copyright The Andy Warhol Foundation, Inc./Art Resource, NY.

Christmas Day in the Morning

PEARL S. BUCK

The daughter of missionaries, American born Pearl S. Buck (1892–1973) spent most of her life in China. She received the Pulitzer Prize for The Good Earth, *and she was the first American woman to win the Nobel Prize in literature. Here is a story of the power of Christmas to waken love.*

e woke suddenly and completely. It was four o'clock, the hour at which his father had always called him to get up and help with the milking. Strange how the habits of his youth clung to him still! Fifty years ago, and his father had been dead for thirty years, and yet he waked at four o'clock in the morning. He had trained himself to turn over and go to sleep, but this morning, because it was Christmas, he did not try to sleep.

Yet what was the magic of Christmas now? His childhood and youth were long past, and his own children had grown up and gone. Some of them lived only a few miles away but they had their own families, and though they would come in as usual toward the end of the day, they had explained with infinite gentleness that they wanted their children to build Christmas memories about their houses, not his. He was left alone with his wife.

Yesterday she had said, "It isn't worthwhile, perhaps—"

And he had said, "Oh, yes, Alice, even if there are only the two of us, let's have a Christmas of our own."

Then she had said, "Let's not trim the tree until tomorrow, Robert—just

so it's ready when the children come. I'm tired."

He had agreed, and the tree was still out in the back entry.

He lay in his big bed in his room. The door to her room was shut because she was a light sleeper, and sometimes he had restless nights. Years ago they had decided to use separate rooms. It meant nothing, they said, except that neither of them slept as well as they once had. They had been married so long that nothing could separate them, actually.

Why did he feel so awake tonight? For it was still night, a clear and starry night. No moon, of course, but the stars were extraordinary! Now that he thought of it, the stars seemed always large and clear before the dawn of Christmas Day. There was one star now that was certainly larger and brighter than any of the others. He could even imagine it moving, as it had seemed to him to move one night long ago.

He slipped back in time, as he did so easily nowadays. He was fifteen years old and still on his father's farm. He loved his father. He had not known it until one day a few days before Christmas, when he had overheard what his father was saying to his mother.

"Mary, I hate to call Rob in the morning. He's growing so fast and he needs his sleep. If you could see how he sleeps when I go in to wake him up! I wish I could manage alone."

"Well, you can't, Adam." His mother's voice was brisk. "Besides, he isn't a child anymore. It's time he took his turn."

"Yes," his father said slowly. "But I sure do hate to wake him."

When he heard these words, something in him woke: his father loved him. He had never thought of it before, taking for granted the tie of their blood. Neither his father nor his mother talked about loving their children—they

had no time for such things. There was always so much to do on a farm.

Now that he knew his father loved him, there would be no more loitering in the mornings and having to be called again. He got up after that, stumbling blind with sleep, and pulled on his clothes, his eyes tight shut, but he got up.

And then on the night before Christmas, that year when he was fifteen, he lay for a few minutes thinking about the next day. They were poor, and most of the excitement was in the turkey they had raised themselves and in the mince pies his mother made. His sisters sewed presents and his mother and father always bought something he needed, not only a warm jacket, maybe, but something more, such as a book. And he saved and bought them each something, too.

He wished, that Christmas he was fifteen, he had a better present for his father. As usual he had gone to the ten-cent store and bought a tie. It had seemed nice enough until he lay thinking the night before Christmas, and then he wished that he had heard his father and mother talking in time for him to save for something better.

He lay on his side, his head supported by his elbow, and looked out of his attic window. The stars were bright, much brighter than he ever remembered seeing them, and one star in particular was so bright that he wondered if it were really the Star of Bethlehem.

"Dad," he had once asked when he was a little boy, "what is a stable?"

"It's just a barn," his father had replied, "like ours."

Then Jesus had been born in a barn, and to a barn the shepherds and the Wise Men had come, bringing their Christmas gifts!

The thought struck him like a silver dagger. Why should he not give his father a special gift too, out there in the barn? He could get up early, earli-

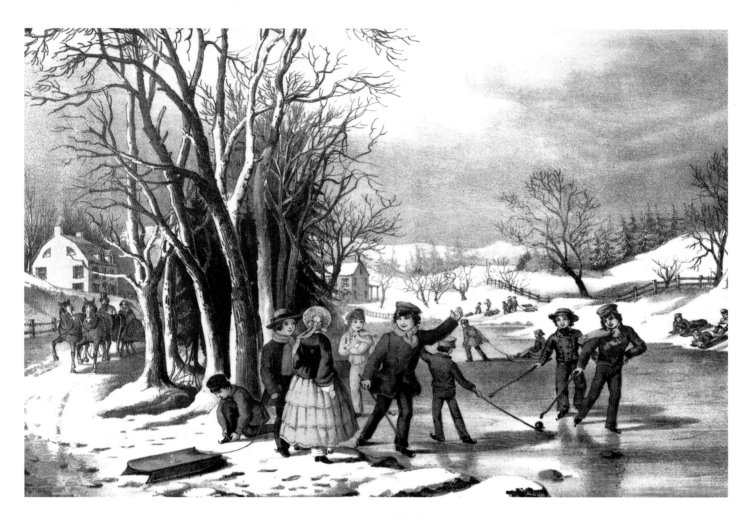

Francis F. Palmer. *Winter Pastime*. Published 1855 Nathaniel Currier.
Hand colored lithograph on paper. Image provided by the Currier & Ives Foundation.

EASTMAN JOHNSON. *Christmas Time; The Blodgett Family*. 1864. Oil on canvas.
The Metropolitan Museum of Art, Gift of Mr. and Mrs. Stephen Whitney Blodgett, 1983. (1983.486)
Photograph © 1984 The Metropolitan Museum of Art.

er than four o'clock, and he could creep into the barn and get all the milking done. He'd do it alone, milk and clean up, and then when his father went in to start the milking, he'd see it all done. And he would know who had done it.

He laughed to himself as he gazed at the stars. It was what he would do, and he mustn't sleep too sound.

He must have waked twenty times, scratching a match each time to look at his old watch—midnight, and half past one, and then two o'clock.

At a quarter to three he got up and put on his clothes. He crept downstairs, careful of the creaky boards, and let himself out. The big star hung lower over the barn roof, a reddish gold. The cows looked at him, sleepy and surprised. It was early for them, too.

"So, boss," he whispered. They accepted him placidly, and he fetched some hay for each cow and then got the milking pail and the big milk cans.

He had never milked all alone before, but it seemed almost easy. He kept thinking about his father's surprise. His father would come in and call him, saying that he would get things started while Rob was getting dressed. He'd go to the barn, open the door, and then he'd go to get the two big empty milk cans. But they wouldn't be waiting or empty; they'd be standing in the milk-house, filled.

"What the—" he could hear his father exclaiming.

He smiled and milked steadily, two strong streams rushing into the pail, frothing and fragrant. The cows were still surprised but acquiescent. For once they were behaving well, as though they knew it was Christmas.

The task went more easily than he had ever known it to before. Milking for once was not a chore. It was something else, a gift to his father who loved

him. He finished, the two milk cans were full, and he covered them and closed the milkhouse door carefully, making sure of the latch. He put the stool in its place by the door and hung up the clean milk pail. Then he went out of the barn and barred the door behind him.

Back in his room he had only a minute to pull off his clothes in the darkness and jump into bed, for he heard his father up. He put the covers over his head to silence his quick breathing. The door opened.

"Rob!" his father called. "We have to get up, son, even if it is Christmas."

"Aw-right," he said sleepily.

"I'll go on out," his father said. "I'll get things started."

The door closed and he lay still, laughing to himself. In just a few minutes his father would know. His dancing heart was ready to jump from his body.

The minutes were endless—ten, fifteen, he did not know how many—and he heard his father's footsteps again. The door opened and he lay still.

"Rob!"

"Yes, Dad—"

His father was laughing, a queer sobbing sort of a laugh. "Thought you'd fool me, did you?" His father was standing beside his bed, feeling for him, pulling away the cover.

"It's for Christmas, Dad!"

He found his father and clutched him in a great hug. He felt his father's arms go around him. It was dark and they could not see each other's faces.

"Son, I thank you. Nobody ever did a nicer thing—"

"Oh, Dad, I want you to know—I do want to be good!" The words broke from him of their own will. He did not know what to say. His heart was bursting with love.

CHRISTMAS DAY IN THE MORNING

"Well, I reckon I can go back to bed and sleep," his father said after a moment. "No, hark—the little ones are waked up. Come to think of it, son, I've never seen you children when you first saw the Christmas tree. I was always in the barn. Come on!"

He got up and pulled on his clothes again and they went down to the Christmas tree, and soon the sun was creeping up to where the star had been. Oh, what a Christmas, and how his heart had nearly burst again with shyness and pride as his father told his mother and made the younger children listen about how he, Rob, had got up all by himself.

"The best Christmas gift I ever had, and I'll remember it, son, every year on Christmas morning, so long as I live."

They had both remembered it, and now that his father was dead he remembered it alone: that blessed Christmas dawn when, alone with the cows in the barn, he had made his first gift of true love.

Outside the window now the great star slowly sank. He got up out of bed and put on his slippers and bathrobe and went softly upstairs to the attic and found the box of Christmas-tree decorations. He took them downstairs into the living room. Then he brought in the tree. It was a little one—they had not had a big tree since the children went away—but he set it in the holder and put it in the middle of the long table under the window. Then carefully he began to trim it. It was done very soon, the time passing as quickly as it had that morning long ago in the barn.

He went to his library and fetched the little box that contained his special gift to his wife, a star of diamonds, not large but dainty in design. He had written the card for it the day before. He tied the gift on the tree and then stood back. It was pretty, very pretty, and she would be surprised.

But he was not satisfied. He wanted to tell her—to tell her how much he loved her. It had been a long time since he had really told her, although he loved her in a very special way, much more than he ever had when they were young.

He had been fortunate that she had loved him—and how fortunate that he had been able to love! Ah, that was the true joy of life, the ability to love! For he was quite sure that some people were genuinely unable to love any-one. But love was alive in him, it still was.

It occurred to him suddenly that it was alive because long ago it had been born in him when he knew his father loved him. That was it: love alone could waken love.

And he could give the gift again and again. This morning, this blessed Christmas morning, he would give it to his beloved wife. He could write it down in a letter for her to read and keep forever. He went to his desk and began his love letter to his wife: My dearest love . . .

When it was finished he sealed it and tied it on the tree where she would see it the first thing when she came into the room. She would read it, surprised and then moved, and realize how very much he loved her.

He put out the light and went tiptoeing up the stairs. The star in the sky was gone, and the first rays of the sun were gleaming the sky. Such a happy, happy Christmas!

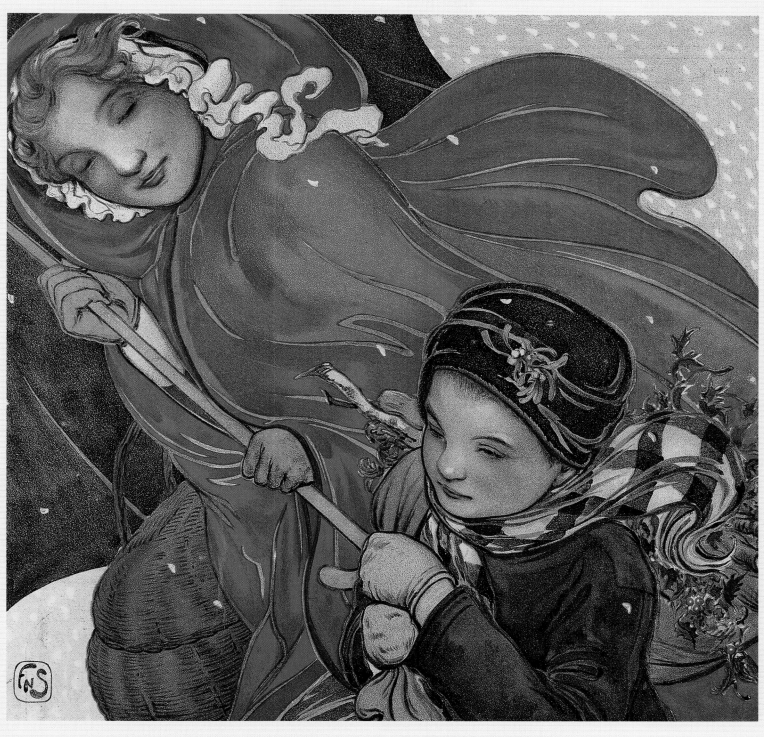

NEWTON SHEPHERD. *Battling Home through Wind and Snow with Holly and Mistletoe
for Christmas Decoration*. 1901. Lithograph. Private collection.
Copyright Image Select/Art Resource, NY.

The Montreal Aunts

MAUREEN HULL

Maureen Hull is a Canadian writer whose fiction and poetry have appeared in numerous magazines and anthologies. Here is the amusing drama of a modern family at Christmas time told with great honesty, charm, and wit.

izbeth and I climbed spruce trees. We only did this in winter when our snowsuits, hats and mittens protected us. We squeezed past dense branches and needles that wanted to poke our eyes out, but it *had* to be a bushy tree or we'd fall between the branches on the way down and break our necks. We climbed as high as possible, then sat on a big branch, feet pointing out and down. Laid back and shoved off. It was a fall—broken by branch after branch as we sped groundward. As we dropped from each one, it would spring back up and shower us with snow and spruce cones. It was a glorious ride down—and a game we never described to our parents, or played within view of the house. We had a kind of a feeling about it.

So I was up as high as I could climb, with a prickly green and white view of the world, and just about to launch myself, when I saw Dad coming across the field. He was heading for the woods, straight towards us.

"Don't come up, Lizbeth," I hissed. "Dad's coming, and he's got the axe." I let go and whooshed down without my usual kamikaze yell, so he wouldn't notice me. When I hit the snow drift at the bottom, Lizbeth had already run off. Dad in the woods with an axe meant it was time to cut the tree, and Christmas could start. I staggered after her, beating clumps of snow and spruce cones from my hat.

In our house, the tree went up on Christmas Eve day, after lunch. Once Dad had built the stand and set the tree up in the bay window in the living room, it was Mum's to decorate. I helped, putting my favourite decorations in a cluster at the front, where I could see them all at once. Lizbeth couldn't decorate, she dropped the glass balls and broke them, and she threw tinsel instead of hanging it.

"Get out of here and let me finish in peace," Mum would say. She'd turn the radio on to Christmas carols, and hum and not care how many mince tarts we ate off the racks cooling on the kitchen table. She'd undo Lizbeths' tinsel and move my favourite ornaments around. When she was finished, it was always more beautiful than the year before.

After supper and a bath, Lizbeth and I would lie on the floor in our nightgowns, cross our eyes, and stare up at the magnificent sparkling blur while Dad read from St. Luke, 2:1-19.

"And it came to pass that in those days, that there went out a decree from Caesar Augustus, that all the world should be taxed."

The minute I heard those words my heart ballooned out in every direction. By the time he got to, "And she brought forth her first-born son, and wrapped him in swaddling clothes, and laid him in a manger; because there was no room for them in the inn," I was sniffing back tears. It is the best story.

It was hard to settle down and fall asleep, but neither Lizbeth nor I ever wanted to stay awake to see Santa. If he caught you up late, you were naughty, not nice, and you would get a lump of coal. We went to bed at the usual hour, squeezed our eyes shut and tried desperately to pass out. Besides, we were Baptists, and we knew that Christmas was supposed to be all about Baby Jesus. We were to be good for Him, not for a present from Santa. And greed was a

sin, so we were only allowed to ask for one present, although I had friends at school who wrote letters asking for twenty different things, quite sure they'd get at least half of what they asked for.

"Santa's not a millionaire," my father said, "He has all the other children in the world to think of, not just you."

When I brought up the matter of my friends' bounty, he told me that Santa really only brings one present for each child, the rest are bought by the parents who then pretend that Santa has brought it all. Well, that settled that. We didn't have That Kind of Money.

We chose our Santa present after weeks of deliberation. We thumbed the pages of the toy section of Eaton's catalogue ragged until time was up, and a final decision had to be made, and the letter to the North Pole printed and mailed. On Christmas morning it was the one present we were allowed to open before breakfast. The rest had to wait until my parents were good and ready to get up and we had been fed a bowl of porridge to steady us.

Our parents gave us new slippers, boxes of sixty-four Crayola crayons, collections of Illustrated Bible Stories. At the back of the tree, in bright foil wrapping and store-bought bows, were the presents from the Aunts.

Our family was decidedly skimpy in the blood-relative department. Most of my schoolmates had crowds of cousins, kitchenfulls of aunts, Legionfulls of uncles, three or four grandparents and at least one great-grandparent mumbling the rosary and spitting in a back bedroom. We had no uncles, no grandparents. My mother and her two younger sisters had been orphaned when their parents drowned in the St. Lawrence River on a canoe outing. They were taken in by an elderly cousin twice-removed who ran a boarding house in

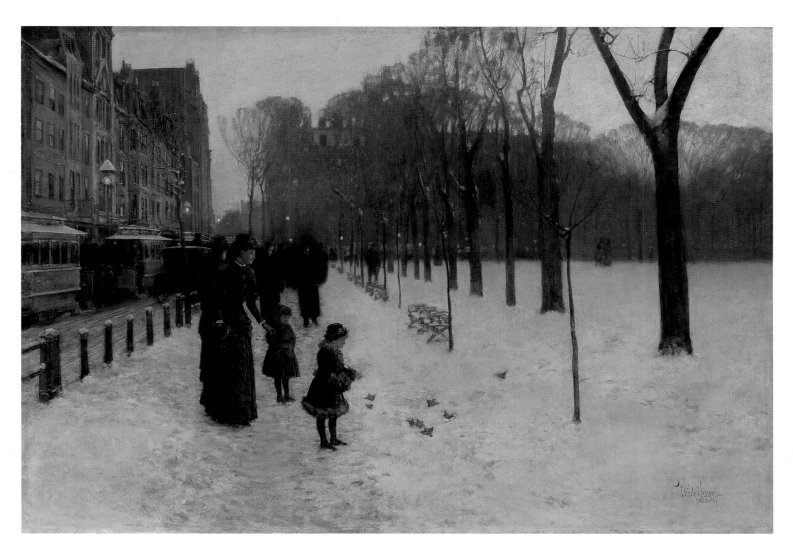

CHILDE HASSAM. *Boston Common at Twilight.* 1885–86. Oil on canvas.
Museum of Fine Arts, Boston. Gift of Miss Maud E. Appleton.
© 2003 The Museum of Fine Arts, Boston.

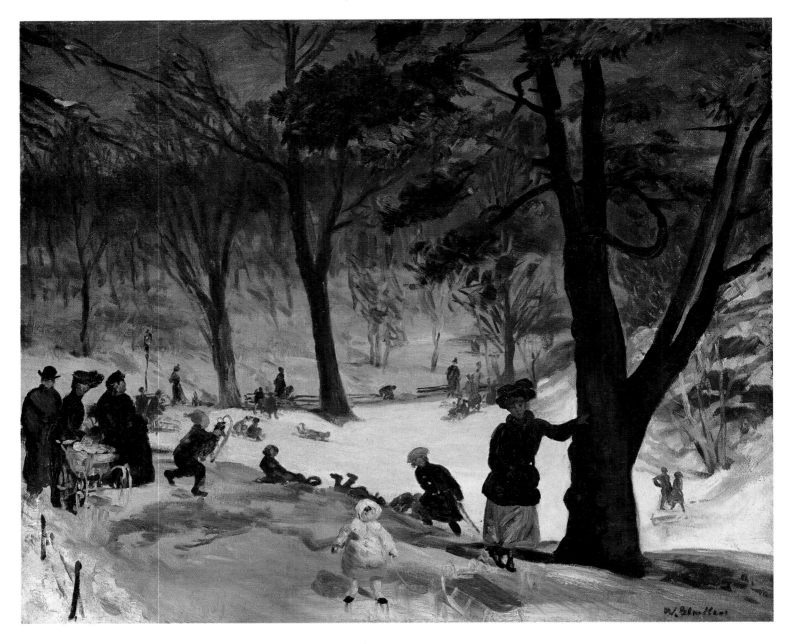

WILLIAM JAMES GLACKENS. *Central Park in Winter.* 1905. Oil on canvas.
The Metropolitan Museum of Art. George A. Hearn Fund, 1921. (21.164)
Photograph © 1992 The Metropolitan Museum of Art.

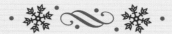

Montreal. She made them scrub and cook for their keep and sent them out to work at Eaton's as soon as they turned sixteen.

Dad's parents were dead, too, his father of pneumonia when Dad was seventeen. We had moved into his mother's house in Glace Bay to look after her when I was a baby. When Nana had finished reading the bible for the eleventh time (one for each of the apostles, except for that traitor, Judas Iscariot) she took herself off to heaven and left us her house.

Dad had two sisters, too. The Ottawa Aunts. They were much older than he was, they both worked for the government, and they were both war widows. One had a son, Cousin-Richard-the-Divinity-Student, who was grown up and was going to go to Africa to convert the heathen. Dad said he didn't need to go all the way to Africa, there was plenty of work to be done at home, and why didn't he start a Mission in Montreal? Mum would fold her mouth and leave the room. I knew he meant the Montreal Aunts. By accidentally listening at keyholes and such, I knew that the Montreal Aunts smoked, drank gin, went dancing, and wore red lipstick, which they used to kiss the boyfriends they weren't in any great hurry to marry.

The Ottawa Aunts sent us copies of the New Testament, bound in white leather with gold-leaf printing, and cream coloured writing paper with matching envelopes. They sent us white cotton blouses with lace, like strings of snowflakes holding hands, sewn to the collar, and blue diaries that locked with a golden key. They sent us Fair Isle tams and matching scarves and gloves. Mum said they had Good Taste.

The Montreal Aunts, unconstrained by a Baptist upbringing or a steady marriage or Good Taste, sent us whatever amused them. Back when they were sending cartons of chocolate bars, or dolls that walked, talked and peed on the

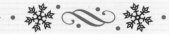
living room floor, it had become a tradition that we were allowed to wear whatever we liked from our Christmas pile to the church service we went to before we sat down to Christmas dinner. This meant cotton blouses or Fair Isle tams for us, leather gloves or a silk scarf for Mum, a new Arrow shirt for Dad. But when I turned five, the Montreal Aunts decided we weren't babies any more and sent Lizbeth and me a jug of pink bubble-bath and a quart of highly scented cologne apiece. Lily of the Valley for me, Lilac for Lizbeth. Of course we wanted to wear *that* to church. Mum showed us how to subtly dab behind our ears and at our wrists, but we wanted more of the wonderful stuff, so when she wasn't looking, we poured on a generous amount. Dad made us sit at the very end of the pew, as far from him as possible, because, he said, we made his eyes water.

Next year—lace underwear and a dozen silver bangles each, and oh, what a fine clash and clatter they made every time we turned the page of the hymnal, or scratched an itch, or stood up, or sat down again. The following year— purple velvet clutch purses and gobs of gaudy costume jewellery—women's jewellery. Painted plastic and glass and gold beads as big as marbles, three rows of them hooked together. Matching clip-on earrings made of clusters of the same beads. Dad was speechless, Mum rolled her eyes. Lizbeth and I thought we looked just grand.

The year I was eight and Lizbeth was six, the Aunts Went Too Far. They sent us nylon stockings and red plastic high heeled shoes with rhinestone butterflies on the toes, butterflies as big as my fist. The shoes fit perfectly. Dad was horrified to think they made such things in children's sizes, but Mum assured him that you could find *anything* in Montreal. Lizbeth took over the front hall, practising so she could wear her new shoes to church, one hand held against

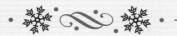

the wall for balance. I was swooning with delight, dancing around the dining room table in my nightgown and heels and hardly falling at all. Since I could walk I'd been sneaking into my parents' closet to stand in Mum's Sunday shoes: navy blue leather, solid square heels lifting me up. When we played dress-up, I stuffed a wooden block into the heel of each sock and minced about until my feet were crippled with the pain and I had to take the blocks out and rub my feet better.

Lizbeth and I hurried to get dressed for church. We struggled into layers of warm, practical things: Stanfield undervests and bloomers; garter belts hooked to the nylon stockings we substituted for the thick brown ribbed stockings we usually wore; cotton petticoats and starched white blouses; pleated navy-blue jumpers and wool cardigans (blue for me, pink for Lizbeth). And red high-heeled shoes with rhinestone butterflies. I wouldn't have traded them for all the velvet Christmas dresses, all the lace flounces and clusters of artificial pink roses pinned to satin bows . . . every year I didn't envy my friends their Christmas dresses. Envy was a sin. It wasn't allowed. So I didn't. And Baby Jesus had finally rewarded me, with the help of the Montreal Aunts.

". . . looking like streetwalkers!" he was saying, his voice very loud.

". . . just little girls," she was arguing.

They were fighting in the kitchen downstairs.

Lizbeth crouched down by her bed and put her thumb in her mouth. I felt sick to my stomach, felt the peppermint surge of candy canes wanting out.

". . . sequined g-strings next!" he was yelling.

". . . my sisters you're insulting," she was yelling back.

I clomped downstairs and into the kitchen to try to make the stop.

"You're scaring Lizbeth." I threw my arms around my mother's middle and

burst into tears. "Baby Jesus says you have to love everybody, even if they live in Montreal!"

"Oh, Christ," said my father, sitting down.

My mother started to laugh.

Lizbeth and I were carried off to church with toffees in our pockets and our gorgeous new shoes on our feet. The Senior Choir sang "O, Holy Night" and made a lump in my throat. Reverend Miles read the story of the Wise Men and their gifts. Our whole family held hands while he prayed Christmas thanks, and in the quiet minute after, when you were supposed to add your own private PS, I thanked Baby Jesus for Lizbeth and my parents, for six Excellents and two Very Goods on my report card, for the new baby we would have by Easter (another girl would be fine) and, most fervently, I thanked him for the Montreal Aunts.

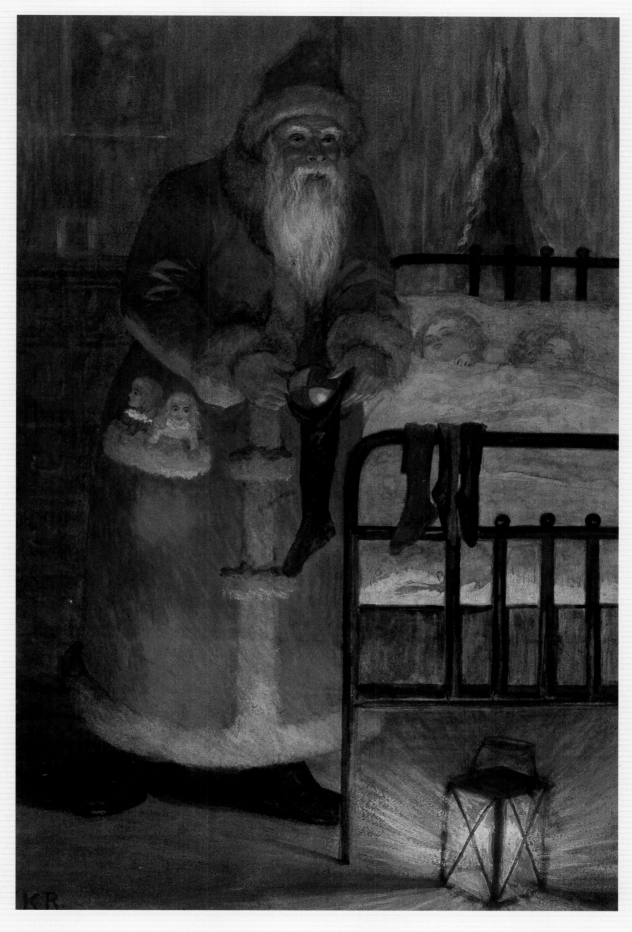

KARL ROGER. *Father Christmas.* Victoria & Albert Museum, London, UK/Bridgeman Art Library.

OUR RICHEST CHRISTMAS

Margery Talcott

Set in the Depression era, Margery Talcott's heartwarming tale reminds us that often the best gifts are those that cost nothing but enrich the soul. Here is a family filled with inspiration, imagination, and the joyous spirit of Christmas.

When our son Pete was six, it was a depression year and the bare essentials were all we could afford. We felt we were richer than most people, though, in things of the mind and imagination and spirit. That was a comfort of sorts to us, but nothing a six-year-old could understand.

With Christmas a week off, we told Pete that there could not be any store-bought presents this year—for any of us.

"But I'll tell you what we can do," said his father with an inspiration born of heartbreak. "We can make *pictures* of the presents we'd *like* to give each other."

For the next few days each of us worked secretly, with smirks and giggles. Somehow we did scrape together enough to buy a small tree. But we had pitifully few decorations to trim it with.

Yet, on Christmas morning, never was a tree heaped with such riches! The gifts were only *pictures* of gifts, to be sure, cut out or drawn and colored and painted, nailed and hammered and pasted and sewed. But they were presents, luxurious beyond our dreams:

A slinky black limousine and a red motor boat for Daddy. A diamond bracelet and a fur coat for me. Pete's presents were the most expensive toys cut from advertisements.

Our best present to him was a picture of a fabulous camping tent, complete with Indian designs, painted, of course, by daddy, and magnificent pictures of a swimming pool, with funny remarks by me.

Daddy's present to me was a water-color he had painted of our dream house, white with green shutters and forsythia bushes on the lawn. My best present to Daddy was a sheaf of verses I had written over the years, verses of devotion and of sad things and amusing things we had gone through together.

Naturally we didn't expect any "best present" from Pete. But with squeals of delight, he gave us a crayon drawing of flashy colors and the most modernistic technique. But it was unmistakably the picture of three people laughing—a man, a woman, and a little boy. They had their arms around one another and were, in a sense, one person. Under the picture he had printed just one word: US.

For many years we have looked back at that day as the richest, most satisfying Christmas we have ever had.

Mr. K★A★P★L★A★N and the Magi

LEO ROSTEN

In The Education of H★Y★M★A★N K★A★P★L★A★N, *Polish born Leo Rosten (1908–1997) affectionately recounts the struggles of immigrants trying to acclimate to life in America. Here is the endearing Christmas gift from the indomitable Hyman Kaplan and his classmates to their teacher.*

hen Mr. Parkhill saw that Miss Mitnick, Mr. Bloom, and Mr. Hyman Kaplan were absent, and that a strange excitement pervaded the beginners' grade, he realized that it was indeed the last night before the holidays and that Christmas was only a few days off. Each Christmas the classes in the American Night Preparatory School for Adults gave presents to their respective teachers. Mr. Parkhill, a veteran of many sentimental Yuletides, had come to know the procedure. That night, before the class session had begun, there must have been a hurried collection; a Gift Committee of three had been chosen; at this moment the Committee was probably in Mickey Goldstein's Arcade, bargaining feverishly, arguing about the appropriateness of a pair of pajamas or the color of a dozen linen handkerchiefs, debating whether Mr. Parkhill would prefer a pair of fleece-lined slippers to a set of mother-of pearl cuff links.

"We shall concentrate on—er—spelling drill tonight," Mr. Parkhill announced.

The students smiled wisely, glanced at the three empty seats, exchanged knowing nods, and prepared for spelling drill. Miss Rochelle Goldberg

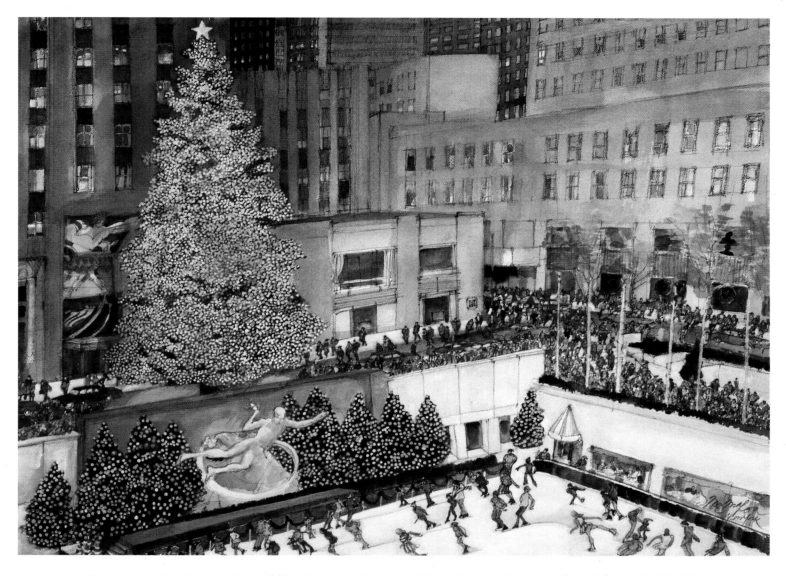

FRANKLIN MCMAHON. *Rockefeller Center at Christmas Time*. Copyright Frank McMahon/CORBIS.

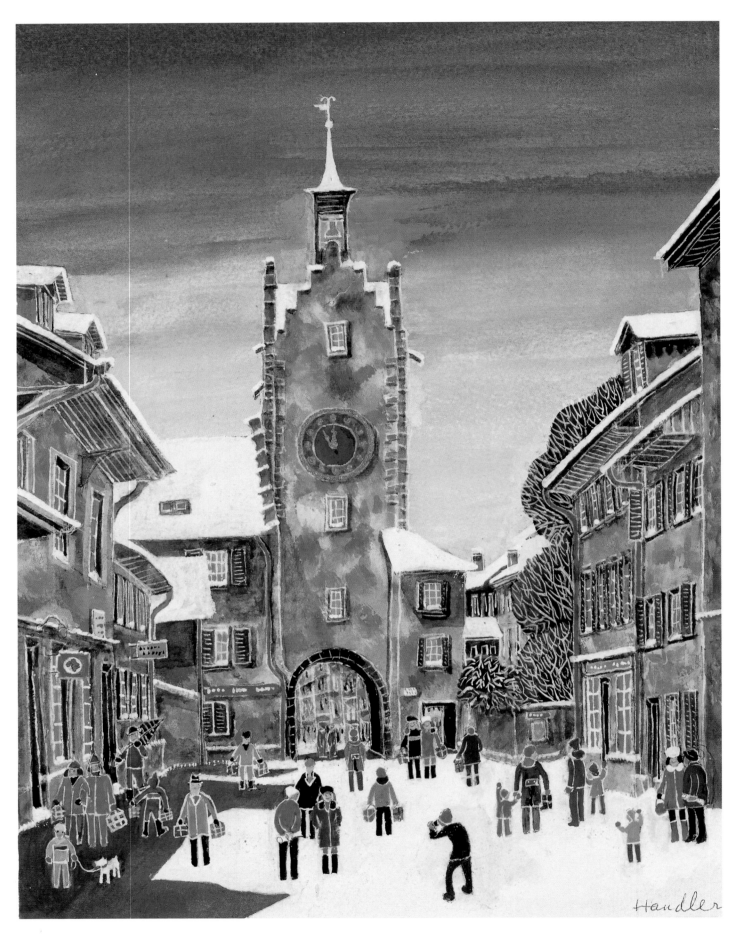

EDITH HANDLER. *A Winter's Day in Diessenhofen*. Private collection/Bridgeman Art Library.

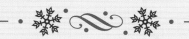
giggled, then looked ashamed as Mrs. Rodriguez shot her a glare of reproval.

Mr. Parkhill always chose a spelling drill for the night before the Christmas vacation: it kept all the students busy simultaneously; it dampened the excitement of the occasion; above all, it kept him from the necessity of resorting to elaborate pedagogical efforts in order to hide his own embarrassment . . .

That was the ritual, fixed and unchanging, of the last night of school before Christmas. . . .

"Nervous . . . Goose . . . Violets."

The hand on the clock crawled around to eight. Mr. Parkhill could not keep his eyes off the three seats, so eloquent in their vacancy, which Miss Mitnick, Mr. Bloom, and Mr. Kaplan ordinarily graced with their presences. He could almost see these three in the last throes of decision in Mickey Goldstein's Arcade, harassed by the competitive attractions of gloves, neckties, an electric clock, a cane, spats, a "lifetime" fountain pen. Mr. Pakhill grew cold as he thought of a fountain pen. Three times already he had been presented with "lifetime" fountain pens, twice with "lifetime" pencils to match. Mr. Parkhill had exchanged these gifts: he had a fountain pen. Once he had chosed a woollen vest instead; once a pair of mittens and a watch chain. Mr. Parkhill hoped it wouldn't be a fountain pen. Or a smoking jacket. He had never been able to understand how the Committee in '32 had decided upon a smoking jacket. Mr. Parkhill did not smoke. He had exchanged it for fur-lined gloves.

Just as Mr. Parkhill called off "Sardine . . . *Exquisite* . . . Palace" the recess bell rang. The heads of the students bobbed up as if propelled by a single spring. There was a rush to the door, Mr. Sam Pinsky well in the lead. Then, from the corridor, their voices rose. Mr. Parkhill began to print "Banana" on the blackboard, so that the students could correct their own papers after recess. He tried not to listen, but

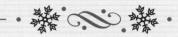

the voices in the corridor were like the chatter of a flock of sparrows.

"Hollo, Mitnick!"

"Bloom, Bloom, vat is it?"

"So vat did you gat, Keplen? Tell!"

Mr. Parkhill could hear Miss Mitnick's shy "We bought—" interrupted by Mr. Kaplan's stern cry, "Mitnick! Don' say! Plizz, faller-students! Come *don* mit de voices! Titcher vill awreddy hearink, you hollerink so lod! Still! Order! Plizz!" There was no question about it: Mr. Kaplan was born to command.

"Did you bought a Tsheaffer's Fontain Pan Sat, guarantee for de whole life, like *I* said?" one voice came through the door. A Scheaffer Fountain Pen Set, Guaranteed. That was Mrs. Moskowitz. Poor Mrs. Moskowitz, she showed so little imagination, even in her homework. "Moskovitz! Mein Gott!" the stentorian whisper of Mr. Kaplan soared through the air. "Vy you don' open op de door Titcher should *positivel* hear? Ha! Let's goink to odder and fromm de hall!"

The voices of the beginners' grade died away as they moved to the "odder and" of the corridor, like the chorus of "Aïda" vanishing into Egyptian wings.

Mr. Parkhill printed "Charming" and "Horses" on the board. For a moment he thought he heard Mrs. Moskowitz's voice repeating stubbornly, "Did—you—bought—a—Tsheaffer—Fontain—Pan—Sat—*Guarantee*?"

Mr. Parkhill began to say to himself, "Thank you, all of you. It's *just* what I wanted," again and again. One Christmas he hadn't said "It's just what I wanted" and poor Mrs. Oppenheimer, chairman of the Committee that year, had been hounded by the students' recriminations for a month.

It seemed an eternity before the recess bell rang again. The class came in *en masse*, and hastened to the seats from which they would view the impending spectacle. The air hummed with silence.

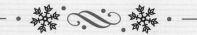
Mr. Parkhill was printing "Cucumber." He did not turn his face from the board as he said, "Er—please begin correcting your own spelling. I have printed most of the words on the board."

There was a low and heated whispering. "Stend op, Mitnick!" he heard Mr. Kaplan hiss. "You should stend op *too!*"

The *whole* Committee," Mr. Bloom whispered. "Stand op!"

Apparently Miss Mitnick, a gazelle choked with embarrassment, did not have the fortitude to "stend op" with her colleagues.

"A fine reprezantitif *you'll* gonna make!" Mr. Kaplan hissed scornfully. "Isn't for *mine* sek I'm eskink, Mitnick. Plizz *stend op!*"

There was a confused, half-muted murmur, and the anguished voice of Miss Mitnick saying, "I *can't.*" Mr. Parkhill printed "Violets" on the board. Then there was tense silence. And then the voice of Mr. Kaplan rose, firmly, clearly, with a decision and dignity which left no doubt as to its purpose.

"Podden me, Mr. Pockheel!"

It had come.

"Er—yes?" Mr. Parkhill turned to face the class.

Messrs. Bloom and Kaplan were standing side by side in front of Miss Mitnick's chair, holding between them a large, long package, wrapped in cellophane and tied with huge red ribbons. A pair of small hands touched the bottom of the box, listlessly. The owner of the hands, seated in the front row, was hidden by the box.

"De hends is Mitnick," Mr. Kaplan said apologetically.

Mr. Parkhill gazed at the tableau. It was touching.

"Er—yes?" he said again feebly, as if he had forgotten his lines and was repeating his cue.

"Hau Kay!" Mr. Kaplan whispered to his confreres. The hands disappeared behind the package. Mr. Kaplan and Mr. Bloom strode to the platform with the box. Mr. Kaplan was beaming, his smile rapturous, exalted. They placed the package on Mr. Parkhill's desk, Mr. Bloom dropped back a few paces, and Mr. Kaplan said, "Mr. Pockheel! Is mine beeg honor, becawss I'm Chairman fromm de Buyink an' Deliverink to You a Prazent Committee, to givink to you dis fine peckitch."

Mr. Parkhill was about to stammer, "Oh, thank you," when Mr. Kaplan added hastily, "Also I'll sayink a few voids."

Mr. Kaplan took an envelope out of his pocket. He whispered loudly, "Mitnick, *you still got time to comm op mit de Committee*," but Miss Mitnick only blushed furiously and lowered her eyes. Mr. Kaplan sighed, straightened the envelope, smiled proudly at Mr. Parkhill, and read.

"Dear Titcher—dat's de beginnink. Ve stendink on de adge fromm a beeg holiday." He cleared his throat. "Ufcawss is all kinds holidays in U.S.A. Holidays for politic, for religious, an' *plain* holidays. In Fabrary, ve got Judge Vashington's boitday, a *fine* holiday. Also Abram Lincohen's. In May ve got Memorable Day, for dad soldiers. In July comms, netcheral, Fort July. Also ve have Labor Day, Denksgivink, for de Peelgrims, an' for de feenish fromm de Voild Var, *Armistress* Day."

Mr. Parkhill played with a piece of chalk nervously.

"But arond dis time year ve have a *difference* kind holiday, a spacial, movvellous time. Dat's called—Chrissmas."

Mr. Parkhill put the chalk down.

"All hover de voild," Mr. Kaplan mused, "is pipple celebraking dis vunderful time. Becawss for som pipple is Chrissmas like for *odder* pipple is Passover.

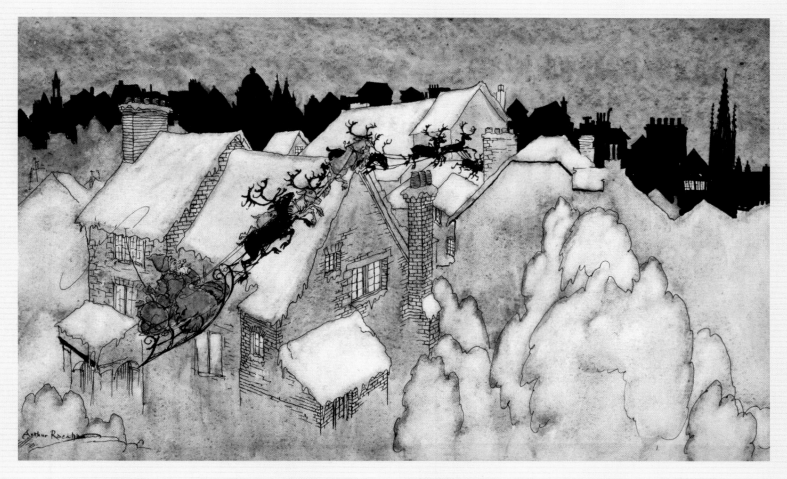

ARTHUR RACKHAM. *So Up to the House-Top the Coursers They Flew.* Copyright Christie's Images/CORBIS.

Or Chanukah, batter. De most fine, de most beauriful, de most *secret* holiday fromm de whole bunch!"

("'Sacred,' Mr. Kaplan, 'sacred,'" Mr. Parkhill thought, ever the pedagogue.) "Ven ve valkink don de stritt an' is snow on de floor an' all kinds tarrible cold!" Mr. Kaplan's hand leaped up dramatically, like a flame. "Ven ve see in de vindows trees mit rad an' grin laktric lights boinink! Ven is de time for tellink de fancy-tales abot Sandy Claws commink fromm Naut Pole on rain-enimals, an' climbink don de jiminies mit *stockings* for all de leetle kits! Ven ve hearink abot de beauriful toughts of de Tree Vise Guys who vere follerink a star fromm de dasert! Ven pipple sayink, 'Oh, Mary Chrissmas! Oh, Heppy Noo Yiss! Oh, bast regotts!' Den ve *all* got varm fillink in de heart for all humanity vhich should be brodders!"

Mr. Feigenbaum nodded philosophically at this profound thought; Mr. Kaplan, pleased, nodded back.

"*You* got de fillink, Mr. Pockheel. *I* got de fillink, dat's no qvastion abot! Bloom, Pinsky, Caravello, Schneiderman, even Mitnick"—Mr. Kaplan was punishing Miss Mitnick tenfold for her perfidy—"got de fillink! An' vat is it?" There was a momentous pause. "De Chrissmas Spirits!"

("'Spir*it*,' Mr. Kaplan, 'spir*it*,'" the voice of Mr. Parkhill's conscience said.)

"Now I'll givink de prazent," Mr. Kaplan announced subtly. Mr. Bloom shifted his weight. "Becawss you a foist-cless titcher, Mr. Pockheel, an' learn abot gremmer an' spallink an' de hoddest pots pernonciation—ve know is a planty hod jop mit soch students—so ve fill you should havink a sample fromm our—fromm our—" Mr. Kaplan turned the envelope over hastily—"aha! From our santimental!"

Mr. Parkhill stared at the long package and the huge red ribbons.

"Fromm de cless, to our lovely Mr. Pockheel!"

Mr. Parkhill started. "Er—?" he asked involuntarily.

"Fromm de cless, to our lovely Mr. Pockheel!" Mr Kaplan repeated with pride.

("'*Beloved,*' Mr. Kaplan, '*beloved.*'")

A hush had fallen over the room. Mr. Kaplan, his eyes bright with joy, waited for Mr. Parkhill to take up the ritual. Mr. Parkhill tried to say, "Thank you, Mr. Kaplan," but the phrase seemed meaningless, so big, so ungainly, that it could not get through his throat. Without a word Mr. Parkhill began to open the package. He slid the big red ribbons off. He broke the tissue paper inside. For some reason his vision was blurred and it took him a moment to identify the present. It was a smoking jacket. It was black and gold, and a dragon with a green tongue was embroidered on the breast pocket.

"Horyantal style," Mr. Kaplan whispered delicately.

Mr. Parkhill nodded. The air trembled with the tension. Miss Mitnick looked as if she were ready to cry. Mr. Bloom peered intently over Mr. Kaplan's shoulder. Mrs. Moskowitz sat entranced, sighing with behemothian gasps. She looked as if she were at her daughter's wedding.

"Thank you," Mr. Parkhill stammered at last. "Thank you, all of you."

Mr. Bloom said, "Hold it op everyone should see."

Mr. Kaplan turned on Mr. Bloom with an icy look. "*I'm* de chairman!" he hissed.

"I—er—I can't tell you how much I appreciate your kindness," Mr. Parkhill said without lifting his eyes.

Mr. Kaplan smiled. "So now you'll plizz hold op de prazent. Plizz."

Mr. Parkhill took the smoking jacket out of the box and held it up for all to see. There were gasps—"Oh!"s and "Ah!"s and Mr. Kaplan's own ecstatic

"My! Is beauriful!" The green tongue on the dragon seemed alive.

"Maybe ve made a mistake," Mr. Kaplan said hastily. "Maybe you don' smoke—dat's how *Mitnick* tought." The scorn dripped. "But I said, 'Ufcawss is Titcher smokink! Not in de cless, netcheral. At home! At least a *pipe*!'"

"'No, no, you didn't make a mistake. It's—it's *just* what I wanted!"

The great smile on Mr. Kaplan's face became dazzling. "Hooray! Vear in de bast fromm helt!" he cried impetuously. "Mary Chrissmas! Heppy Noo Yiss! You should have a *hondert* more!"

This was the signal for a chorus of acclaim. "Mary Chrissmas!" "Wear in best of health!" "Happy New Year!" Miss Schneiderman burst into applause, followed by Mr. Scymzak and Mr. Weinstein. Miss Caravello, carried away by all the excitement, uttered some felicitations in rapid Italian. Mrs. Moskowitz sighed once more and said, "Sooch a *sveet* ceremonia." Miss Mitnick smiled feebly, blushing, and twisted her handkerchief.

The ceremony was over. Mr. Parkhill began to put the smoking jacket back into the box with fumbling hands. Mr. Bloom marched back to his seat. But Mr. Kaplan stepped a little closer to the desk. The smile had congealed on Mr. Kaplan's face. It was poignant and profoundly earnest.

"Er—thank you, Mr. Kaplan," Mr. Parkhill said gently.

Mr. Kaplan shuffled his feet, looking at the floor. For the first time since Mr. Parkhill had known him, Mr. Kaplan seemed to be embarrassed. Then, just as he turned to rush back to his seat, Mr. Kaplan whispered, so softly that no ears but Mr. Parkhill's heard it, "Maybe de spitch I rad vas too *formmal*. But avery void I said—it came fromm *below mine heart!*"

Mr. Parkhill felt that, for all his weird, unorthodox English, Mr. Kaplan had spoken with the tongues of the Magi.

The Night Before Christmas. Cover of a late 19th century edition of
Clement Clarke Moore's *The Night Before Christmas.* The Granger Collection, New York.

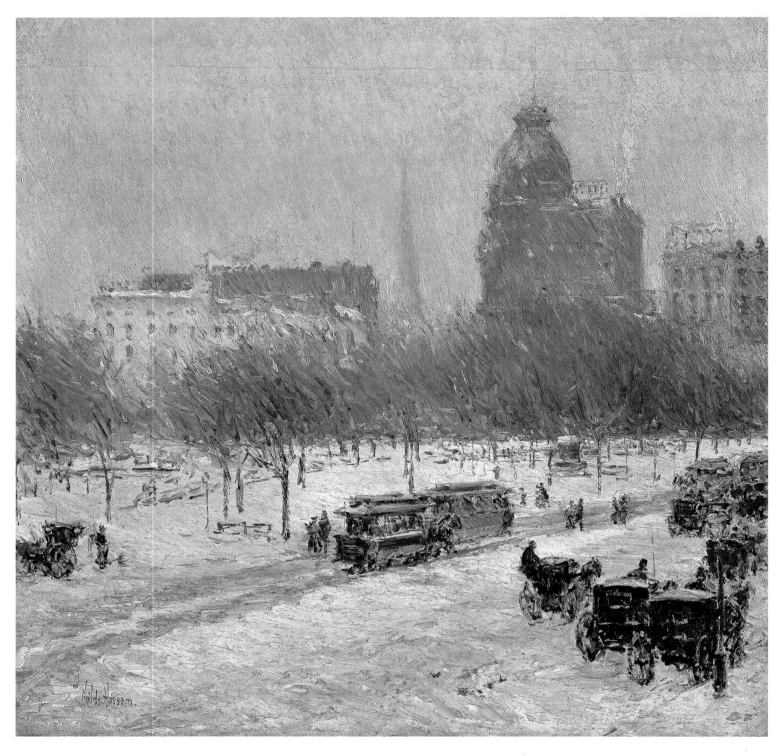

CHILDE HASSAM. *Winter in Union Square*. Oil on canvas.
The Metropolitan Museum of Art. Gift of Miss Ethelyn McKinney,
in memory of her brother, Glenn Ford McKinney, 1943. (43.116.2)
Photograph © 1995 The Metropolitan Museum of Art.

A Typical Irish Christmas

MAEVE BINCHY

Irish journalist and best-selling author Maeve Binchy (b.1940) examines her characters and their relationships with great wit and understanding. In this moving story of new friendship and family reconciliation, we see how Christmas brings people together.

veryone in the office wanted to ask Ben for Christmas. He was exhausted trying to tell them that honestly he was fine. He didn't look fine, he didn't sound fine. He was a big sad man who had lost the love of his life last springtime. How could he be fine? Everything reminded him of Ellen. People running to meet others in restaurants, people carrying flowers, people spending a night at home, a night away.

Christmas would be terrible for Ben.

So they all found an excuse to invite him.

For Thanksgiving he had gone to Harry and Jeannie and their children. They would never know how long the hours had seemed, how dry the turkey, how flavorless the pumpkin pie, compared to the way it had been with Ellen.

He had smiled and thanked them and tried to take part, but his heart had been like lead. He had promised Ellen that he would try to be sociable after she was gone, that he would not become a recluse working all the hours of the day and many of the night.

He had not kept his promise.

But Ellen had not known it would be so hard. She would not have known the knives of loss he felt all over him as he sat at a Thanksgiving table with Harry and Jeannie and remembered that last year his Ellen had been alive and well with no shadow of the illness that had taken her away.

Ben really and truly could not go to anyone for Christmas. That had always been their special time, the time they trimmed the tree, for hours and hours, laughing and hugging each other all the while. Ellen would tell him stories about the great trees in the forests of her native Sweden, he told her stories about trees they bought in stores in Brooklyn, late on Christmas Eve when all the likely customers had gone and the trees were half price.

They had no children, but people said this is what made them love each other all the more. There was nobody to share their love but nobody to distract them either. Ellen worked as hard as he did, but she seemed to have time to make cakes and puddings and to soak the smoked fish in a special marinade.

"I want to make sure you never leave me for another woman . . ." she had said. "Who else could give you so many different dishes at Christmas?"

He would never have left her and he could not believe that she had left him that bright spring day.

Christmas with anyone else in New York would be unbearable. But they were all so kind, he couldn't tell them how much he would hate their hospitality. He would have to pretend that he was going elsewhere. But where?

Each morning on his way to work he passed a travel agency that had pictures of Ireland. He didn't know why he picked on that as a place to go. Probably because it was somewhere he had never been with Ellen.

She had always said she wanted the sun, the poor cold Nordic people were starved of sunshine, she needed to go to Mexico or the islands in winter. And

that's where they had gone, as Ellen's pale skin turned golden and they walked together, so wrapped up in each other that they never noticed those who traveled on their own.

They must have smiled at them, Ben thought. Ellen was always so generous and warm to people, she would surely have talked to those without company. But he didn't remember it.

"I'm going to Ireland over Christmas," Ben told people firmly. "A little work and lot of rest." He spoke authoritatively, as if he knew exactly what he was going to do.

He could see in their faces that his colleagues and friends were pleased that something had been planned. He marveled at the easy way they accepted this simplistic explanation. Some months back of a colleague had said he was doing business and having a rest in Ireland, Ben would have nodded too, pleased that it had all worked out so well.

People basically didn't think deeply about other people.

He went into the travel agency to book a holiday.

The girl at the counter was small and dark, she had freckles on her nose, the kind of freckles that Ellen used to get in summer. It was odd to see them in New York on a cold, cold day.

She had her name pinned to her jacket—Fionnula.

"That sure is an unusual name," Ben said.

He had handed her his business card with a request that she should send him brochures and details of Irish Christmas holidays.

"Oh, you'll meet dozens of them when you go to Ireland, if you go," she said. "Are you on the run or anything?"

Ben was startled, it wasn't what he had expected.

"Why do you ask that?" he wanted to know.

"Well, it says on your card that you're a vice-president, normally they have people who do their bookings for them. This seems like something secret.

She had an Irish accent and he felt he was there already, in her country where people asked unusual questions and would be interested in the reply.

"I want to escape, that's right, but not from the law, just from my friends and colleagues—they keep trying to involve me in their holiday plans and I don't want it."

"And why don't you have any of your own?" Fionnula asked.

"Because my wife died in April." He said it baldly, as he had never done before.

Fionnula took it in.

"Well, I don't imagine you'd want too much razzmatazz then," she said.

"No, just a typical Irish Christmas," he said.

"There's no such thing, any more than there's a typical United States Christmas. If you go to one of the cities I can book you a hotel where there will be a Christmas program, and maybe visits to the races and dances, and pub tours . . . or in the country you could go to somewhere with a lot of sports and hunting and—or even maybe rent a cottage where you'd meet nobody at all, but that might be a bit lonely for you."

"So what would you suggest?" Ben asked.

"I don't know you, I wouldn't know what you'd like, you'll have to tell me more about yourself." She was simple and direct.

"If you say that to every client you can't be very cost effective; it would take you three weeks to make a booking."

Fionnula looked at him with spirit. "I don't say that to every client, I only

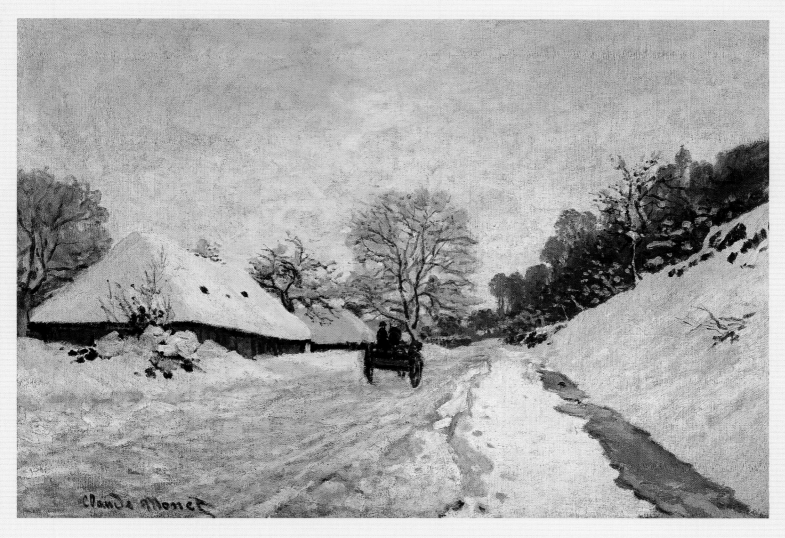

CLAUDE MONET. *The Carriage. Snow on the Road to Honfleur, with the Farm of Saint Siméon.* 1867.
Oil on canvas. Musée d'Orsay, Paris, France. Copyright Erich Lessing/Art Resource, NY.

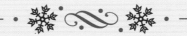
say it to you, you've lost your wife, it's different for you, it's important we send you to the right place."

It was true, Ben thought, he had lost his wife. His eyes filled with tears.

"So you wouldn't want a family scene then?" Fionnula asked, pretending she didn't see that he was about to cry.

"Not unless I could find someone as remote and distant as myself, then they wouldn't want to have anyone to stay."

"Isn't it very hard on you?" she said, full of sympathy.

"The rest of the world manages. This city must be full of people who lost other people." Ben was going back into his shell.

"You could stay with my dad," she said.

"What?"

"You'd be doing me a huge favor if you did go and stay with him, he is much more remote and distant than you are, and he'll be on his own for Christmas."

"Ah, yes, but…"

"And he lives in a big stone farmhouse with two big collie dogs that need to be walked for miles every day along the beach. And there's a grand pub a half a mile down the road, but he won't have a Christmas tree because there'll be no one to look at it but himself."

"And why aren't you there with him?" Ben spoke equally directly to the girl Fionnula, whom he had never met before.

"Because I followed a man from my hometown all the way to New York City, I thought he'd love me and it would be all right."

Ben did not need to ask if it had been all right, it obviously had been nothing of the sort.

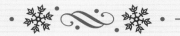

Fionnula spoke. "My father said hard things and I said hard things, so I'm here and he's there."

Ben looked at her. "But you could call him, he could call you."

"It's not that easy, we'd each be afraid the other would put the phone down. When you don't call that could never happen."

"So I'm to be the peacemaker." Ben worked it out.

"You have a lovely kind face and you have nothing else to do," she said.

The collie dogs were called Sunset and Seaweed. Niall O'Connor apologized and said they were the most stupid names imaginable chosen by his daughter years back, but you have to keep faith with a dog.

"Or a daughter," Ben the peacemaker had said.

"True, I suppose," Fionnula's father said.

They shopped in the town and bought the kind of food they would like for Christmas, steak and onions, runny cheese, and up-market ice cream with lumps of chocolate in it.

They went to midnight Mass on Christmas Eve.

Niall O'Connor told Ben his wife had been called Ellen too; they had a good cry together. Next day as they cooked their steaks they never mentioned the tears.

They walked the hills and explored the lakes, and they called on the neighbors and they learned the gossip of the neighborhood.

There had been no date fixed for Ben's return.

"I have to call Fionnula," he said.

"She's your travel agent," Niall O'Connor said.

"And your daughter," said Ben the peacemaker.

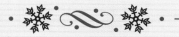

Fionnula said New York was cold but back in business, unlike Ireland which had presumably closed down for two weeks.

"It went great, the typical Irish Christmas," Ben said. "I was about to stay on and have a typical Irish New Year as well....so about the ticket....?"

"Ben, your ticket is an open ticket, you can travel any day you like...why are you really calling me?"

"We were hoping that you could come over here and have a quick New Year with us," he said.

"Who was hoping…"

"Well, Sunset and Seaweed and Niall and myself to name but four," he said. "I'd put them all on to you but the dogs are asleep. Niall's here though."

He handed the phone to Fionnula's father. And as they spoke to each other he moved out to the door and looked at the Atlantic Ocean from the other side.

The night sky was full of stars.

Somewhere out there two Ellens would be pleased. He took a deep breath that was more deep and free than any he had taken since the springtime.

PAULINE BAYNES. *Winter Games and Gathering Holly*.
Private collection/Bridgeman Art Library.

WILLIAM MATTHEW PRIOR. *Games on Ice*. Oil on canvas.
© Shelburne Museum, Shelburne, Vermont.

The Tree That Came To Stay

Anna Quindlen

*Anna Quindlen (b. 1953), best-selling novelist and award-winning newspaper columnist,
shows us that with a little bit of ingenuity it is possible to extend some of
the magic of Christmas through the year.*

he day the tree came to stay the snow fell with a hissing sound. The children saw the separate flakes, for just a minute, sticking to the car windows, and then they melted and were gone. When the car climbed the big hill to the farm where they always found their Christmas tree, the wind whistled around them, and they felt warm behind the glass.

"I want a Christmas tree that's as tall as the stars," said Bud.

"I want a Christmas tree that's as fat as Santa Claus," said Woo.

"Douy, douy, douy," said Bubba, the baby, who was too young to know what she wanted yet.

When they got to the farm, Mom tied Bubba's hat under her chin and Dad took the saw out of the back of the car, the snow making white shadows on his shoulders. The trees stood at attention, blue spruces and Douglas firs and Scotch pines that had grown from little trees to big ones, just waiting for December. Bud walked slowly between the rows, looking closely at each tree. Woo ran up and down, catching flakes in his cold fingers.

"Baa baa baa," said Bubba. Her red boot got caught in a little drift, and it

came off, and she tumbled into a tree, her fat little arms hugging its trunk to stop her fall, her white sock waving in the white air. Mom ran to rescue her.

"I think we've found it," said Dad, uncurling Bubba's fingers from the tree trunk and lifting her high on his shoulders. And everyone gathered round the tree that Bubba had found, and saw that he was right.

"It's not that tall, but I like it," said Bud.

"It's not that fat, but I like it," said Woo.

"Aaaah," said Bubba, as Mom put her boot back on.

It was a Bubba kind of tree. It was shortish and plump, a perfect triangle, and it made everyone feel good. The snow melted on its branches and dripped off like tears, and there was silver in each drop.

"It looks like Christmas," said Dad.

So they took it home.

That night the children stayed up late so that they could decorate the tree. They put the silver bell, the tiny stuffed bear, the satin rocking horse and the wooden soldier on its branches. They hung the red and silver glass balls and looked at their faces in them, their noses fat and their mouths wide. Dad helped Bud lift the angel onto the top branch, and when they plugged the lights in, the candle in the angel's hand lit up.

"Hooray," everyone yelled, even Bubba. And then they had hot chocolate and went upstairs to bed.

"It's the best tree yet," said Woo, as he looked back over his shoulder.

"It's the best tree yet," said Bud, the next morning, when they came downstairs in their pajamas with the rubber feet on them and saw all the boxes in their red and silver paper in piles beneath its plump green branches.

It was the best Christmas yet, too. Bubba got a bear made out of lamb's

wool, and Woo got a dragon that breathed fire when it walked, and Bud got a model of a dinosaur with real bones. The Christmas before, Bubba hadn't even been born yet, and Woo had been a little too little to really understand. Bud liked it better this way.

"I wish it could be forever," he said, as they ate cookies shaped like Christmas trees with green sugar sprinkles on them.

"Nothing lasts forever," Mom said, but Bud wished Christmas could, and the tree, and the cookies, and he and Bubba and Woo eating them together.

Then one morning, a week later, the cookie tin was empty and Dad said it was time to take the tree down. They took off the silver bell, the bear, the rocking horse and the wooden soldier and wrapped them in tissue paper. They took off the glass balls and packed them away carefully in their boxes. Dad held Bud in the air again, and Bud put his hands around the angel's little waist and lifted her gently from the top branch. The tree looked sad with nothing on it but some bits of wrinkled tinsel. Its branches were prickly instead of soft, and its green was a little gray. Dad carried it outside, to the telephone pole beside the trash can, and laid it in the snow. The children came and stood beside it.

"Christmas is over," said Woo sadly.

"I hate it when Christmas is over," said Bud, his eyes scratchy.

"Ohhhhh," said Bubba, in a deep voice, and it was almost as if she knew.

Mom saw them from the window, and she came and stood with them and looked down at the tree.

"Nothing lasts forever," Bud said.

"Well . . . ," said Mom, "nothing stays exactly the same." Then she went back in the house, and when she came out she had a basket in her hand. She knelt down next to the tree and ran her hand down each of its branches, and a shower

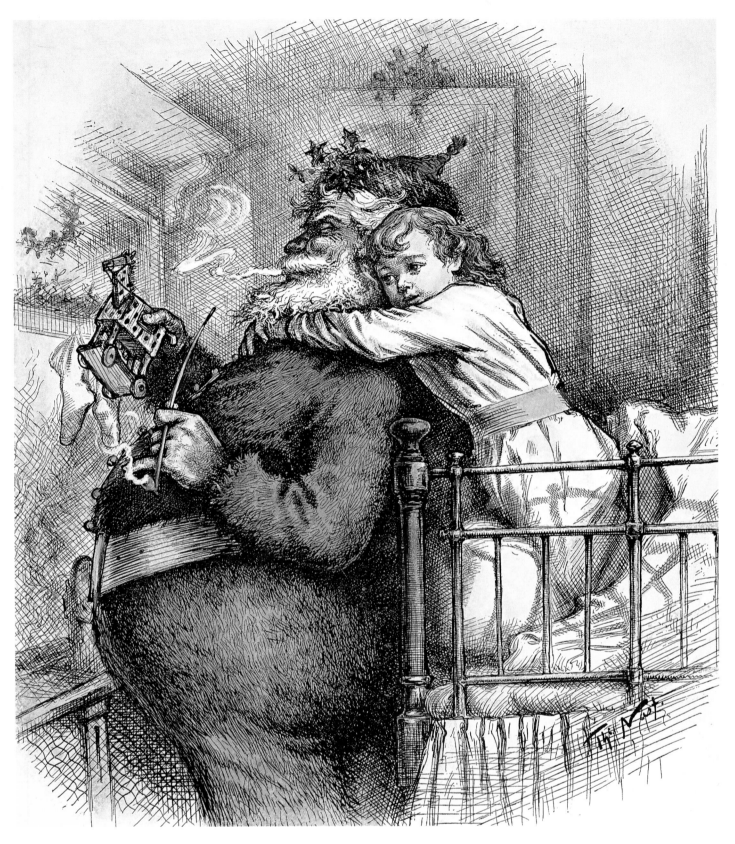

THOMAS NAST. *Caught!* 1881. Colored engraving.
The Granger Collection, New York.

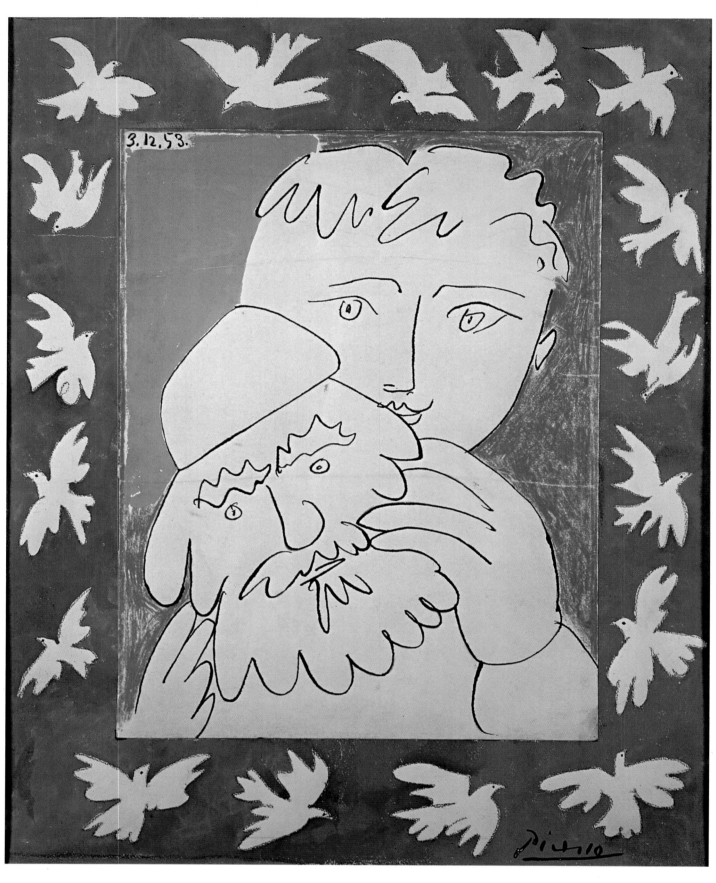

PABLO PICASSO. *The Old Year (L'Ancienne Année), 3 december 1953.* Gouache.
Musee d'Art et d'Histoire, St. Denis, France.
© 2003 Estate of Pablo Picasso/Artists Rights Society (ARS), NY.
Copyright Scala/Art Resource, NY.

of pine needles fell into the basket. Soon, the basket was full of needles.

"Smell," she said.

Bud and Woo put their faces into the basket, and a sharp, fresh green smell went into their noses.

"Christmas in a basket," shouted Woo, and Bud smiled.

"Baah, baah," yelled Bubba, falling over beside the tree and putting a pine needle into her mouth.

And that was how the Christmas tree came to stay. Mom put the basket on the table near the back door, and on its handle she tied red and green ribbons left over from the presents. And at least once a day, when children passed through the room, they stopped to smell the Christmas smell, and though it got fainter and fainter, there was always still at least a little bit of it there. Bud and Woo held Bubba up, so that she could smell it, too.

"Mmmmm," said Bubba, and they were sure she understood.

Keeping Christmas

Henry van Dyke

Pennsylvania-born author Henry Jackson van Dyke (1852–1933) was a professor of English at Princeton, American ambassador to the Netherlands, and a Presbyterian minister. This thoughtful poem reminds us that observing Christmas really means keeping its spirit always.

t is a good thing to observe Christmas day.

The mere marking of times and seasons, when men

agree to stop work

and make merry together, is a wise and wholesome custom.

It helps one to feel the supremacy of the common life over the individual life.

It reminds a man to set his own little watch, now and then,

by the great clock of humanity which runs on sun time.

But there is a better thing than the observance of Christmas day,

and that is keeping Christmas.

Are you willing to forget what you have done for other people,

and to remember what other people have done for you;

to ignore what the world owes you, and to think what you owe the world;

to put your rights in the background, and your duties in the middle distance,

and your chances to do a little more than your duty in the foreground;

to see that your fellowmen are just as real as you are,

and try to look behind their faces to their hearts hungry for joy;

to own that probably the only good reason for your existence

is not what you are going to get out of life, but what you are going to give
 life;

to close your book of complaints against the management of the universe,

and look around you for a place where you can sow a few seeds of
 happiness—

are you willing to do these things even for a day?

Then you can keep Christmas.

Are you willing to stoop down and consider the needs and the desires of
 little children;

to remember the weakness and loneliness of people who are growing old;

to stop asking how much your friends love you,

and ask yourself whether you love them enough;

to bear in mind the things that other people have to bear in their hearts;

to try to understand what those who live in the same house with you really
 want,

without waiting for them to tell you;

to trim your lamp so that it will give more light and less smoke,

and to carry it in front so that your shadow will fall behind you;

to make a grave for your ugly thoughts and a garden for your kindly
 feelings,

with the gate open—

are you willing to do these things for even a day?

Then you can keep Christmas.

Are you willing to believe that love is the strongest thing in the world—
stronger than hate, stronger than evil, stronger than death—
and that the blessed life which began in Bethlehem nineteen hundred
 years ago
is the image and brightness of the Eternal Love?
Then you can keep Christmas,

And if you can keep it for a day, why not always?
But you can never keep it alone.